Courbet James H Rubin

ART&IDEAS

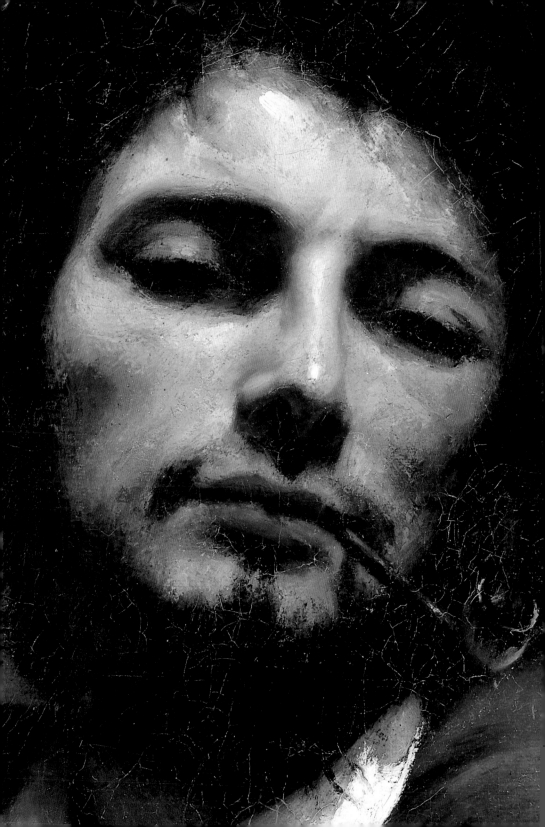

Opposite
Self-Portrait:
Man with Pipe
(detail of 30),
c.1848–9.
Oil on canvas;
45×37 cm,
18¹⁸×15 in.
Musée Fabre,
Montpellier

Few artists have been so directly involved in the events of their time as the French Realist painter Gustave Courbet (1819–77). And perhaps no painter has ever been so important to an understanding of his century. Amid the social transformations of the mid-nineteenth century, Courbet produced the most powerful artistic expression of the emerging modern world and of the new artistic freedom he claimed within it. Single-mindedly committed to his own experiences and thus disdainful of outworn traditions, the ambitious painter from rural Ornans challenged Parisian authority with the raw voice of honesty and authenticity. His politically leftish grandfather had advised him: 'Shout loud and march straight ahead.' He unapologetically took that advice. He drew themes from the world around him, and he represented them with a fresh, unconventional vision, insisting that the art world take them seriously. His enormous aspirations were equalled only by his moral commitment and generosity; his irrepressible belief in himself was balanced by a deep devotion to humanity.

Rebuffed by the Parisian art world and attacked as 'Realist', Courbet seized upon that name to reassert his provincial sympathy for the ordinary citizens whose way of life was being profoundly affected by industrialization and demographic shifts. Realism would reveal underlying truths by stripping away the myths perpetuated by both academic art and conservative politics – myths that served to keep people in their place. Taking his cue from political and social thinkers of his time, Courbet proclaimed the artist's role of helping others to see the world for themselves and to see themselves in the mirror of art. Like the famous writers Balzac, Flaubert and Zola, he plunged his audience into the lives of the rural and working classes. He wanted art to be representative of its own time and beliefs; he swept away an artistic language that remained relevant only to a privileged few, and he adopted poses and production strategies that

sought access to the widest possible public through the press and independent art dealers in addition to the official art exhibitions. In the end, Realism's concrete representation of the contemporary was no less than an extraordinary campaign to change human consciousness so profoundly that all society would be revolutionized. But Courbet's career also exemplified profound changes that had already occurred in the structure of society and in patronage. As a result of both his personal and artistic persistence and vitality, which brought him often into public controversy, Courbet's straightforward, unprettified representations of his own world came to embody values that many of his contemporaries found politically radical and threatening. To the accusation of arrogance he responded that, yes, he was the most arrogant man in the world. Eventually, he was perceived as so dangerous that when he became implicated in a political affair under the Paris Commune, he was forced into exile in Switzerland. Nonetheless, Courbet's militant assertion of individual freedom and his vision of a transformative art would forever set the example for what was to become the avant-garde.

The story of Courbet is the tale of interaction between the artist and his culture. The words 'realist' and 'visionary' offer a clue to the major themes of that interaction. They can appear to be contradictory: 'realist' generally means down-to-earth and practical, while 'visionary' implies rising above restraint to gaze upon the future. But what of the claim that by looking at daily reality and immersing ourselves in its commonplace details, we can seize the future and improve the world? That was the essence of Courbet's reasoning. It was so simple that it could readily be dismissed as naïve by those with more sophisticated concepts, but by its very lack of complication and its accessibility to ordinary people it also became compelling. The impact of Courbet's works was similar: *The Stonebreakers* (32), *A Burial at Ornans* (49), and *The Studio of the Painter* (87) were as controversial as they were prophetic. Thus, Courbet transformed the arts less by his rhetoric than by his example, although that does not mean his thoughts are not to be taken seriously. On the contrary, as time has passed artists have

actually taken far more from the principles underlying his art than from its visual appearance. His many writings and opinions must be given adequate weight in any account of his career. For all these reasons, this book is as much about ideas as about art.

This is intended to be an updated, reliable and stimulating overview for the general reader rather than an exhaustive reference work for scholars. The absence of footnotes aims to streamline the text and promote its readability. At the same time, however, the book inevitably offers an introduction to the 'discourse' of art history, that is, to the modes of discussion and interpretation that constitute and characterize possibilities within the discipline. I have therefore tried to acknowledge scholarly debts and sources through means other than the cumbersome apparatus of references. When indications in the text are not sufficient to lead the reader to original sources, the Further Reading list will do so. Years for quotations from Courbet's letters are either given in the text or should be clear from the context.

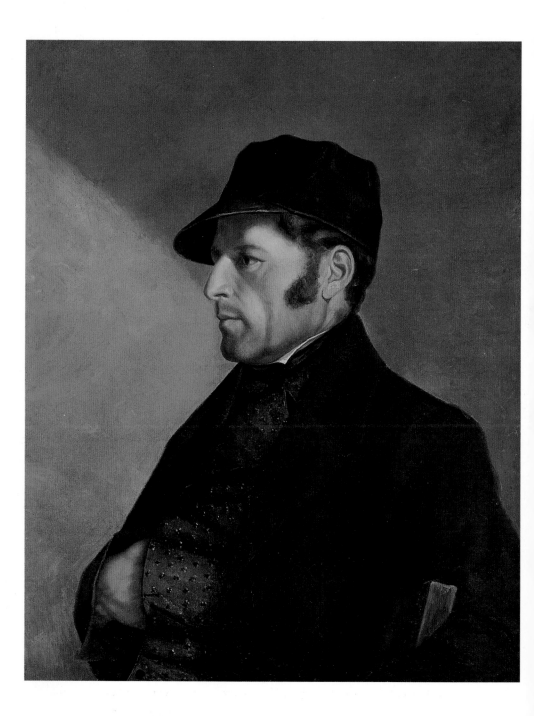

It was often said that Courbet was a born painter. But there was nothing in the circumstances of his heritage or of his birth in Ornans, in eastern France, on 10 June 1819 to predict his career. However, there was a great deal to foreshadow his ambitious attitudes, both political and personal. His father, Régis Courbet, known to us through one of Courbet's earliest portraits (1), was a successful landowner and farmer. His ways were a mixture of the bourgeois and the peasant. He was described as excitably loquacious and as a dreamer full of impractical schemes and inventions – an *original*, as the French would say. He was obviously as full of self-confidence as Courbet's mother was of quiet contentment. Born Sylvie Oudot, she was the daughter of the Ornans tax collector descended through a line of vintners. The Courbet family had an unpretentious but comfortable stone house on the water in the middle of the small town, which is traversed by the Loue River and even today retains much of its charm (2). The young Gustave was raised in middle-class security and idealism.

1
Régis Courbet,
c.1840.
Oil on canvas;
73×59cm,
28³⁄₄×23¹⁄₄ in.
Private
collection

Ornans would forever remain close to the painter's heart, but it had no particularly outstanding artistic tradition. It was located in Franche-Comté (meaning 'Free County', though it had been annexed to France by Louis XIV a century and a half before), a region known for a spirit of independence that spawned many free thinkers. The most notorious was Courbet's eventual acquaintance and intellectual mentor, the philosopher of anarchism, Pierre-Joseph Proudhon (1809–65), who came from the nearby city of Besançon. Courbet's own maternal grandfather Oudot had been an ardent partisan of the French Revolution of 1789. Ornans was in the administrative department of Doubs, named after the river, near the rolling plateau of the Jura mountains, which is crossed by the many streams and marked by the many caverns and granite cliffs that appear in Courbet's landscapes. He grew up loving not just the look of its many green

pastures and pine forests but the peaceful magic of its mysterious refuges; and he also understood the countryside's central role in the lives of those who cultivated, hunted and wandered in it.

When Gustave, who in the autumn of 1837, aged eighteen, had been sent to boarding school in Besançon, announced almost immediately to his family that he was terribly homesick, far behind in his studies, and desired to be a painter, his father resisted, having pinned his hopes on having a lawyer in the family. Courbet's father, whose own father had risen from peasant stock and who himself aspired to the bourgeoisie, understandably sought professional status for his only son, especially since he could afford to pay for his studies. Besides, his three other children were girls (whom their brother painted frequently; 3). The father eventually allowed the restless Gustave to live in the town rather than at the school, but that concession just strengthened the son's direction by making it possible for him to attend more art classes. In Ornans he had already been taking drawing instruction from an artist named Beau, who encouraged students to draw directly from the motif and sent them out into the landscape, a considerable departure from standard academic practice and one that directly informed Courbet's basic assumptions about the practice of art. At the Besançon school his philosophy professor, Charles-Magloire Bénard, was among the first in France to translate and study the aesthetics of the philosopher Friedrich Hegel (1770–1831). Courbet might thus have been predisposed by his education to the so-called materialist thinking – which tied human nature to its material environment – that was to inform the arguments of Hegel followers such as Proudhon and in a very general way can be said to underlie Beau's art teaching. Both insisted on the direct encounter with reality as the basis for all philosophy or art. Courbet pestered his father to let him go to Paris, and he was finally allowed to depart in the autumn of 1839, with his father sending an allowance through a Parisian second cousin, whom Gustave visited frequently thereafter.

Courbet left a voluminous correspondence through which we know a great deal about his activities and hopes. Despite the image he later

2
Ornans, showing the Courbet family's house (right, with three arches) and the Loue River

cultivated as bohemian and unruly, he remained dutiful to his parents, indulgent with his adored sisters (especially Juliette, the youngest, whom he represented in many paintings and drawings), and close to his childhood friends, whom he cherished and supported throughout his life. He travelled often to Ornans and wrote frequently when he did not. In addition, he counted among his Parisian art school and café acquaintances many writers, such as Jules Champfleury, Francis Wey and Alexandre Schanne, all of whom also left records of their encounters. Settled in the Latin Quarter on Paris's Left Bank, on the rue Hautefeuille not far from what was the artists' quarter of Saint-André-des-Arts, Courbet enrolled in the art school of Baron von Steuben. However, he was more attracted to the less formal Atelier Suisse, where cheap life-drawing classes were run by a former artist's model by the name of Suisse. He also copied Old Master paintings in the Louvre, concentrating primarily on the Northern, Venetian and Spanish schools, rather than the more tradi-

3
Courbet's
Sisters with an
Old Gossip,
*c.*1846–7.
Oil on canvas;
61×50 cm,
24×19³⁄₄ in.
Private
collection

tional classics of the Italian Renaissance and Baroque. Courbet also got to know another teacher, Auguste Hesse, whose course was attended by a boyhood friend named Adolphe Marlet. Hesse was impressed by Courbet's work and took a lively interest in him. Courbet never made an effort to enter the state-run École des Beaux-Arts, which was at the heart of the academic system. He was too impatient to endure its years of arduous and repetitive study, and he was out of sympathy with its Classical ideals.

Crowded and bustling Paris (4) could not have been more different from sleepy Ornans. In July 1830, when Courbet was eleven years old, the reactionary Bourbon Restoration was overthrown by a three-day revolution. In place of the ageing Charles X, Louis-Philippe of the collateral Orléans line headed a slightly more liberal regime. Politics were even more fragmented than before, as opposition to the new government came from widely different quarters, including Legitimists, who mourned the privileges of the old aristocracy under the Bourbons, Bonapartists, republican holdovers from the revolution of 1789, and the increasingly vocal Socialists, whose utopian theories would gain enormous influence during the 1840s. Their general perception was that the government was run on the backs of

workers and farmers for the crass interests of bourgeois investors. Physically, Paris of the 1850s was beginning to be transformed by the creation of the splendid network of wide, tree-lined boulevards, luxury apartment blocks and beautiful shops. An economic boom that followed the defeat of Napoleon created a surge of immigrants to Paris, and the effect of a growing communications and transporta-

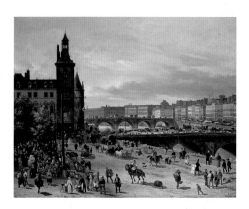

4
Giuseppe Canella, *The Flower Market, Paris*, 1832. Oil on canvas; 52×66cm, 20½×26in. Musée Carnavalet, Paris

5
A Parisian dandy from the 1840s

tion infrastructure was to focus the nation on the capital more than ever before. The city became a complex sprawl of increasing wealth and squalor, hope and disenchantment.

The so-called dangerous classes, consisting primarily of the poor, many of whom had moved in from the country, were both hated and ridiculed, yet idealized and admired, depending on where one stood. In 1846, three-quarters of the French population was rural; in 1852, nearly 70 per cent of the nation's economic production was agrarian. However, during the first half of the century, the French Industrial Revolution had begun (considerably later than the British), and as the population of Paris doubled from 1830 to 1860 the peasant-worker became common. For many this population was associated with violence and radical uprisings while, for others the life of the countryside was filled with virtues that a corrupt urban society would do well to emulate, and its loss was a basis for nostalgia. Although the first collectivist impulses had urban origins, for example, the Lyon silkworker protests of the 1830s, social criticism often looked to ideals of a pre-industrial society located in the countryside.

The literary and artistic activity of the time was often a response to
such conditions, whether it was a watered-down version of
Romantic painting that was ingratiating to bourgeois materialism or
a burgeoning Realist literature that abhorred it. The cult of the
dandy (5), which came from England, revealed a similar ambiva-
lence, for while the dandy displayed wealth and fashionable taste,
he cultivated indifference and disdain above all. Established writers
and painters often presented themselves as a separate and select
breed, continuing, as in previous generations, to meet in literary
salons. The bohemian gatherings in beer halls of younger artists
and writers such as Courbet and his friends both adopted the forms
of such separatism and yet parodied them with their earthier taste
and manners.

Traditional art-historical terminology holds that the early nineteenth-century conflict between Classicism and Romanticism gave way to Realism. However, it is now widely accepted that definitions of such movements become oversimplistic if examined closely. For French Realism did not emerge from nowhere but had strong antecedents in the first half of the nineteenth century. It is therefore important briefly to sketch the situation of the arts on the eve of Courbet's arrival. Who were the artists everyone knew and respected when Courbet first started out? What might Courbet have found compelling in their work?

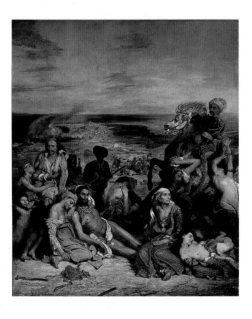

6
Eugène Delacroix, *Scenes from the Massacres at Chios*, 1824. Oil on canvas; 419×354 cm, 165×139¼ in. Musée du Louvre, Paris

The maxim *il faut être de son temps* (one must be of one's times), supposedly first uttered by the famous caricaturist Honoré Daumier (1808–79), was central to the generation of 1830, the so-called Romantics, even though it sounds worthy of Courbet and the Realists of some ten to twenty years later. As early as 1819 the novelist Stendhal (Henri Beyle, 1783–1842) praised Michelangelo as being inspired by the spirit of his own times, and urged that artists of the nineteenth century seek similar motivation. Stendhal had experienced the Napoleonic wars as an officer of the Imperial Guard and had seen its effects on culture. The poet and critic Charles Baudelaire (1821–67), who soon became Courbet's friend, took up

Stendhal's plea in the 1840s, holding that Romanticism was none other than 'the most recent and the most actual expression of the beautiful ... He who says Romanticism, says modern art.' Baudelaire was writing in 1846 about the painting of Eugène Delacroix (1798–1863), who almost twenty-five years earlier had emerged as the leader of the Romantic painters. His notoriety was based on the modernity of his subject matter and the naturalism of his style, features taken up by Realism. Delacroix's painting contrasted with the academic manner and conservative attitudes of Jean-Auguste-Dominique Ingres (1780–1867), the leader of the opposing camp of so-called Classicists. At the Salon of 1824 (the official, usually bi-annual government-sponsored art exhibition), a masterpiece by each of them – Delacroix's *Scenes from the Massacres at Chios* (6) and Ingres's *The Vow of Louis XIII* – called forth an inevitable comparison that redefined the discussion of art for a generation. From then on, the question of modernity would be central.

For his painting Delacroix had imagined a scene from the Greek wars of independence against the Turks in which the women and children of defeated Greeks were being dragged off into slavery. Not only was it based on contemporary historical events, but it was charged with appeal to liberal political principles, namely freedom for oppressed peoples. By contrast, Ingres's painting looked to the past. It represented a French sovereign from the time of the Renaissance placing his sceptre, symbol of royal power, under the aegis of a Raphaelesque Virgin and Christ. Ingres's theme thus overtly appealed to traditional notions of hierarchy and authority. Stylistically, Delacroix's painting looked as if it was based on natu-ralistic observation. He worked directly from live models and from costumes brought back from the Middle East by friends; he also handled his paint with a looseness that suggested the spontaneity of immediate experience, when compared to the more rigorously linear and smoothly finished style of Ingres.

The political dimension acquired by realistic artistic style in the early nineteenth century helps explain its appeal to Courbet and Théodore Géricault (1791–1824). In showing the victims of a recent

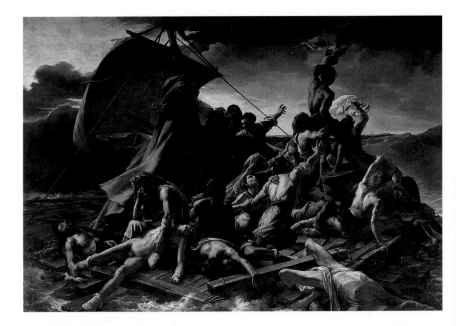

7
**Théodore
Géricault**,
*The Raft of the
Medusa*, 1817.
Oil on canvas;
491×716 cm,
193¼×282 in.
Musée du
Louvre, Paris

8
**Eugène
Delacroix**,
*Liberty on the
Barricades*,
1830.
Oil on canvas;
260×325 cm,
102¼×128 in.
Musée du
Louvre, Paris

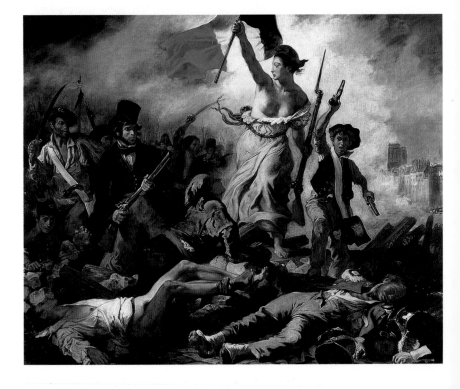

shipwreck caused by the incompetence of officers appointed by the Restoration King Louis XVIII, Géricault's *The Raft of the Medusa* of 1817 (7) established a precedent within large-scale painting for expressing political opposition. His dark tenebrism and monumental figures were echoed in Delacroix's *Liberty on the Barricades* (8), which celebrated the Paris uprising of 1830. Together, these two paintings established a form through which liberal aspirations might be expressed. Courbet's *A Burial at Ornans* (see 49) would eventually share their characteristics of darkness, scale and naturalism, despite many other differences.

However, these powerful examples were in the background during Courbet's early years, while he tried to use more modish trends to curry favour in the Parisian art world. For when Courbet began painting in the 1840s, the liberal and naturalist impetus of Géricault and Delacroix's grand paintings had been diluted by other elements. A fashionable strain of Romantic painting drawing from medieval and Renaissance tales is called 'Troubadourism'; another, with subjects from North Africa and the Middle East, reflecting French colonial expansion into areas of Islamic culture, is called 'Orientalism'. Courbet drew on these styles for a number of his earliest works. They used an optical realism executed in the polished manner exemplified by Ingres, forming an eclectic compromise between Romanticism and Classicism that was in some cases called *Juste Milieu* (Middle-of-the-Road). By the 1830s Delacroix himself had begun producing small paintings on medieval or oriental themes. One of Courbet's earliest-known subject paintings, *The Pirate Held Prisoner by the Dey of Algiers* (9), echoes them, although with an earthiness that hints towards his future.

Even when their subject matter was contemporary and political, these so-called Romantic styles never represented the ordinary and the everyday as something to be taken seriously, as Courbet later would. Nor did they, as had Géricault and Delacroix, embody universal themes through the experiences of anonymous sufferers. On the contrary, their infatuation with visual incident and detail constituted a minor expansion of the repertoire of history painting rather than a

grand opening into modernity. This trend did not influence Courbet's art for long; eventually he turned to more 'realist' trends to be found in non-historical categories of painting, namely the landscapes of the Barbizon School and the genre paintings of Dutch-inspired French regionalists.

9
The Pirate Held Prisoner by the Dey of Algiers, 1844.
Oil on canvas; 81×65 cm, 31⅞×25⅝ in.
Musée Gustave Courbet, Ornans

During his first few years in Paris Courbet began to dress dandily, and he acquired a black English spaniel, shown in two self-portraits, the *Small Self-Portrait with Black Dog* and the larger *c.1842–4 Self-Portrait with Black Dog* (10). In the latter the painter wears a brightly lined coat, fashionable plaid trousers, a wide-brimmed hat,

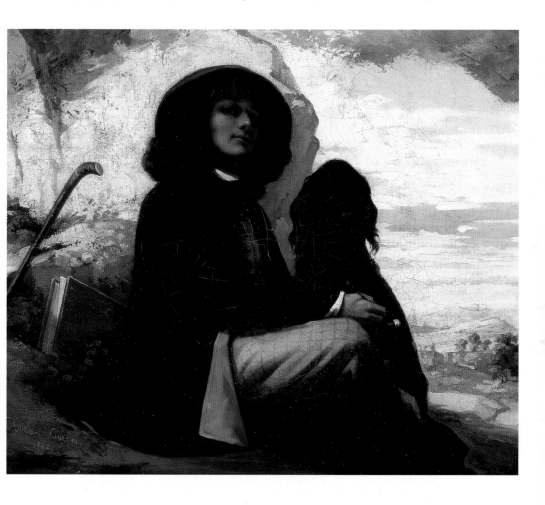

10
*Self-Portrait
with Black
Dog*, *c.*1842–4.
Oil on canvas;
46×55 cm,
18⅛×21⅝ in.
Musée du
Petit Palais,
Paris

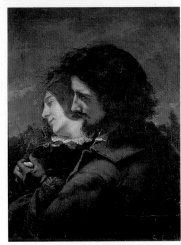

11
**Jean-Baptiste
Camille Corot**,
*Girl Reading in
Fontainebleau
Forest*, c.1830.
Oil on canvas;
175·6×242·6cm,
69⅛×95½in.
National
Gallery of Art,
Washington, DC

12
The Large Oak,
1843.
Oil on canvas;
29×32cm,
11½×12⅝in.
Private
collection

13
*Lovers in the
Countryside*,
1844.
Oil on canvas;
77×60cm,
30¼×23⅝in.
Musée des
Beaux-Arts, Lyon

and sports a walking stick. He has taken a book along on his outing, presumably for sketching. Personal appreciations of nature had been glorified by Romantic poetry and were already the subject of the most current art, as in a landscape by Camille Corot (1796–1875) of c.1830 (11). But at this time Courbet used landscape as no more than background. Indeed, he cut such an elegant figure one supposes his mind was less on the countryside than on Paris, and he looks as if he expected to take it by storm. Courbet's need for proper clothing is a frequent topic in early letters requesting money from his parents. (He had run up debts borrowing from friends.) Perhaps he thought it would help overcome the stigma generally associated with provincial origins. During these years Courbet also painted a number of rather sentimental romantic scenes, such as *The Large*

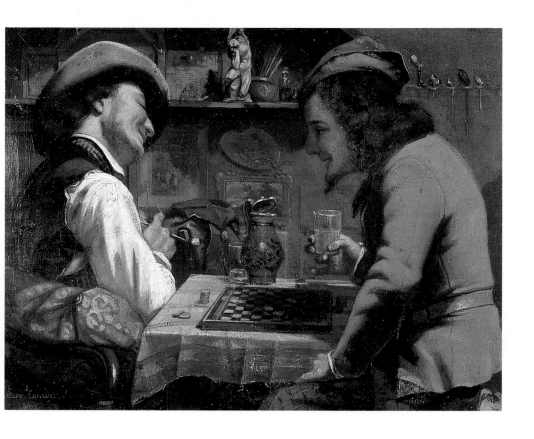

Oak (12) and *Lovers in the Countryside* (13) of 1843 and 1844. Scholars have wondered if the latter documents his relationship with Virginie Binet, the mistress who dominated his romantic life until she left him sometime around 1855. She bore him a son in 1847, though Courbet almost never mentions him. These paintings are mostly quite small and many are executed in a meticulous style not far from Flemish paintings of genre subjects, which he pastiched in his curious *The Draughts Players* (14). In this painting, Courbet, to our right, is accompanied by his friend Alexandre Schanne. Courbet holds a glass of water – though one usually thinks of him with beer – identifying the two as members of the bohemian circle known as the 'Buveurs d'eau' (the Waterdrinkers).

14
The Draughts Players, 1844.
Oil on canvas;
25×34cm,
9⅞×13⅜in.
Adolfo Hauser
Collection,
Caracas

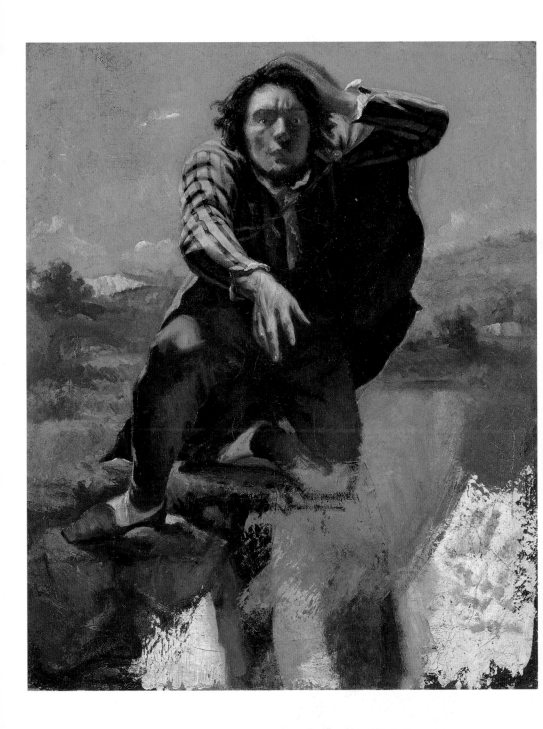

All of these early works contain self-portraits (at this time in his career their proportion in comparison to other subjects probably far exceeded that in the work of any other painter). Clearly Courbet's narcissism went beyond the convenience of his self-image as a handy subject. Even when he is not represented as an actor in some romantic role, he is certainly posing quite self-consciously. In an early self-portrait called *The Desperate One* he stares into a mirror (without which self-portraits would have been impossible), either tearing at or re-arranging his hair. In the unfinished *Man Filled with Fear* (15) his striped waistcoat and slippers emphasize the element of play-acting. Perhaps Courbet's search for identity had a note of desperation, for his shifts of pose are only slightly more frequent than his changes of coiffure and styles of facial hair (16). The main constant was an ostentatiously precious style of painting in bright contrasts and tight forms, imparting a sophisticated sense of control. Courbet quickly came to possess the full range of stylistic possibilities within Romanticism, from the sheen of its more conservative practitioners – stylistic followers of Ingres – to the massing of colour and fluid technique of Delacroix. But while he could imitate these styles and show off his technical proficiency, he seems not to have assimilated them. They are little more than poses adopted by a painter whose conviction at this time was to search around for the strategy most likely to win public recognition.

15
Man Filled with Fear, c.1843–5. Oil on cardboard; 60·5 × 50·5 cm, 23³₄ × 19⁷₈ in. Nasjonalgalleriet, Oslo

16
Nadar (Gaspard Félix Tournachon), Caricature of Courbet in his studio, showing his flamboyant beard. *Le Petit journal pour rire*, no. 85, 1857

Despite his productivity and high hopes, Courbet's success during these early years was in some doubt. In repeated blows to his ego, all the pictures he submitted to the Salon in 1841, 1842 and 1843 were refused. Finally, in 1844, the larger *Self-Portrait with Black Dog* was admitted. Courbet then submitted five paintings to the jury for 1845, but only one, a *Guitarrero* (17), probably a portrait of his musician friend, Alphonse Promayet (1823–72), was accepted. This glossy and colourful little painting, with its guitarist in an outdoor setting, evokes the taste for medieval subjects (the Troubadour style) through the figure's minstrel costume. It tries to combine linear definition of the main figure with a more loosely painted background, where forms are created out of pigment masses. The richness of Courbet's vegetation and the luminous contrast between white clouds and blue skies suggest he might have been looking at Venetian art, then thought to embody an ideal synthesis of Classicism, with its tight, linear style, and Romanticism, with its more permissive generalizations of form.

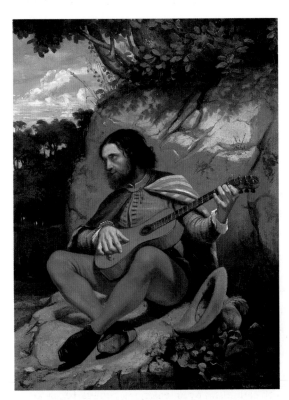

17
Guitarrero,
1844.
Oil on canvas;
55×41 cm,
21⅝×16⅛ in.
Private
collection

As a sign of his ambition, Courbet increased the size of some of his works, and their subjects became more varied. In 1845, *The Dream*, now known as *The Hammock* (19), was turned down by the Salon jury, although it is surely one of his best early efforts. Perhaps it was too provocatively close to overt eroticism for the jury. Courbet's semi-exposure of the sleeping girl's ample breasts was complemented by his already uncanny ability to produce the sensation of material presences – to make things look as if the viewer could touch and feel them. Here Courbet's synthesis of figure and landscape styles is more successful than before. His transition from the figure to the background is gradual, with numerous carefully painted flowers and leaves. He restricted his sketchiness primarily to areas of darkness or distance, as was more conventional in the painting of his time. Rejected in the same year were *The Draughts Players*, already mentioned, a large portrait of his friend Urbain Cuenot (1820–67), and a *Portrait of Juliette Courbet* (18). The latter, perhaps in a concession to provincial taste, is luminous but stiff. Yet Courbet wrote home bravely that Marlet's teacher Hesse had praised him in front of all the others in the studio. If he could continue to produce such pictures, Hesse told him, he would win a high rank among painters. Courbet seemed to feel that he had to make a bold and immediate effort: 'I must make a name for myself in Paris within the next five years. There can be no middle course.' Yet there was little indication of what direction he should take. His two successes of 1844 and 1845 were of male figures in landscapes. Everything else had been refused. In 1846 a large portrait was accepted, possibly *The Man with Leather Belt* (20), but seven other paintings were refused, and, in 1847, three more were rejected. After seven years and a brief glimmer of success, Courbet's frustration must now have been complete.

The 1840s was a period of uncertainty as well as hope, not just for Courbet but for many who contested the social and political status quo. During the 1840s the conflicts unleashed by the French Revolution continued to boil up in French society – monarchists versus republicans, landowners versus peasants, and the more modern struggle with capitalism by an emerging proletariat, as in

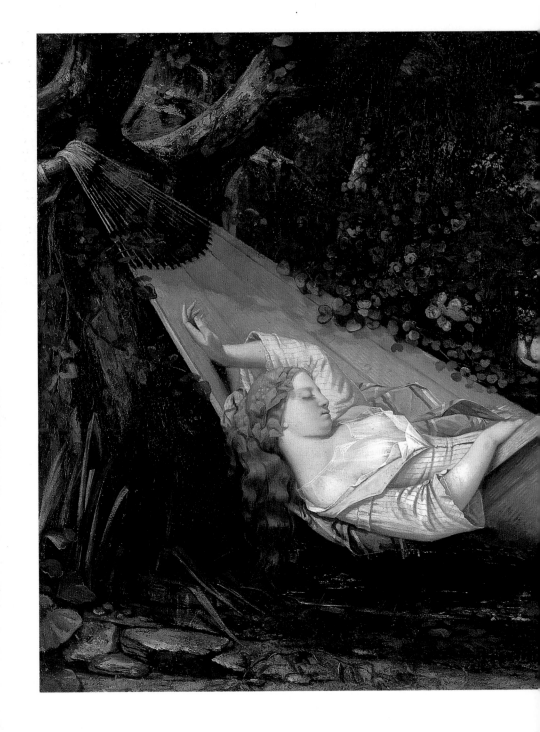

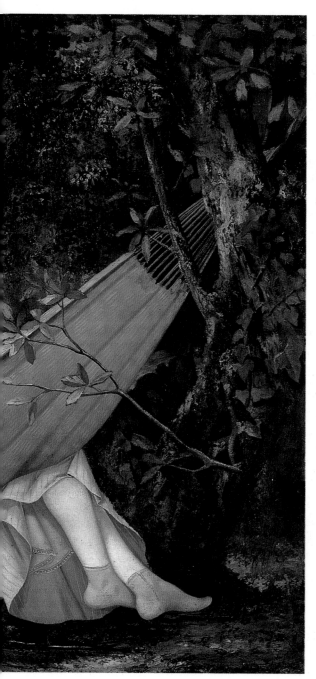

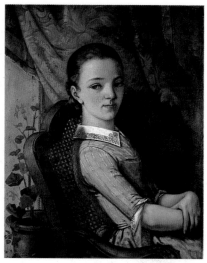

18 Above
*Portrait of
Juliette Courbet,*
1844.
Oil on canvas;
78×62 cm,
29³⁄₄×24³⁄₈ in.
Musée du Petit
Palais, Paris

19 Left
The Hammock,
1844.
Oil on canvas;
70·5×97 cm,
27³⁄₄×38¹⁄₄ in.
Oskar Reinhardt
Collection,
Winterthur

the Lyon riots or disturbances in working-class neighbourhoods of Paris. These changes were chronicled in the newly popular literary form of the novel, as practised by Stendhal and Honoré de Balzac (1799–1850). There is no proof that Courbet had read particular books, but his Parisian circle included many writers who helped him to formulate his ideas. In literature, one of the most effective expressions of what in retrospect can be called a positive 'anti-modern critique' emerged in the novels of George Sand (1804–76; born Aurore Dupin, she was later famous as the mistress of the composer and pianist Frederick Chopin). Deriving ultimately from the Swiss-born philosopher Jean-Jacques Rousseau's claim that all virtue lay in nature and in following feelings, her books proclaimed the concept of social regeneration based on freeing those sentiments repressed by tradition and convention. She was also a collaborator of Utopian Socialist writers such as Pierre Leroux, whose book *On Humanity* (1840) promoted egalitarianism and solidarity among all humans. Sand's detailed descriptions of the landscape near her native Nohant, in the Berry region of central France, and of the activities of farming and shepherding, created visions of harmony and fulfilment, and she declared them noble subjects for painting. Naturally, her idyllic image of the countryside was far from its reality, yet her writing had the feeling of realism. Its power lay in its ability to create the impression of an alternative way of life, one set in nostalgia but which served as a foil for the frustrations of the present. In retrospect, the works of Sand, Balzac, and others who wrote about the lives of ordinary folk came to be associated with Realism. However, it was a realism steeped in a loathing of modernity that must also be considered Romantic. Regionalism might be a better term, especially for George Sand.

Another writer of provincial origins who shared many of Sand's attitudes was Jules Champfleury (1821–89), Courbet's best-known early literary friend. After a brief collaboration with Henri Murger, soon-to-be author of the *Scènes de la vie de Bohème* (1848; on which Giacomo Puccini's famous 1896 opera, *La Bohème*, was based), Champfleury began writing articles about art. One of his early publications was a short story of 1845 called *Chien-Caillou* (literally

Pebble-Dog), which told the tale of a down-and-out artist living in a garret who eventually loses his sanity. However, his idealistic implication that lack of artistic success was based on conflict between the artist's non-conformity and the philistine vision of bourgeois patrons neglected to consider some harsh economic realities that have been too easily forgotten. The legislation of the French Revolution had abolished the Royal Academy of Painting and Sculpture and outlawed artists' craft guilds in order to open the profession of artist to the free market. As a result, from 1789 to 1838, the number of individuals declaring themselves to be artists in the Paris census records leapt from 354 to 2,159. Even the widening of the audience for art to include the middle classes and the expansion of marketable media to include drawings and prints, thanks especially to the new technique of lithography, were not enough to support this exploding artist population economically. The 1830s saw the beginnings of refusals at the Salon, which increased dramatically in the 1840s. Young new artists, less well known or less well supported by eminent teachers, were the first to suffer poverty. Courbet's disappointing experience was hardly unique.

The glossy romanticism and the attempted appeal to a middle-class clientele of many of Courbet's works during the years prior to 1848 were completely in keeping with those of his contemporaries. So it is most likely that his success or failure at the Salon was as much a matter of chance as of recognition. Even *The Man with Leather Belt*, in spite of its bold chiaroscuro and other technical strengths, places its subject, again Courbet himself, well within a traditional sphere (it has recently been discovered that he painted it over his copy of Titian's *Man with Glove*). The picture stands in a long line of introspective artists' portraits that are exemplified by a *Portrait of an Artist in His Studio* (22), formerly attributed to Géricault, of almost thirty years before. In his other self-portraits, too, Courbet stressed the sensitive, Romantic persona, whether it be the lover or the artist-troubadour.

In a similar spirit of sensitivity and introspection is a fresh and vivid portrait painted on wood of H J van Wisselingh (21), probably done

in 1846, when Courbet went to Holland. Van Wisselingh and Courbet had met the previous year in Paris, when the young Dutch dealer and collector came on a buying expedition. In Courbet's first sales to an outsider, Van Wisselingh bought two of his paintings. Still on a stipend from his father, Courbet surely savoured this small but important success. Courbet's affinities for Dutch art may have sparked Van Wisselingh's interest, and in any case, it can only have contributed to the painter's desire to make a trip to the Netherlands, where, partly through Van Wisselingh's efforts, he was eventually to have a consistent following. The portrait itself is a fine example of Rembrandtesque chiaroscuro lighting, broad massing of forms through areas of colour, and loose paint handling that together convey convincing sensations of the tactile. Courbet's stylistic experiments and changing poses seemed to have finally led to solid ground.

On returning from these travels, Courbet painted another self-portrait, *The Cellist* (23), which reveals just such a consolidation. Although his facial expression is still of romantic inspiration, its complexity is sophisticated. The figure's physical presence and spatial ambiance are both greatly improved since *The Man with*

20
The Man with Leather Belt, 1846.
Oil on canvas; 100×82 cm, 39³⁄₈×32¹⁄₄ in.
Musée d'Orsay, Paris

21
Portrait of H J van Wisselingh, 1846.
Oil on panel; 57×46 cm, 22¹⁄₂×18¹⁄₈ in.
Kimbell Art Museum, Fort Worth, Texas

22
Artist unknown (formerly attributed to Théodore Géricault), *Portrait of an Artist in His Studio*, c.1818–19.
Oil on canvas; 147×114 cm, 57⁷⁄₈×44⁷⁄₈ in.
Musée du Louvre, Paris

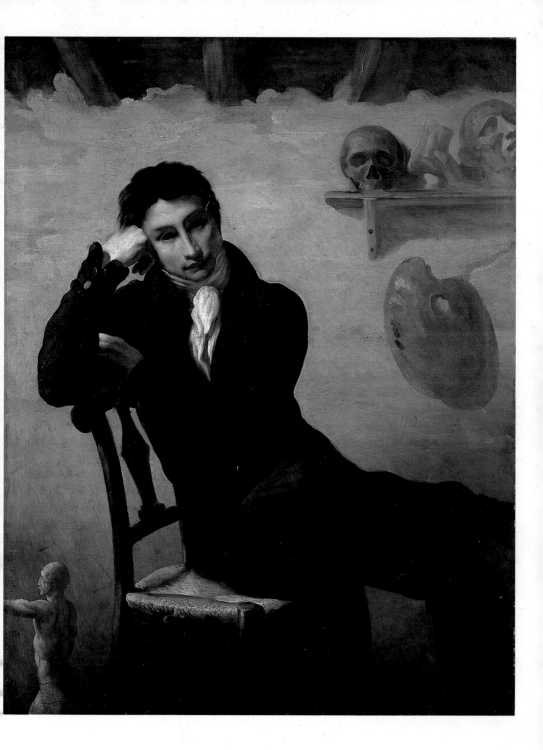

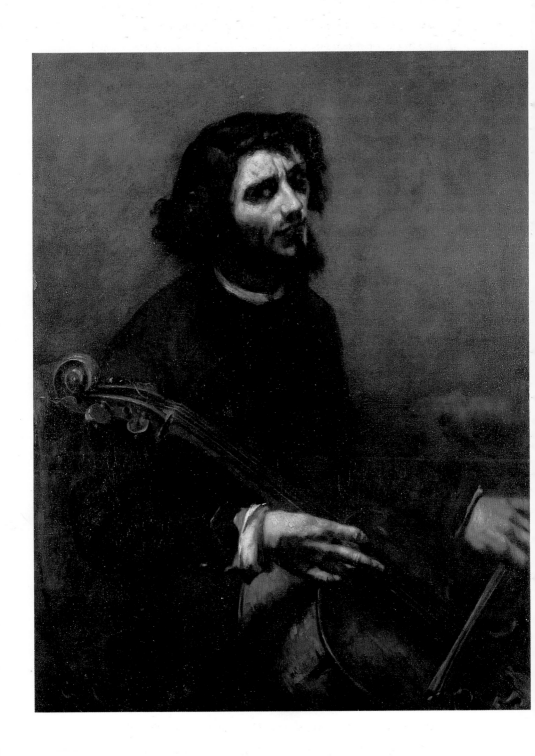

Leather Belt. The Cellist was apparently submitted to the Salon of 1847 (though refused by the jury) under the title *Souvenir of Consuelo. Consuelo* (1842–3) was a novel by George Sand in which song and musical reverie embodied the aspirations of her main character. Courbet considered himself a music lover; he sang in choruses and thought he had a great voice, and, through his friendships with Promayet and others, he took an interest in popular musical expression. Thus, Courbet's search for stylistic identity still served a romanticized persona as artist-dreamer.

However, Courbet had no more success in pleasing the jury than before. Yet, despite his increasing distance from official style, his self-confidence was increasing, too. He felt he was no longer alone. Artists had begun publicly protesting against the narrowness of the juries' choices and the volume of their rejections. Although working so doggedly that he frequently undermined his health, by the second half of the 1840s Courbet's rounds at the cafés had produced close relationships with a number of contemporaries who became what might be called spiritual partners, when they were not actual collaborators. They gathered regularly at places like the Café Momus and especially the Brasserie Andler, which they made, as Champfleury termed it, 'the temple of Realism'. Courbet's studio at rue Hautefeuille was practically next door to Andler's, and he made a drawing there in 1848 showing himself, dressed in plaid trousers and with a top hat, seated to the right of two companions (24). In January of that year Courbet wrote proudly to his parents about a large painting he was preparing and claimed that he was 'on the point of success because I have all around me very influential people in the press and in the arts who are enthusiastic about my work'. With them, he hoped 'to constitute a new school, of which I shall be the representative in painting'. Most notable amongst the group's members was the poet and critic Charles Baudelaire.

Courbet's first major break came with the February Revolution of 1848, when he was twenty-eight, for the Salon jury was eliminated, and all of his entries were hung. While he was upset that his paintings were among a crowd of some 5,500 exhibited works, for the

23
The Cellist, 1847. Oil on canvas; 117×89 cm, 46×35 in. Nationalmuseum, Stockholm

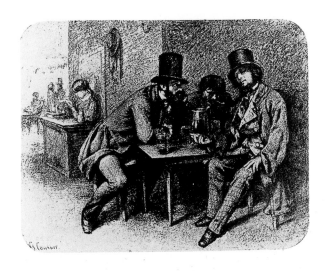

first time they were actually noticed. In particular, a huge painting (2×2·5 m, 6¹₂×8 ft) called *Classical Walpurgis Night* was deemed memorable by one critic, who predicted that 'this unknown … would turn out to be a great painter'. Although Courbet had indeed invested a great effort in the painting, it seems not to have survived his eventual decision to jettison all Romantic subjects in favour of concrete, visible reality: he painted over it in 1853.

The relative success of this ambitious effort would undoubtedly have led most artists to continue along the same track. But for Courbet the liberation provided by the Revolution of 1848 also meant that he could pursue work closer to the programme of his proto-Realist friends. It is hard to judge how swept up in the politics of the moment he was, for his pacifist reasons for not participating in the actual fighting do correspond to the positions of many social thinkers, including Pierre Leroux and Pierre-Joseph Proudhon. Courbet claimed to be waging a war of the intellect, and he did collaborate with Baudelaire and Champfleury on a short-lived political journal called *Le Salut public* (*The Public Welfare*), for which he designed a title page (25). Its composition shows elements derived from Delacroix's famous *Liberty on the Barricades* (8) cast into more proletarian terms. Courbet understood that the 1848 Revolution was a popular uprising based on left-wing ideology that celebrated the lower classes. And the major effort to which he dedicated himself

LE SALUT PUBLIC.

immediately in the revolution's wake, while on a scale similar to the *Walpurgis Night,* was no longer derived from Romantic literature but from country life – a life, in fact, that was arguably Courbet's own. For his *After Dinner at Ornans* (26) named his obscure home town as its location and represented figures who were not only his closest friends, Marlet, Promayet and Cuenot, but his own somewhat rumpled father, who is seen dozing with a glass of spirits to the left. Although the figure leaning on his elbow is not literally a self-portrait (but has at times been identified as such), the painting nonetheless clearly associates the artist's self with this milieu, with its homely, modest interior infused with tacit camaraderie and unpretentious culture. As Marlet, in his hunting jacket and accompanied by his old dog, lights his pipe, Promayet offers a solo on his violin. Cuenot leans away from the table on which some wine and fruit still remain (in a marvellous still life), losing himself in the shared love of rustic culture – food, music and companionship. A fire glows in the background, unfortunately darkened with age.

Yet this painting is also informed by the painter's ever growing

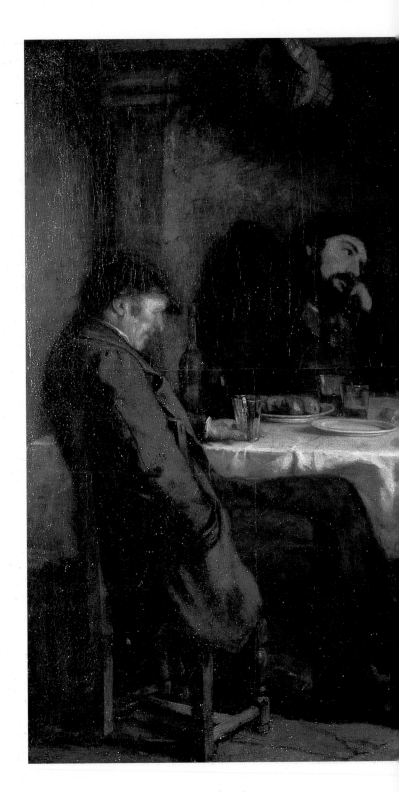

26
*After Dinner at
Ornans*, 1848–9.
Oil on canvas;
195×257cm,
76¾×101¼in.
Musée des
Beaux-Arts, Lille

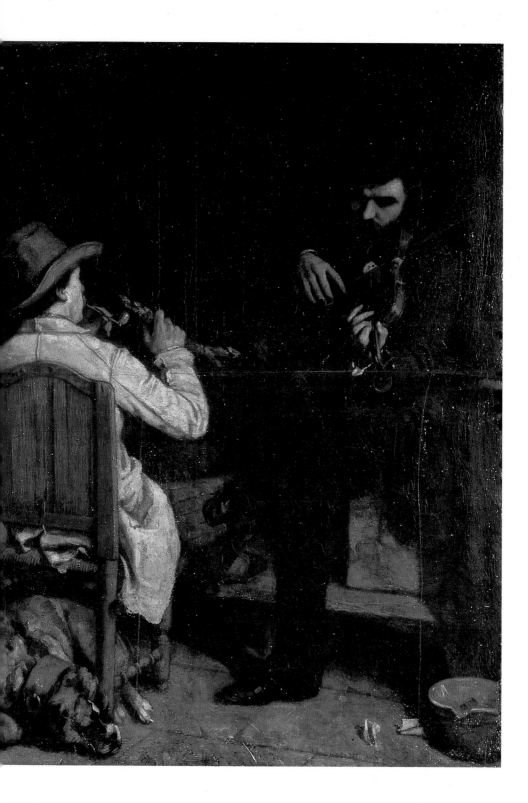

ambition. Its scale itself was an important statement, for large formats had generally been reserved for history painting. Representations of ordinary people in everyday life were considered to be of the lower, so-called 'genre' category. As in Dutch art, genre painting was usually done on canvases of modest size, like those of Courbet's earliest works. Courbet's *After Dinner* challenged these traditions in two ways – first, by implying that everyday figures are as worthy of large-scale composition as ancient heroes and, second, by suggesting that genre painting could be the vehicle for the highest artistic ambitions.

But in preparing his *After Dinner* Courbet consistently drew on other traditions, some of which he had already been using. Along with what I have called regionalist literature, there existed a number of painters depicting regionalist themes. Often motivated by a democratic impulse to make the subject matter of art include the lives of simple folk, painters such as the brothers Armand and Adolphe Leleux (1818/20–85 and 1812–91) and Philippe-Auguste Jeanron (1809–77) specialized in such pictures (27). However, their adherence to the conventions of Dutch genre painting, which was associated with democratic ideals, and their usually modest scale were no particular threat to the established order of Salon painting. With Courbet such a mediocre destiny became impossible, for he gave his figures the scale of history painting and executed them with a warm, atmospheric realism. Moreover, there was a strong tradition of group portraiture in Holland, and such paintings were often done on a grand, life-size scale, as in Frans Hals's *Regents of the Hospital of Saint Elizabeth*. Of course, in Holland group portraits were commissioned by powerful people whose institutions could afford them. The contrast between them and Courbet's friends is striking, for by giving unknowns such prominence and size, Courbet offered them as substitutes for the traditional subjects and patrons of art. It has also been suggested that this composition is reminiscent of scenes showing the Supper at Emmaus, where Christ appeared at dinner at an ordinary country inn. Surely Courbet would have known one of Rembrandt's versions of the theme, which was in the Louvre; and he would certainly have appreciated how such a reference might impart

a religious aura to his own picture, enhancing the theme of rural virtue which it proffered.

The painting's earthy tenebrism also brings to mind the Spanish school, which was much in vogue in the 1830s. (This characteristic darkness is exacerbated in many of Courbet's works by his use of bitumen, a tar-like substance that absorbs pigments into it because it dries so slowly.) Diego Velázquez (1599–1660) and Francisco de Zurbarán (1598–1664) were two artists whose powerful and realistic figures had enormous impact on the burgeoning French Realist school. The common-man saints of the latter probably informed the emotional directness in Courbet's maturing works, and Velázquez himself had painted a *Supper at Emmaus*. However another work by Velázquez, the famous *Las Meninas* (28), may have been relevant, too, for in it the Spaniard portrayed the royal entourage within which he proudly placed himself. The old dog in Courbet's *After Dinner* seems modelled on that in *Las Meninas*, but instead of that painting's grotesque dwarves and clowns – mere entertainments for the King and Queen – Courbet has represented the homely, yet more dignified entertainments of his own family and friends.

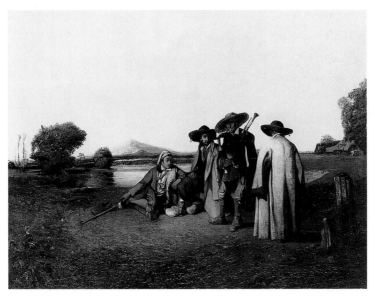

27
Philippe-Auguste
Jeanron,
Peasants from Limousin,
c.1834.
Oil on canvas;
97×130cm,
38¼×51¼in.
Musée des
Beaux-Arts, Lille

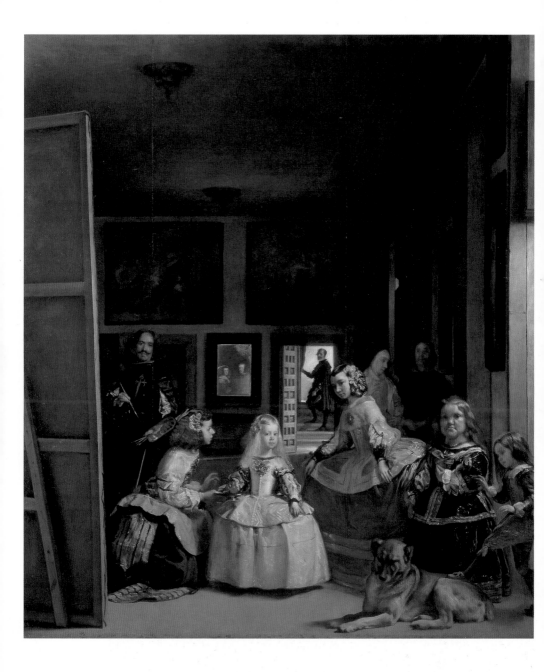

At the time Courbet was painting *After Dinner at Ornans* his friend Champfleury was gathering material for a book, to be published in 1850, on the Le Nain brothers (Antoine, c.1588–1648; Louis, c.1593–1648; Mathieu, c.1607–77). These seventeenth-century painters from Laon, Champfleury's home town, had produced pictures, sometimes of large size, showing families considered until recently to have been peasants. Champfleury hailed the Le Nains as 'worker-painters', because of their seeming social proximity to the people they represented and because of the sturdy values their paintings seemed to embody. In their pictures Courbet and others might have found a model for the artist who took sustenance from simple origins to produce large paintings of ordinary subjects in bold forms. The theme of *The Peasants' Meal* (29) is typical of the Le Nains and analogous to Courbet's conception. Especially comparable are a certain disconnectedness in the arrangement of figures and a flattening of space. Together, they suggest an additive process of composition-building rather than one in which a perspectival system

28
Diego
Velázquez,
Las Meninas,
1656.
Oil on canvas;
318×276cm,
125½×108¾in.
Museo del
Prado, Madrid

29
Louis Le Nain,
*The Peasants'
Meal*, 1642.
Oil on canvas;
97×122cm,
38¼×48in.
Musée du
Louvre, Paris

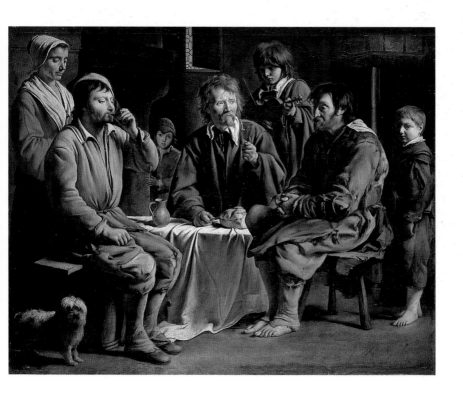

is inhabited by placing figures into its pre-determined space. In Courbet's picture each character seems to live within its own world. What better vehicle for Courbet's vision of simple country pleasures than a style à la the Le Nain brothers that embodies provincial pictorial *naïveté*?

Of course, no artist who draws upon such a complex of themes and sources can really be called naïve. Courbet's performance was clearly a masterful one, now combining and synthesizing rather than merely pastiching. In addition, there can be no doubt that his self-positioning was politically opportune, for glorification of the ordinary citizen was encouraged under the new regime, as it had been in some of the Realist literature of the 1840s. But such opportunism does not make Courbet insincere. In May 1849 he had written to the president of a lottery set up to help artists in difficulty that he had never sold a thing (a slight exaggeration). Like any artist, he needed to make a name for himself just in order to survive, and despite the artists' protests, the established system offered not just the best but still the only way to that minimal goal. When the system opened up to ideas that had been brewing within his intellectual and artistic circle, Courbet immediately knew he could draw from his own experience. The effect of this liberation must have been exhilarating, all the more so when he was awarded a silver medal for his effort! The prize meant more than just a state purchase (the price was 1,500 francs); it meant that in the future he would be exempt from the jury's deliberations: he could freely exhibit henceforth without worry of rejection. Following the announcement, Courbet and his friends partied until dawn.

Most of the other paintings Courbet exhibited at the Salon of 1849 were landscapes showing sites located near his home. Here, too, he displayed his origins, with titles such as *Valley of the Loue, taken from the Roche du Mont or the Roche du Miserere (Doubs)*. At this time he was also working on another self-portrait, one generally called *Man with Pipe* (30), in which the autobiographical content is slightly different – more Parisian. The smoker theme was an identifiably Dutch motif, which could allude to moral dissolution; smoking

had been discouraged by the Church and blamed for corrupting innocent youth. In addition, the ephemerality of smoke was often an emblem of the fragility of life. On both levels, such paintings urged viewers not to waste time with useless and idle occupations, for life could end in a snap. Courbet's painting, on the other hand, is more centred on his state of mind than on petty moralizing, which his self-consciousness and condescension overtly defy. It suggests a controlled state of disorder, as evidenced by the open collar and the long and wavy hair, one possibly induced by substances in the pipe. In this attitude Courbet approached his friend Baudelaire, whose love of both art and politics were forms of escapist intoxication. In addition, Baudelaire's infatuation with hashish and his comparisons of it to wine were proclaimed publicly in writings on 'artificial paradises', which appeared first in 1851. According to one account, Courbet himself made sketches of Baudelaire during the latter's opium trance.

Pipes had already appeared in several of Courbet's paintings: *After Dinner at Ornans*, *The Draughts Players*, the drawing of *The Brasserie Andler*, and the *Self-Portrait with Black Dog*, in which the painter himself prominently holds one in his hand. He had also made at least two self-portraits with pipe in charcoal or black chalk, one of which is highly finished (31). The pipe is therefore a persistent attribute, and an accurate one, since Courbet was a heavy smoker whose habit had got him in trouble at boarding school. (In 1869, in Munich, he made a small painting, now lost, of a pipe, which he called 'Courbet without ideal and without religion'.) In the finished drawing, with the pipe clenched in his teeth, Courbet purses his lips and furrows his brow in an expression of deep inhalation and the introspection glibly associated with it. He wears a hunter's cap so low on his forehead that it could be taken as a parody of a country simpleton or as the look of someone on dope. In comparison, the later oil of *Man with Pipe* shows the painter more relaxed and assured; the subtle shading on the face concentrates more on inner sensitivity. That face is almost assertively close to the picture plane. Whether there is opium in the pipe or not is hardly the point, since, for Courbet, smoking is associated with pleasure and repose and is

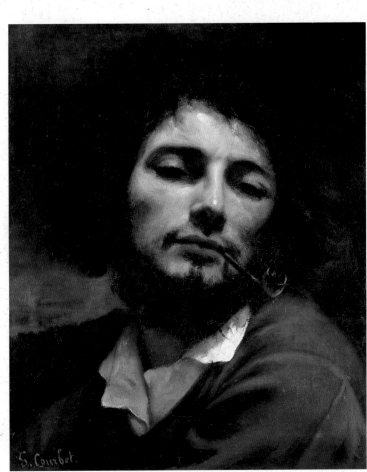

30
Self-Portrait:
Man with Pipe,
c.1848–9.
Oil on canvas;
45×37cm,
18⅛×15in.
Musée Fabre,
Montpellier

31
Self-Portrait
with Pipe,
c.1846–8.
Black chalk
on paper;
28×21cm,
11¼×8¾in.
Wadsworth
Athenaeum,
Hartford,
Connecticut

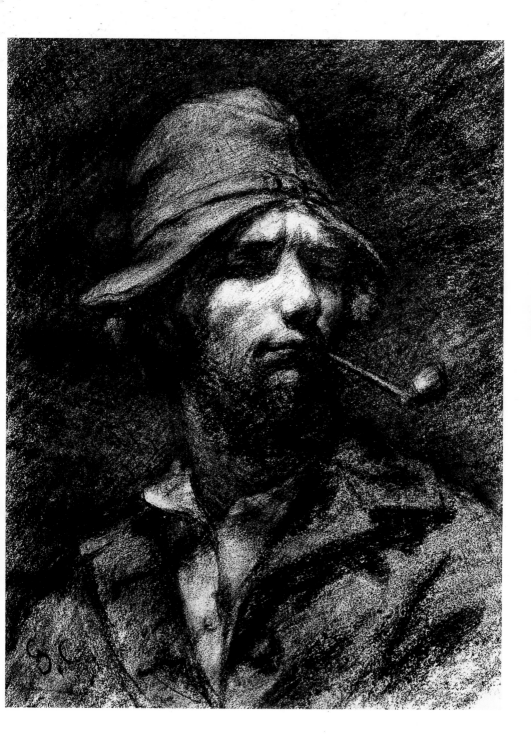

an inducement to reverie. That state of mind, so much a theme in his other work, now has an equal footing with bohemian posturing; subtle introspection and potential arrogance coexist.

Which is the real Courbet, then, the humble man of the provinces or the more confident and complex Parisian? Simply put, the former permitted Courbet to play the latter: the virtues of the provinces gave him access to respect and status in the city. Commenting on the *Man with Pipe* in 1854, Courbet asserted: 'It is the portrait of a fanatic, an ascetic. It is the portrait of a man who, disillusioned by the nonsense that made up his education, seeks to live by his own principles.' Although writing in hindsight, Courbet thus presented the painting as commemorating the turning point between his early floundering and what he now could call a firm direction.

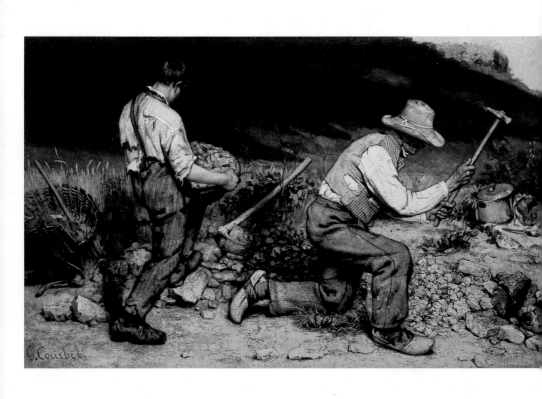

Reacting to *After Dinner at Ornans*, one critic held that 'no one could drag art into the gutter with greater technical virtuosity'. Such an attack on its representation of common people nonetheless recognized Courbet's pictorial powers. (Courbet's answer was his famous: 'Yes, art must be dragged into the gutter!') Eugène Delacroix's response to *After Dinner at Ornans* at the Salon of 1849 was immediate and also recognized Courbet's technical gifts: 'Have you ever seen anything like it, so strong and so independent of others? Here's an innovator, a revolutionary, too: he has hatched suddenly, without precedent: he's an unknown!' However, the fact is that not only was Courbet's *After Dinner*, as we saw, tied to precedent and to a school, but other artists were producing work with many similar characteristics, if not comparable to his in sheer force.

In order to assess the validity of Delacroix's perception and Courbet's claims, then, we must take a look at some of those other artists' works. One of them was François Bonvin (1817–87), a friend of Courbet's from the Atelier Suisse and a member of the Brasserie Andler gang. Bonvin painted country scenes on a modest scale. Courbet chided him for painting too small; Bonvin countered by telling Courbet he painted too big. Bonvin's *The Cook* (33), a version of which was shown at the same Salon as Courbet's *After Dinner*, has much of the flavour of rural culture celebrated in Champfleury's writings and in the poetry of Max Buchon (1818–69), a childhood friend of Courbet's. At the Salon of 1850 Bonvin presented his state commission, *The School for Orphan Girls*, which he had begun years earlier. Its concept of the community caring for those less fortunate is embodied by the Church and traditional values – there is a crucifix on the wall and a teacher in nun's habit. Although more ostensibly secular, *The Cook*, too, expresses conservative ties, bearing an unmistakable and ingratiating relationship to the genre paintings (34) of Jean-Siméon Chardin (1699–1779). Bonvin's image conveys a

32
The Stonebreakers (Doubs), 1849–50. Oil on canvas; 190×300 cm, 74³⁄₄×118¹⁄₈ in. Formerly Gemälde-galerie, Dresden (destroyed)

sense of tradition that imparts to his figure not simply the virtues of the country life but the timeless values associated with art that had entered the classical canon. Courbet, on the other hand, using portraits of his contemporaries as the primary elements of his work (*eg After Dinner at Ornans*), managed to impart to them as individuals the virtues of country life. Although he and Bonvin shared the ideology of the rural utopia, they thus approached it from entirely different directions. In Courbet's painting we perceive figures first as individuals, not as types. The artist locates rural virtues in those figures rather than deriving their values from some general concept

33
François
Bonvin,
The Cook,
1846.
Oil on panel;
17×10 cm,
6¾×4 in.
Musée des
Beaux-Arts,
Mulhouse

34
Jean-Siméon
Chardin,
The Kitchen
Maid,
c.1738.
Oil on canvas;
46×37 cm,
18⅛×14⅝ in.
Alte Pinakothek,
Munich

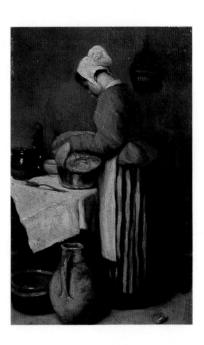

of 'tradition'; his countrymen have an identity and wholeness: the particular customs of the countryside become their attribute and empower them.

A second painter who bears comparison with Courbet is a slightly older contemporary of his, Jean-François Millet (1814–75), who is generally associated with the Barbizon School of landscapists but actually concentrated more on figures from rural life. The success of Courbet's *After Dinner at Ornans* at the Salon of 1849 was not simply a personal one, for it coincided with the emergence of the

so-called Realist (or regionalist) trend that had coalesced in the 1840s. Bonvin had won a third-class medal at the same Salon, and Millet had a parallel success the previous year with his painting of *The Winnower* (35). The latter was purchased by Alexandre Ledru-Rollin, the Minister of the Interior under the provisional left-wing government of 1848, and Millet also received a state commission to do a painting of harvesters. Ledru-Rollin had published a book in 1847 about pauperism in the countryside, and in Millet's painting he may well have seen an illustration of his ideas. In this painting a solitary farm worker seems to have dedicated his total being to

separating the chaff out from the wheat. The painting's rough surface, compared by one critic to masonry, expresses both the worker's energy and the vigour underlying Millet's own ostensibly unprettified and rustic-looking handwork. Lit from behind, the figure turns into the darkness as his gaze is fixed upon his basket, from which the grain he tosses up seems to leap like flame. He occupies almost the entire field of vision and in some versions of the painting is seen from below, acquiring a monumental scale. Millet's depersonalization of his workers' faces by casting them in shadow also contributed to their success as generalized, even mysterious types.

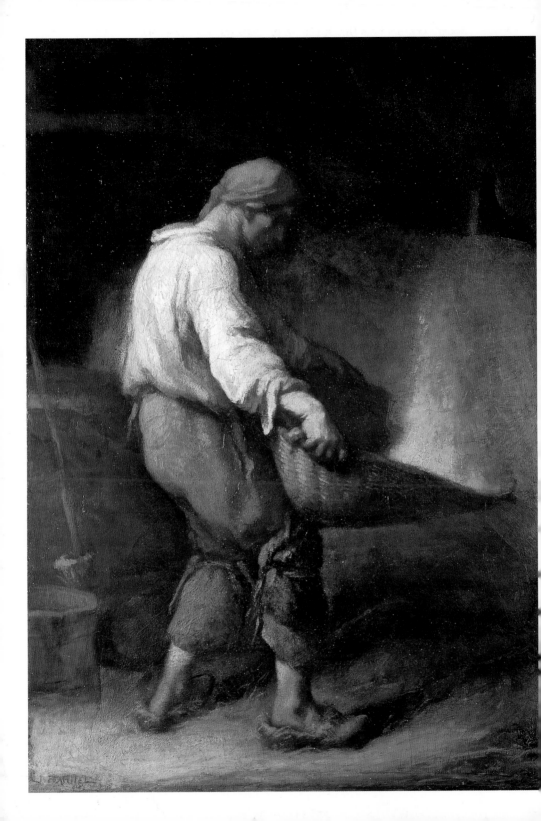

Millet's commitment to this kind of painting was confirmed by his move to the farming village of Barbizon, near the Forest of Fontainebleau, where he worked in a community with other painters. One critic praised him for the ability to give the simplest tasks a biblical dimension, and indeed, Millet quite unashamedly cultivated religious comparisons for the occupations he represented, as in his *Going to Work* (36) of *c*.1851. The composition of the picture was based on Masaccio's famous *Expulsion from Paradise* (*c*.1425–8) in the fresco for the Brancacci Chapel in Florence. By implicitly comparing the labour of French peasants to Adam and Eve's condemnation to toil the land, Millet suggested that his figures were enacting a fate determined long ago. Moreover, their attitude of physical concentration expresses an acceptance of their lot that endows them with moral dignity and serves as an ideal against which others might measure their own lives. They thus embody a profoundly conservative morality derived from pre-modern society, but secularized to provide radical lessons for a contemporary audience.

35
Jean-François
Millet,
*The
Winnower*,
c.1847–8.
Oil on canvas;
105×71 cm,
41⅜×28 in.
National
Gallery,
London

36
Jean-François
Millet,
*Going to
Work*,
c.1851.
Oil on canvas;
56×46 cm,
22×18 in.
Cincinnati Art
Museum

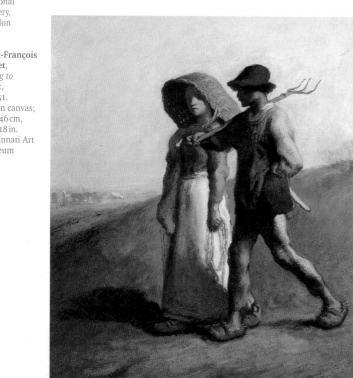

Millet surely knew as well as anyone that farm life was changing and that the kind of stability his paintings implied was under siege. Yet precisely during a period of political change there was both comfort in the rural myth and a critique of society's ills. Nowhere is this attitude better demonstrated than through Millet's *The Gleaners* (37). Although the picture was not exhibited until the 1857 Salon, Millet began working on the theme in the early 1850s. In earlier versions, the scene of harvesting in the background is much closer to the women bent over in the foreground, making the contrast between their poverty and fatigue and the bounty of modern farming techniques even more poignant than in the final work. Gleaning was an

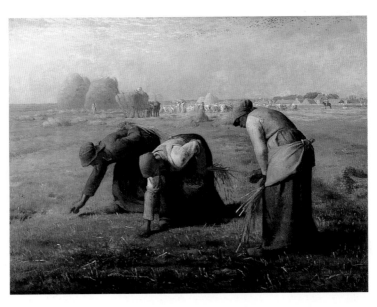

ancient custom in which landowners allowed the poor to pick up scraps left by the harvest. With modern technology gathering became more efficient, and less remained for the indgent. With the collapse of grain prices many smaller farmers had to sell their land, which city speculators consolidated or richer farmers combined in ever larger operations. In view of these conditions, it is not surprising that the poverty of Millet's principal figures was perceived as a threat by conservatives who recalled the peasant uprisings of the past, while for more liberal viewers Millet's figures expressed the dignity of the individual and the democratic values so implied.

Courbet's *After Dinner at Ornans* certainly capitalized on Millet's achievement, coming as it did a year after *The Winnower*. And in his next major effort (32), entitled *The Stonebreakers* (*Doubs*), Courbet paid direct homage to the Millet, but he also transcended Millet's example by drawing once again on his own experience. Courbet's left-hand figure of the boy with a heavy basket of stones is clearly a paraphrase of Millet's *The Winnower*. Yet Courbet claimed to have first seen the workers he represented while he was driving the family carriage along the roadside near the village of Maisières, not far from Ornans. He invited them to his studio and had them pose. Hence, *The Stonebreakers* is a scene of rural labour that might have taken place in proximity to other scenes more closely resembling the ones depicted by Millet. But it is much less filtered through tradition than in Millet's or his own previous work. Perhaps for that reason Courbet's painting produced a much stronger public response than had Millet – one bordering on outrage. Although not engaged in an agricultural activity, *The Stonebreakers* surely reminded people all too clearly of tensions between rural and urban France and between the old system of traditional crop-sharing and the new pattern of minimal daily wages. *The Stonebreakers'* difference from *The Winnower* is that Courbet made those conditions explicit. For daily-wage jobs, such as breaking stones into gravel for the construction of roadbeds or buildings, where they were raw material for a rudimentary form of concrete, were generally taken by workers who had been forced off farms that could no longer support them from the land. Although, unlike the *After Dinner*, his figures' faces cannot be identified as portraits, they retain the individuality of their specific location in place and time. The deadpan contrast of Courbet's shadowless sunlight and dry dust to Millet's Rembrandtesque atmospheric melodrama strips his rural figures of the mythologizing dimension we found in Millet. Their shabby clothes just hang on their bodies, the old man's skin appears leathery, the boy's basket seems immobile. While Courbet took over Millet's monumentality, the vitality is deliberately absent; everything seems weighted down. Whatever allusion his figures make beyond the robot-like execution of their repetitive and monotonous

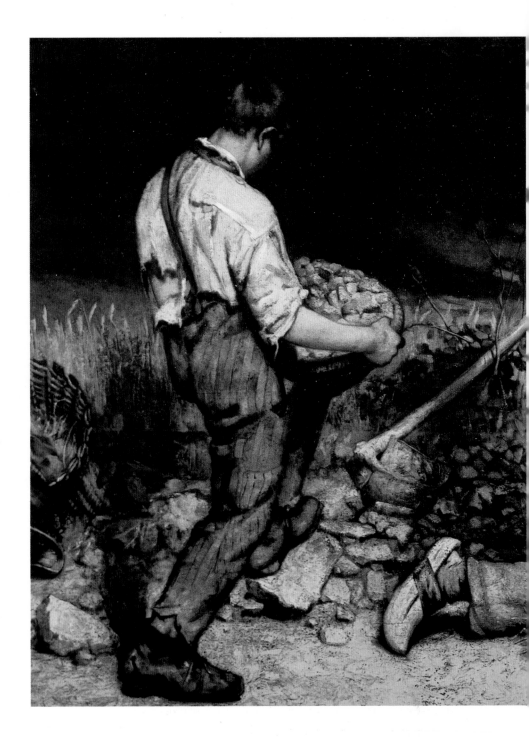

labour, it is an allusion stemming from their connection to the present rather than the past. Their poses and gestures may be compared to those of potato harvesters in a touching work made by the Alsatian painter Gustave Brion (1824–77) in 1852 (39).

Brion's painting was meant to document the deplorable conditions caused by the flooding of the Rhine in the year he made his picture. Yet despite the mud and the poverty of his figures, Brion's skilful linkages between them, three of whom form a pyramidal group dressed in patriotic colours in the foreground, and the way they are framed by the landscape which rises at the right to silhouette a

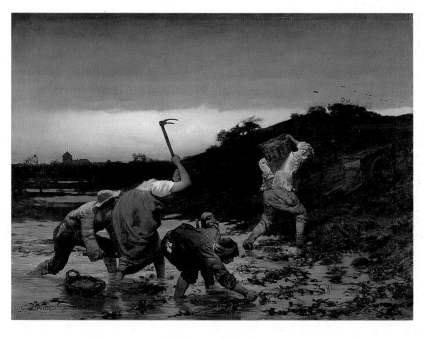

38
The
Stonebreakers
(detail of 32)

39
Gustave Brion,
The Potato
Harvest during
the Flooding of
the Rhine in
1852, Alsace,
1852.
Oil on canvas;
98×132 cm,
38⅝×52 in.
Musée des
Beaux-Arts,
Nantes

fourth figure, mould their travails into the heroic traditions of artistic representation. Their adversity, though dated and located as actual and current, implies the same morality of eternal struggle and virtues of the poor as we found in Millet, a morality which provided the reason for Brion's choice of theme in the first place. By contrast, Courbet's insistence on the present provided no satisfying redemption through high moralization, for the conditions his figures implied were called forth by the very lack of uniqueness in their situation and the apathy of their response.

There is no more eloquent description of *The Stonebreakers* than Courbet's own in a letter to Champfleury:

[It] is composed of two very pitiable figures: one is an old man, an old machine grown stiff with service and age. His sunburned head is covered with a straw hat blackened by dust and rain. His arms, which look sprung, are dressed in a coarse linen shirt. In his red-striped vest you can see a tobacco pouch made of horn with copper edges. At the knee, resting on a straw mat, his heavy trousers, which could stand by themselves, show a large patch; through his worn blue socks one sees his heels in his cracked wooded clogs. The one behind him is a young man about fifteen years old, suffering from scurvy. Some dirty linen tatters are his shirt, exposing his arms and his sides. His trousers are held up by a leather strap, and on his feet he has his father's old shoes, which have long since developed gaping holes on all sides. Here and there the tools of their work are scattered on the ground: a hod, a stretcher, a hoe, a rustic pot in which they carry their midday soup, and a piece of black bread in a scrip. All this takes place in full sunlight, by a ditch alongside a road … I have made none of it up, dear friend. I saw these people every day on my walk. Besides, in that station one ends up the same way as one begins. The vine growers and the farmers, who are much taken with this painting, claim, were I to do a hundred more, none would be more true to life.

The details that fill that description include features one might hardly notice in the painting itself even if it had not been destroyed in the bombing of Dresden in World War II. They clearly indicate how Courbet's vision dwells on the specific and the particular in contrast to the generalizing approach of his contemporaries and even of his own *After Dinner at Ornans*. And in citing the response of local citizens, Courbet seems to accept their criteria rather than those that might have been issued by the Parisian art world. That is, Courbet's painting had ceased operating through the artistic 'codes' of high culture to draw from common knowledge available to ordinary people. Yet Courbet was also aware of the social significance of his subject – the abjectness of the figures and the hopelessness of their situation. 'In that station one ends up the same way as one

begins,' he had said. Hence, the comment made by the social philosopher Pierre-Joseph Proudhon was certainly appropriate, and in certain details, probably based on Courbet's advice:

The Stonebreakers is an irony addressed to our industrial civilization ... Here indeed is the mechanical or mechanized man, in the state of ruin to which our splendid civilization and our incomparable industry have reduced him. This man, however, has seen better days; ... while that deplorable boy who carries the stones will never be acquainted with any of the joys of life; chained before his time to day labour, he is already falling apart; his shoulder is out of joint, his step is enfeebled, his trousers are falling down; ... Thus modern servitude devours the generations in their growth: here is the proletariat.

Although Proudhon's lines were written a number of years after Courbet made his painting, he has surely captured something of the political awakening that made it possible for Courbet to recognize the power such subjects offered when he saw them near his home town. Although the subject of stonebreakers was not a totally new one, most artists, especially those who believed in the noble suffering of the peasant and associated working the land with farming, would not have had Courbet's instinct for its relevance to current economic conditions. We know from a eulogy Courbet gave in 1845 at the funeral of an obscure socialist activist that his politics were leaning to the left even at that early date. His position was not unusual, since many social theorists of the time foresaw social development towards democracy and called upon artists to be in its forefront.

Even though Republicanism was something of a tradition in Courbet's family and his region, only now did the artist discover its real meaning. During the Revolution of 1848 he received a new political baptism through his association with Baudelaire and Proudhon. The latter had come to the Brasserie Andler when he moved permanently to Paris that year. Indeed, near the time of Courbet's collaboration on the title page for *Le Salut public*, Baudelaire actually copied down a paragraph from Proudhon's writings in which art, morality and economics were linked. The popular social thinkers of

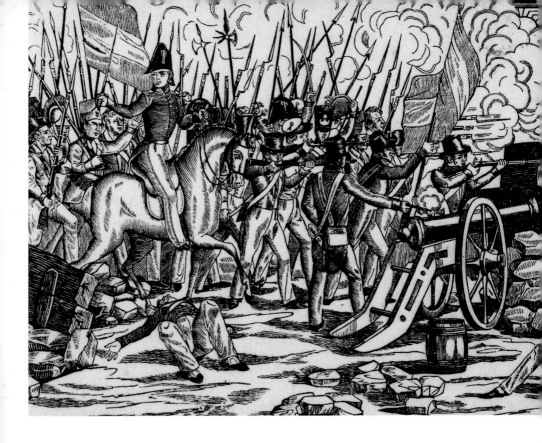

the previous decades often argued that social evolution was inevitable, and they sometimes adopted religious forms as a sign of this faith as well as to convey the transcendental basis of their ideals of justice and equality. Unlike these predecessors, however, Proudhon was not content to wait for such forces to take their course. He realized the need for direct action and claimed to have practical plans grounded on his personal experience as a worker and on the empirical science of economics. In his inflammatory, anti-bourgeois book of 1840, entitled *What is Property?*, Proudhon answered, 'Property is theft.' He distinguished between 'possession' and 'property': the former acquired through labour in simple commerce and artisanship, the latter without labour through profit on investments and the work of others. He regarded labour as a form of capital belonging to the proletariat and he protested at their lack of control over what rightfully was theirs. The passage Baudelaire copied was from a more recent work called *System of*

40 Left
Pierre-Joseph Proudhon Demolishing Property.
The caption includes a play on words: *Seul Moyen de Détruire la Propriété. Mon ami, si tu continues ainsi nous aurons une république sans toi/toits!* (The Only Way to Destroy Property. My friend, if you continue thus we will have a republic without you/roofs!)
1848.
Lithograph

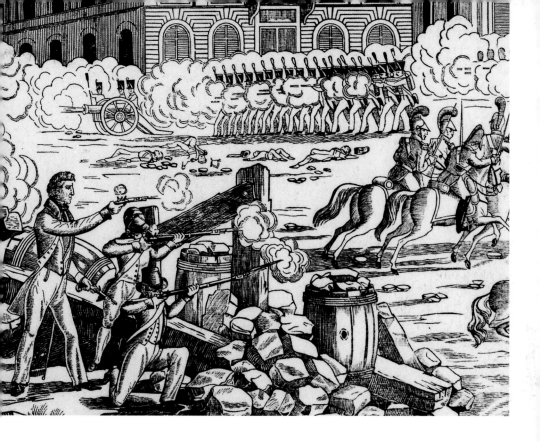

41 Above
*Revolt in Lyon,
April 1834*
*(detail).
Engraving in
Imagerie de
Nancy, c.*1834

Economic Contradictions, or the Philosophy of Poverty (1846). The key idea of the particular passage was that as society progressed towards democracy, in which the distinction between worker and master would be overcome, labour would acquire an aesthetic character and its product would evolve towards art, through which humanity could express its virtue. *The Stonebreakers* proved how far society had yet to go.

Perhaps more important than new political theories, the popular uprisings of 1848 rendered the pastoral utopianism of George Sand and Jean-François Millet obsolete. Events highlighted the role of class distinctions and showed that future struggles would be related to the new conditions emerging in cities. Perceptions of the countryside would henceforth be seen through the lenses of Parisians. Already during the 1830s the silkworkers of Lyon, then France's most industrialized city, had revolted twice over basic economic issues such as wages and ownership of raw materials (41). They

founded mutual-aid societies and tried to form worker cooperatives. In Paris in 1834 workers had demonstrated, and following the arrest of several of their leaders, they put up barricades in some working-class districts. The following day, 15 April, National Guardsmen entered the neighbourhoods to put down the insurrection and murdered a number of civilians. The massacre is commemorated in Honoré Daumier's famous lithograph of *La Rue Transnonain* (42), which shows a working-class family, still in their nightclothes, dead in their apartment. Resentments over such repression boiled over again in 1848. In February of that year the government of King Louis-Philippe was overthrown when the largely middle- and artisan-class National Guard refused to put down similar reformist protests in Paris. Barricades were thrown up (43), the Hôtel de Ville was occupied and a provisional republic was proclaimed. Among its first acts was to open National Workshops and employ-ment agencies under a workers' advisory panel called the Luxembourg Commission. Universal suffrage (males only) was proclaimed on 5 March 1848.

42
Honoré
Daumier,
*La Rue
Transnonain,
15 April 1834*,
1834.
Lithograph;
44·5×29 cm,
17½×11½ in

43
Jean-Louis-
Ernest
Meissonier,
The Barricade
1848.
Oil on canvas
29×22 cm,
11½×8½ in.
Musée du
Louvre, Paris

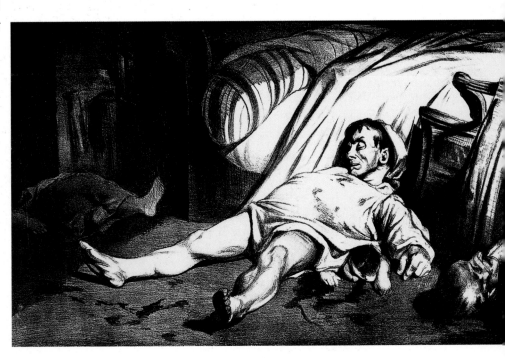

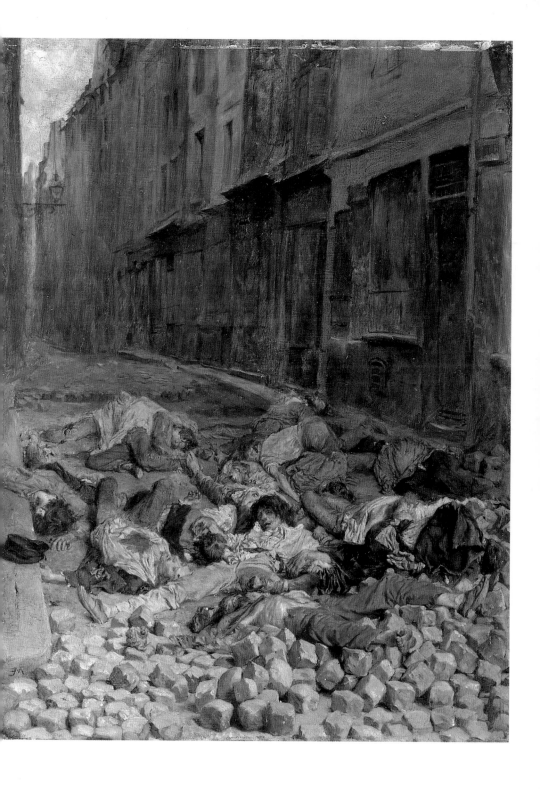

Not the least of the lessons in class consciousness taught by these events was learnt when the euphoric solidarity between shopkeepers, skilled artisans and industrial workers began to disintegrate. The more prosperous shopkeepers and tradesmen did not want to share their voting rights and, frightened by left-wing demands, they supported conservative candidates in the April elections to a new National Assembly. Leftist clubs invaded the chamber in order to press their views, but the result was further to alienate conservatives, who shut down the National Workshops in late June. Paris was now divided but, under the leadership of General Cavaignac, the National Guard now violently suppressed all opposition to the Assembly. In the meantime, Napoleon I's nephew, Louis-Napoleon (1808–73), was running in the presidential election as a candidate who appeared to bring together various factions under an ostensibly reformist programme. His resounding victory in December was in part due to strong support in the countryside, for the peasantry and small landowners saw no advantage to an alliance with workers, and they most of all feared loss of their customary rights or of their land under appropriation. It was, then, in this complex and fragmented environment that *The Stonebreakers* had appeared.

Of course, the setting of Courbet's painting was still rural. But his workers clearly belonged to the breed of disenfranchised being whose suffering made others nervous. When the painting was shown at the Salon of 1850–1 it provoked outrage, surely by the shock of recognition. A cartoon of the painting by Cham (44) shows a father and son in conversation in front of it. The boy asks: 'Why, then, Papa, is this called socialist painting?' The father, dressed in the top hat and long coat of the bourgeois, answers: 'Parbleu! Because instead of being rich painting, it's poor painting!' The son's question reflects the reputation the painting had clearly acquired, while the father associates that reputation with the question of economic class. Indeed, Courbet shattered the myth of a timeless and classless rural ideal by representing figures whose social and economic specificity was corroborated by their material weight and physical exertion. But, in addition, Courbet's painting refused to ingratiate itself to bourgeois standards; it appeared to exclude the bourgeois in

44
Cham,
Caricature
of *The
Stonebreakers*
*Le Salon
caricatural*,
1851

Cham's cartoon from its audience – although, of course, it depended on bourgeois reaction for its resounding effect.

ADDRESSING

What audience did Courbet appear to be addressing? There were two kinds of answers. The first came from Jules Vallès, future leftist writer and member of the Paris Commune who was only nineteen when he roamed the Salon: 'All at once we stopped in front of a canvas … called *The Stonebreakers* … Our emotion was profound. We were all enthusiasts … It was the time when heads were brimming with ideas! … and we asked the new art to play its part in the triumph of justice and truth.' The other may be found in lines written by an irate art critic: 'The first organ of the strange praises dedicated to M. Courbet was a certain low-class inebriate who invaded the benches of the Salon. What was he admiring, if not the worst possible daubs? Then the *rapins* [an unflattering term for art students] echoed the cry, and little by little Courbet became the centre of attention.' Another observer of *The Stonebreakers* commented that Courbet should have patched their shirts and had them wash their feet. One more said the painter had proved that if you want to affect public opinion, you have to seize it by the throat.

— Pourquoi donc, papa, qu'on appelle ça de la peinture socialiste?
— Parbleu ! parce qu'au lieu d'être de la peinture riche, c'est de la pauvre peinture !...

So Courbet had made a name for himself, although he did it by violating decorum and by threatening social privilege – by giving presence, both within his pictures and within the Parisian audience for them, to classes and politics previously excluded either by custom or by lack of power. The idea that Courbet's painting 'was the engine of revolution', as one critic put it, derived precisely from his radically democratic expansion of the realm of art.

As we saw earlier, the lower classes had been represented in genre painting, and we may add that in the 1840s they frequently appeared in prints and drawings of so-called 'popular types'. For example, in 1839–42 a collection called *Les Français peints par*

45
Sulpice-
Guillaume
Gavarni,
*Studies of
Smokers.
L'Illustration*,
no.79, 31
August 1844

eux-mêmes (The French Painted by Themselves) offered an extensive compendium of such images, cataloguing in its 'moral and physiog-nomical' panorama of French society every conceivable type of origin and occupation from the grocer to the ragpicker, the street urchin to the woman 'à la mode', and the art student to the lawyer. Popular magazines such as the *Magasin pittoresque* and *L'Illustra-tion* took up the fad with illustrated series on Parisians, Bohemians, Spanish types, and contemporary fashions, to name but a few. One of the more interesting illustrated topics in *L'Illusration* was beverages, which were categorized through the preferences of different national and social types; another might be smokers (45).

While such illustrations exhibit a detailed knowledge of social differentiation, their focus on the aesthetic interest, emphasized by the word 'picturesque', never implied change in the social order. On the contrary, in exploiting the entertainment value of such people, who included workers of diverse sorts, these illustrations subordinated them to the tastes of the powerful. And by casting such people as general types, they deprived them of a sense of will or individual humanity. When *The Stonebreakers* appeared, it was as if such figures had suddenly entered the halls of high art and demanded to be dealt with on their own terms.

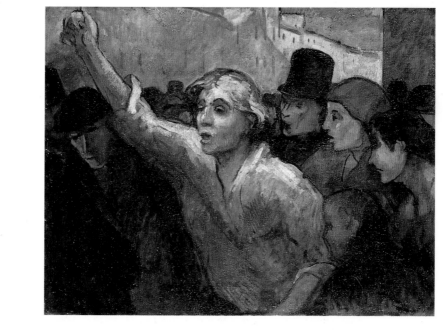

46
Honoré
Daumier,
The Uprising,
c.1849.
Oil on canvas;
88×113 cm,
34¹₂×44¹₂ in.
The Phillips
Collection,
Washington, DC

One more comparison to Courbet's painting may further explain its dramatic effect. That is to the art of Honoré Daumier. For nearly two decades, Daumier's prints in illustrated journals had supported the cause of ordinary people and dealt caustically with those in political power. He exemplified the political artist tied to contemporary happenings. His grand series of lithographs of the 1830s, including the *Rue Transnonain* we saw earlier (42), showed workers in their sturdy anatomical forms either as victims of or as challengers to authority. No artist was more loyal to the working classes; no artist

had so directly confronted power. But for his efforts of the 1830s Daumier had been imprisoned, and in the 1840s he was forced to restrict his satire to a more innocuous form. When the Revolution of 1848 broke out his years of pent-up frustration found an outlet in painting, which he had never before attempted. Here was the chance to express his views in a less circumstantial medium than lithography. Yet he sadly failed to give his laudable intentions viable pictorial form. His *Laundresses* look too much like Millet, with their insistence on generalization and silhouette. In certain other works he allowed himself to be tempted by religious and mythological inspirations that led him far away from the contemporary. A series of paintings representing figures in the streets or on the barricades, such as *The Uprising* (46), certainly evoked the recent turmoil of 1848, but they were not carried through, and they suffer from a lack of clarity about the reasons behind and purpose for their figures' agitation. But despite Daumier's failure to produce much painting adequate to the new politics of 1848, he was still without peer. He had clearly established a form of art, neither picturesque nor caricatural, that featured social conflict. Yet that was the essence of his difference with Courbet. For Courbet's art did not *depict* social conflict. It *produced* it in the same way that material conditions themselves had done.

It was probably during the time just before *The Stonebreakers*, which Courbet began around October 1849, that the painter made his mysterious *Portrait of Baudelaire* (47). With its disjointed juxtapositions and its handling which seems both tentative and reminiscent of Chardin, the painting hovers between being simply an unfinished experiment or a harbinger of the anti-hierarchical and materialistic style of *The Stonebreakers*. Baudelaire sits before his desk at what looks like the end of his bed in the corner of a bare-walled room. Smoking a pipe and dressed in a housecoat for warmth, he appears both dazed and completely absorbed in his reading. The slight bend of his head and the ambiguous pose of his left hand on a pillow imply the possibility of some edginess or inner volatility. We already know that Baudelaire was the leading proponent of states of reverie, artificially induced or not. But in the portrait the poet's creative

47
Portrait of Baudelaire, c.1848–9. Oil on canvas; 54×65·5 cm, 21$\frac{1}{4}$×25$\frac{3}{4}$ in. Musée Fabre, Montpellier

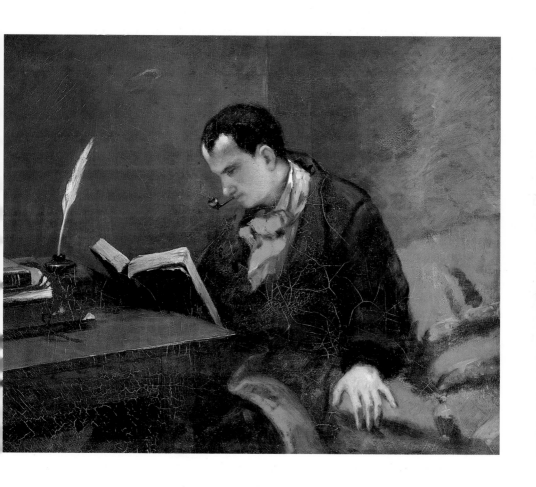

process is at issue, as the hand and white-feathered pen form opposite ends of an axis that runs across his book. The year 1849 was bad for Baudelaire, during which he published nothing. Perhaps the lack of focus so often observed in the painting indeed reflects on some level the poet's state of mind. Indeed, art historian T J Clark has fruitfully compared the portrait to an autobiographical passage from a Baudelaire poem, which suggested the poet's determination to pursue his artistic enterprise even when buffeted by external events.

That position was certainly in sympathy with Courbet's own during the political upheaval of 1848 to 1851. For, although Baudelaire's resolve did not lead to immediate results, Courbet's led him to one of the most productive periods of his life. It is true he had the advantage of being able to leave the city for Ornans, where he spent long periods during those years. Courbet now felt empowered by his country origins to create a new and definitive form of Realism. It was in Ornans that he painted not only *The Stonebreakers* but, soon to come, *A Burial at Ornans* and *The Peasants of Flagey Returning from the Fair (Doubs)*, two other paintings that established his reputation. As embodied by such works, that Realism would present specifically modern and class-identifiable figures in a style that drew from popular visual culture rather than from the traditional formulas of high art. Courbet's painting not only conveyed the material conditions and transient life of such people, it appeared to give them a voice in high culture. For the first time they became subjects for painting on a heroic scale, and they seemed included in its viewership by Courbet's use of forms derived from their own milieu. With the Revolution of 1848 in the background, Realism's political shock effect lay in the realization that the working classes would inevitably command a prominent role in society, as embodied by the role Courbet had seized for himself in the world of art.

Courbet's grandfather Oudot had died in August 1848, and his great-uncle by marriage, Claude-Etienne Teste, died early in the following month. Having gone down to Ornans after his grandfather's death, Courbet must have attended the funeral of his great-uncle. Teste was the first person to be buried in the new cemetery on the outskirts of the town. The site had been a point of conflict between the local church, which wanted to maintain its traditional control, and a more secular faction of townspeople who wanted to follow modern sanitary practices, instituted under Napoleon, by locating cemeteries outside the inhabited area. In late 1849, in a studio set up in the attic of his late grandfather's house, Courbet began painting *A Burial at Ornans* (49). By using the indefinite pronoun, Courbet was not claiming particular status for this burial: it is just 'a burial' in his home town. Yet, as he wrote in the official register of the Salon of 1850–1, it was to be a 'Historical painting of human figures, of a burial at Ornans'. That is, despite his lack of interest in signalling the ceremony's special significance, he nonetheless deemed it a historical event.

The picture's size was extraordinary – more than three metres high and six metres wide (10×20 ft) – and its composition and the way it was painted were virtually unprecedented. Although Courbet drew from elements that he had used already, one could not have anticipated this mutation that would so profoundly challenge the traditions of art. The *Burial*'s dimensions themselves declared Courbet's historical and heroic intent. The composition contained approximately fifty figures, all of them life-size. Yet those figures were simply friends, family and local notables – the village of Ornans assembled at the graveside. The first, to the extreme left, is none other than the deceased Grandfather Oudot. It is Courbet's personal homage to a man he loved. (So much for the vaunted literalness of his Realism!) Also represented are Courbet's parents and sisters, and

48
A Burial at Ornans
(detail of 49)

49
*A Burial at
Ornans:
Historical
Painting,*
1849–50.
Oil on canvas;
315×668 cm,
124×263 in.
Musée d'Orsay,
Paris

50
Study for *A
Burial at
Ornans,*
c.1849.
Charcoal on
bluish paper;
37×95 cm,
14⅝×37⅜ in.
Musée des
Beaux-Arts et
d'Archéologie,
Besançon

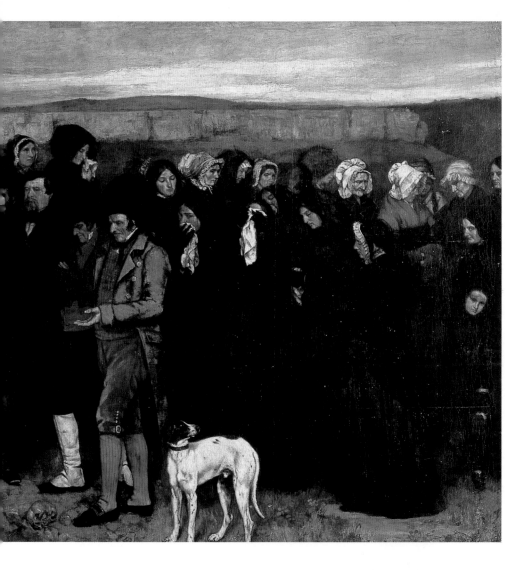

his friends Promayet (the nearest pallbearer), Buchon, Cuenot and Marlet. The corpulent, bearded mayor, Claude-Hélène-Prosper Teste (a relative of the deceased Teste), is prominent in the foreground just behind the grave (51). To the left of him is Hippolyte Proudhon, a prominent local lawyer (but no known relation to Pierre-Joseph Proudhon) and brother-in-law of Cuenot. To the right of the mayor are two elderly figures dressed in the style of an earlier generation who were friends of both Oudot and Teste and shared their liberal republican beliefs. The Abbé Benjamin Bonnet, curé at Ornans, presides, accompanied by an aide, who carries the cross, and, behind him, the sacristan (48). The beadles, men who helped

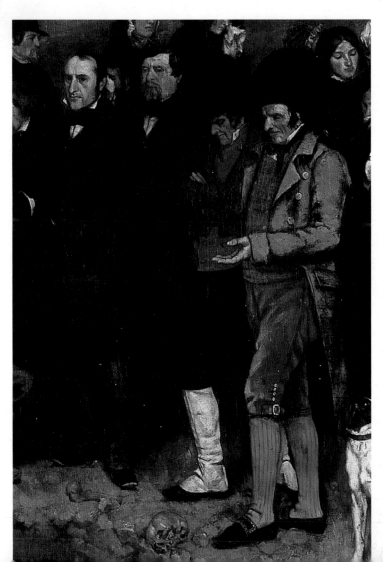

51–52
*A Burial at
Ornans*
(details of 49)

officiate and who performed minor duties at church such as ushering, are a particular focus of attention thanks to their red robes (52): one of them was a vine-grower, the other a shoemaker. It is often thought that Courbet made them look a little tipsy. The gravedigger was a simple vine-grower, Antoine-Joseph Cassard, whose duties allowed him to earn extra cash. Buchon, in an essay on the painting, described him as an avenger of the oppressed. Here, then, was more than an after-dinner at Ornans. Here now was Ornans's public face as it coincided and overlapped with Courbet's family and friends – the township as Courbet knew it personally, a place of community and contradiction.

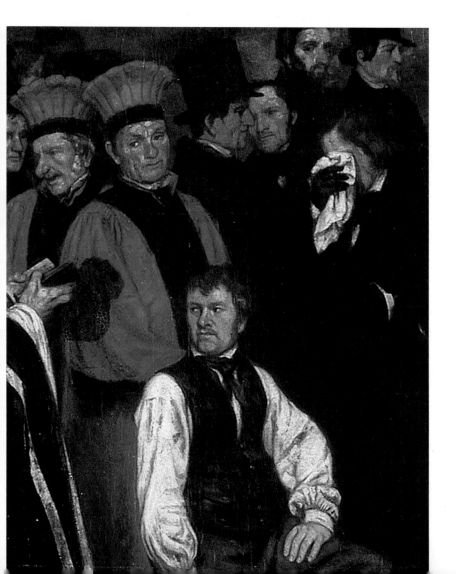

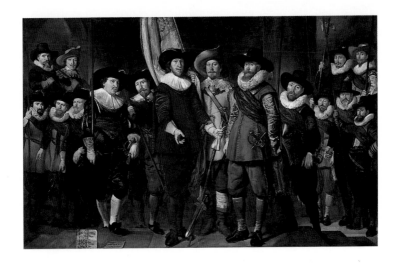

As word got out that Courbet was painting members of the local community, some officers of the church who had not yet been called protested against his playing favourites. After all, they whined, a burial was a religious ceremony, and they had certainly done Courbet no harm. On the contrary, Courbet must have been amused. The lucky ones came to the studio one by one. The painter complained to Champfleury that he was unable to back up far enough to see his composition clearly. These circumstances may partly explain the 'additive' look to his composition, that is, the feeling that figures have been stuck into the painting one after another without there being a coherent relationship between them or to the whole. But this was not so different from large group portraits done in seventeenth-century Holland, such as Thomas de Keyser's *The Company of Captain Allaert Cloek* (53) or others that Courbet might have seen on his travels. Nor was it far from popular prints such as those published in the Vosges mountain town of Epinal, including one representing Napoleon's funeral procession (54). Moreover, once the viewer gets used to the plain sight of so many stolid figures represented on such an imposing scale, he or she may become aware that there is indeed quite a coherent structure. Courbet's preliminary charcoal drawing for the scene can help us to see it (50). This study clearly shows that there is a procession in progress towards the open grave, which, unlike in the painting, is to the

53
Thomas de Keyser,
The Company of Captain Allaert Cloek and Lieutenant Lucas Jacobsz Rotgans, Amsterdam, 1632,
1632.
Oil on canvas;
220×351 cm,
86⅝×138⅛ in.
Rijksmuseum, Amsterdam

54
Napoleon's Funeral Procession, 1821, 1835.
Woodcut;
41·2×60·1 cm,
16¼×23⅝ in.
Published by Pellerin

CONVOI FUNÈBRE DE NAPOLÉON.

extreme left. In the final composition Courbet placed the grave
nearer the centre, where the drawing shows a stone slab. But, as in
the study, the procession shown in the painting has not ended: its
leaders, the priest and his factotums, the pallbearers, and the male
mourners, have arrived, while the women seen in the back row of
the painting are still filing around the grave to our right. The dog
turns his head in the direction of their movement. Since those still
walking are looking more or less ahead, they appear to pay less
attention to what would normally be the centre of interest than are
those who have already arrived at the graveside. Their movement
circling around the grave will eventually bring them forward and out
of the picture's space into our own (the viewer's) space, thus in a
sense including us in the ceremony. Similarly, the gaping grave itself
projects rudely forward from the picture into our space, since the
opening actually shown in the painting is much too small to contain
the coffin and can therefore only represent one end of the hole. In
this way Courbet's painting seems almost physically to impose its
terms upon the viewer, to impinge upon or to invade our world.

Courbet chose what looks like a 'non-moment' in the proceedings,
an uncomfortable instant during which, as the questioning look of
one of the altar boys suggests, the expected clues to meaning are
absent. In contrast to the bewildered boy, the priest looks like a man
accustomed to his role as meaning-giver. He leafs through the Bible.

Only the gravedigger is indifferent to the abbé's sense of power. The crucifix stands out as an ambiguous prop: one of the functions of religion is to explain and to comfort, but here its role is curiously inept. Between these extremes of the taciturn gravedigger, the confused altar boy and the knowing priest the community act out a familiar routine with varying degrees of attention and feeling. Examined closely, this diverse group is linked only by time, place and mortality rather than by an overlying structure implying a common psychology. Courbet seems to respect the particularity and integrity of the raw material of life, the result of a sensitive and direct personal approach to individuals as they posed for him one at a time.

5
l Greco
Domenikos
heotoko-
oulos),
he Burial of
ount Orgaz,
586.
il on canvas;
80×360 cm,
89×141¾ in.
hurch of San
omé, Toledo

56
Jacques-Louis
David,
*Marat
Assassinated*,
1793.
Oil on canvas;
165×128·3 cm,
65×50½ in.
Musées Royaux
des Beaux-Arts
de Belgique,
Brussels

At the end of Baudelaire's essay on the *Salon of 1846* there is a famous passage in which he called the black dress coats of the nineteenth-century bourgeois 'the necessary garb of our suffering age, which wears the symbol of a perpetual mourning even upon its thin black shoulders'. Champfleury thought this passage might have had something to do with Courbet's painting. In *Le Colonel Chabert* (1832) Balzac saw black as standing for 'the mourning of all virtues and illusions'. To his friend, the writer Francis Wey, however, Courbet wrote bluntly that he did not believe in mourning, for he was convinced

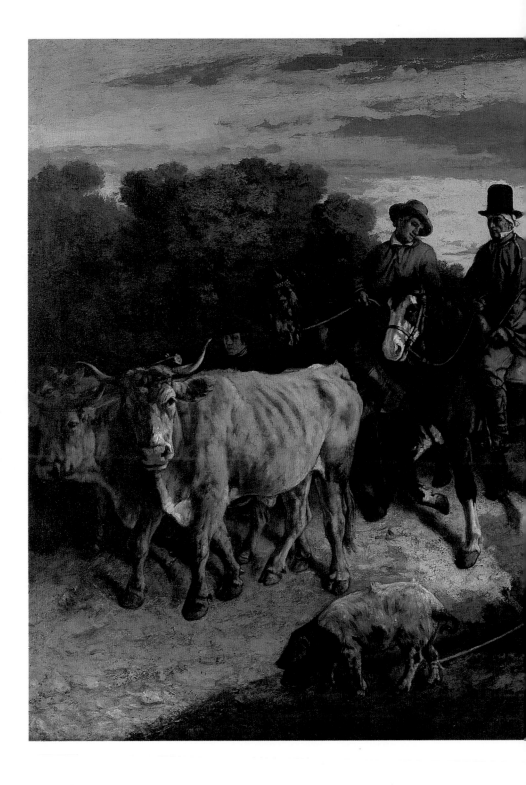

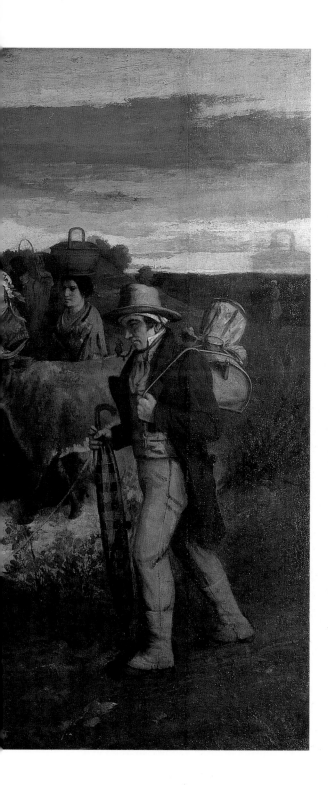

57
The Peasants of Flagey Returning from the Fair (Doubs),
1850
(reworked 1855).
Oil on canvas;
208·5×275 cm,
82⅛×108¼ in.
Musée des Beaux-Arts et d'Archéologie, Besançon

that one mourns for oneself, out of egotism. In traditional represen-
tations of death painters try to give an uplifting meaning to both life
and death; they point to the reassuring rewards of the afterlife,
when one imagines the soul voyaging aloft to its haven in the arms
of God. Courbet had not done so. The lower register of El Greco's
The Burial of Count Orgaz (55) is in some sense comparable to
Courbet's display of officials and individuals, but its upper region
provides a glorious consolation to an audience who can witness the
dearly departed welcomed by his celestial host. Even Jacques-Louis
David's famous painting of *Marat Assassinated* (56), while avoiding
any unrealistic imagery that would undermine the revolutionary
hero's ability to impinge on our feelings, uses its allusion to the
Christian pietà to suggest purposeful sacrifice and salvation. Champ-
fleury had compared the *Marat* to the *Burial*, impressed no doubt by
the realism and the political radicalism both artists shared. However,
Courbet's effort ultimately seems quite opposed to his predecessor's.
In the *Burial* we come face to face with the blunt reality of death
without particular purpose. The scale and dark silhouettes of
Courbet's figures impress by their disconcerting nearness to the
picture surface. Their physical presence cannot be given poetic value
through assimilation to traditions or dissimulated through a know-
ing display of pictorial virtuosity, for Courbet has dispensed with the
techniques of Dutch or Spanish styles to paint flatly, using thick and
broad strokes rather than chiaroscuro to create his figures' bulk.
Finally, there is the hole in the ground, in which we ourselves might
be standing (thinking of the painter's position as he painted and of
the viewer's position in viewing it). Next to it lie a crushed skull and
a broken bone, ultimate reminders that death as represented here is
a material rather than spiritual event.

As soon as *A Burial at Ornans* was finished, Courbet must have
begun work on another large painting, *The Peasants of Flagey
Returning from the Fair* (Doubs), 1850 (57). Again, the scene evoked
local customs and community, as Courbet indicated by mentioning
the Doubs region in the title, as in his official title for *The
Stonebreakers*. The painting showed Courbet's father, dressed in a
blue smock and top hat, on horseback, accompanied by other

58
Léopold
Robert,
*The Arrival of
Harvesters in
the Pontine
Marshes*,
1830.
Oil on canvas;
141·5×220 cm
55³⁄₄×86⁵⁄₈ in.
Musée du
Louvre, Paris

figures. This is the first composition in which Courbet actually took up the peasant theme, so often associated with him but more frequently represented by his contemporaries such as Millet, Jules Breton and others. Indeed, the theme of the country fair had been a great success in a large painting of 1830 entitled *The Arrival of Harvesters in the Pontine Marshes* (58) by Léopold Robert (1794–1835). Here, youthful and happy peasants, looking as if they had just got scrubbed for the party, prepare to celebrate the end of the harvest. Their gaily coloured and freshly laundered costumes have more to do with the rococo shepherds and laundresses painted in the eighteenth century by François Boucher and Jean Honoré Fragonard than with actual social conditions of 1830, whether in

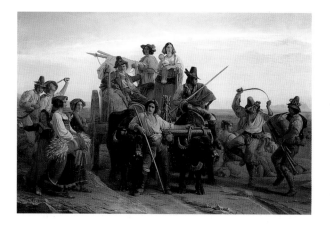

Italy or elsewhere. Indeed, by placing his scene in Italy, Robert was perpetuating the pastoral myth of the Italian countryside. As long as this idyll of peasant happiness prevailed, conditions in any actual countryside could be ignored.

By contrast, Courbet's country fair was a commercial event where farmers bought livestock and provisions. The bony-looking cattle are not signs of poverty, as often thought, but of astute business investment. Their new owners will fatten them up for profit. Returning to their homes at the end of a long day, these tired rustic souls have not been wasting their time at some frivolous entertainment. Their concerns are as entrepreneurial and penny-wise as their gait is sure and plodding. Yet, although the movement of the figures is easier to

grasp here than in the *Burial*, together they form a somewhat less unified group. While they share the same direction, each seems lost in his or her own world as they trudge silently towards their destination. Courbet's warm colour harmonies, in which the blues and greys of the figures' clothing sit easily within the greens of the landscape and the muted orange of the early evening sky, might convey a sense of conventional peace and harmony were it not for the awkwardness of the relationship of the characters to the picture space. For the figures and animals seem almost pasted to the surface, the path lit by the setting sun appears steeply tipped towards the foreground and the man with the piglet seems to have his own landscape perspective to himself, with the rest of the composition looking like his backdrop. For Courbet's acquaintance Proudhon, however, *The Peasants of Flagey* was anything but disharmonious. 'Here is rural France, with its indecisive mood, its gentle passions, its unemphatic style, its thoughts more down-to-earth than in the clouds, its customs as far removed from democracy as from demagoguery ... happy when it can preserve its honest mediocrity under a temperate authority.' Perhaps the harmony created by Courbet cannot be judged by conventional standards, then, since it was rooted in the popular culture and seemingly unsophisticated modes of perception of his own milieu.

Although Courbet's painting had progressed in a relatively coherent development, the public turning point in his career created by these paintings was much more sudden. He had gained some attention thanks to the *After Dinner at Ornans*, but it was no match for the high profile he assumed at the Salon of 1850–1, where he exhibited *The Stonebreakers*, *A Burial at Ornans* and *The Peasants of Flagey* as well as several other works. By the close of that exhibition he was to become famous, at least as artists go. Normally, Courbet might not have exhibited so many, since the exhibition of 1850 should have taken place in the early part of the year, affording him less time to finish such a number. However, political events had forced a delay until New Year's Eve, leading the government to combine exhibitions for two years into a single Salon of 1850–1. It was that Salon which defined the position Courbet, now aged thirty-one, would occupy

both in his immediate time and in the eventual history of art. While the *Burial* by sheer size was the painting that attracted the most attention, responses to his work usually grouped all of it together. Thus, certain opinions that were already heard in the context of *The Stonebreakers* applied in fact to the entire group. Among the other paintings were the *Man with Pipe* and a now lost *Portrait of Jean Journet*. Through the *Man with Pipe*, Courbet personalized the group of works he was presenting, for the self-portrait put a face on the name that was to be on everyone's lips. Moreover, his expression suggests anything but modesty: self-confidence and disdain seem a more accurate description. Through the *Portrait of Jean Journet*, on the other hand, Courbet deliberately flirted with political provocation, since Journet was widely known for itinerant political proselytizing. He was a disciple of the communitarian socialist Charles Fourier (1772–1837), who believed in founding future society on independent communities, called phalanxes, that would be self-sufficient and internally democratic. In such organizations, the profession of artist would exemplify pure freedom thanks to its independence from economic pressures. Courbet admitted to his family that a policeman might have to be stationed near this particular work.

So Courbet surely had some idea of how Paris would react. Having learned prior to finishing *The Peasants of Flagey* that the Salon of 1850 would be postponed, he even took steps to prepare the way, for he organized an exhibition of *The Stonebreakers* and the *Burial* in Ornans and Besançon while awaiting the delayed opening in Paris. This strategy was unusual, for few artists of Parisian ambition would have bothered to engage a provincial audience. But for Courbet, by this time, his provincial origins and audience were essential to the impact he would have in the capital. In Ornans, as one might imagine, everybody came, and there is no reason to doubt Courbet's claim of unanimous admiration. For the Besançon show, he obtained the cooperation of the mayor and charged admission. To prepare the terrain, his friend Buchon published an announcement filled with political allusions in a Fourierist newspaper. Courbet attributed his trouble in arranging a similar exhibition in Dijon to the ignorance of

Republican sympathizers in that city as well as to the opposition of the Monarchists. In spite of the incoherence of this particular reasoning, in which he blames all political sides, it is clear that politics was at its root. As a result, Courbet wrote to Francis Wey that he felt he must go his own way by turning directly to the people: 'Yes, dear friend, even in our oh-so civilized society, I must lead the life of a savage … The people have my sympathy. I must turn to them directly, I must get my knowledge from them, and they must provide me with a living. Therefore, I have just embarked on the great wandering and independent life of the bohemian.' Courbet's experience, then, was that his art would never win official sanction and that he would have to operate independently. He was free from submitting work to the jury; his *After Dinner at Ornans* had been purchased by the state and sent to the museum at Lille. He did not have to be concerned with established opinion; he could address his audience directly and take his chances. So when his paintings were shown in Paris, he could afford to risk some scandal. Perhaps only its intensity was unforeseen.

The attacks in the press were stunning: the majority were hostile and most used political language. One critic called Courbet the Proudhon of painting, '[who] does democratic and social painting – God knows at what cost'. The one who feared it as 'the engine of revolution' said: 'They even add, to terrify us more, that this new art is the legitimate child of the Republic … the product and manifestation of the democratic and popular genius. In M. Courbet, art makes itself part of the people.' Another called it a 'revolutionary catapult' and objected to Courbet's enormous signature in red, the revolutionary colour. And one more exclaimed: 'Courbet … has destroyed art in a single blow, and he has replaced it. There is no art, since the negation of art can substitute for art itself … My eyes have seen egalitarian painting.' A common theme in analyses of the painting itself was the ugliness and vulgarity of his figures, which were considered ludicrous, deformed and bizarre. His apparent lack of skill in traditional drawing and composition was also berated.

But Courbet's supporters, though few, defended his honesty and accuracy. Champfleury first flatly denied the political content of Courbet's art, even though that denial was certainly disingenuous. What prompted his defence was the uproar over Courbet's so-called socialist views. Champfleury's response was that painting with a particular political mission – what we would call propaganda – is always superseded by newer political developments that quickly make specific positions obsolete. Champfleury argued that Courbet's painting merely represented unembroidered reality as he saw it, with no particular political mission. He praised Courbet's 'horror of composition' which he took to mean horror of convention, and asked: 'Is it the painter's fault if the material interests, the small-town life, the sordid egotisms, the selfishness of the provinces leave their mark on the faces, deaden the eyes, furrow the brow, and distort the mouths? Many bourgeois are like that, and M. Courbet has painted bourgeois.' Couched in terms of the rebellious artist's contempt for the bourgeoisie, this apparent justification of his vision reveals a disdain for the provinces that Courbet certainly did not share. In so adopting the values of Paris, then, Champfleury actually confirmed the attitudes underlying the political responses of Courbet's enemies.

So if Courbet's painting was not propaganda, why was it nonetheless so explosively political? The answer lies in Courbet's rejection of Parisian values, and in his introduction of forms from popular culture into a previously exclusive domain. This issue was raised by the infuriated critic who had attacked Courbet for attracting drunks: 'As I see it, M. Courbet must have spent a long time scrawling sign-boards, especially for chimney-sweeps and coal-sellers, and he was probably aiming no higher when he did the rounds of country fairs … exhibiting his incredible canvases in a booth with a sign: GRAND PAINTINGS BY COURBET, WORKER-PAINTER.' The references to signboards and country fairs compare Courbet's work to commercial art and his unwelcome audience to a sort of underclass. In so doing, they allude to a kind of crude visual culture that was associated with the masses. Courbet surely knew what these so-called 'images d'Epinal' looked like, not just from his own rural experience but

Lustucru, d'après une gravure normande.

59
Lustucru.
Woodcut in Jules
Champfleury's
*Histoire de
l'Imagerie
populaire*, Paris,
1869

60
*Crédit est Mort.
Bonhomme crédit
succombant sous
des coups des
mauvais payeurs.
(Credit is Dead.
Mr Credit
succumbing to
blows from bad
payers).*
Woodcut in Jules
Champfleury's
*Histoire de
l'Imagerie
populaire*, Paris,
1869

CRÉDIT EST MORT,
d'après une image d'Épinal.

DEGRES DES AGES.

DE LA FABRIQUE DE PELLERIN, IMPRIMEUR-LIBRAIRE, A ÉPINAL.

61
The Steps of Life.
Coloured lithograph from a woodcut;
41×58 cm,
16⅛×22¾ in.
Published by
Pellerin, c.1830

62
The Apostle Jean Journet Departing for the Conquest of Universal Harmony,
1850.
Lithograph

from Champfleury's systematic collection of them. Although it was not until 1869 that Champfleury published his *History of Popular Imagery*, which featured many of the works he owned, his articles had begun appearing in 1850. Generally, popular prints were simple woodcuts produced as cheaply as possible in the greatest possible quantity. For the sake of legibility, their compositions were rudimentary and often contained words, as in today's comic strips. When their subjects were not religious, they illustrated homilies or the battle of the sexes, that is, matters easy to grasp and of everyday concern. *Lustucru* (59) shows the gruesome fate of the unfaithful wife. *Crédit est Mort* (60) discourages speculating with money in favour of plain hard work – earn a little, and live happily with what you can.

Indeed, in a classic study of Courbet's sources in popular imagery Meyer Schapiro suggested a connection between *A Burial at Ornans* and a type of print showing *The Steps of Life* (61), in which a series of individuals, each one standing for an age and station in life, are gathered on steps in a semicircle around a burial. Although there is no proof that Courbet knew such scenes, the resemblance is remarkable. Moreover, the critic's reference to Courbet as a 'worker-painter' may allude to another popular tradition, to which we know Courbet had direct links. In poetry and song there had developed a movement of so-called worker-poetry dating from the 1840s, which had inspired both of Courbet's poet friends, Max Buchon and Pierre Dupont (1821–70). The latter's 'Song of the Peasants', which heralded the coming 'Republic of Peasants', certainly echoed that dangerous tradition. Courbet repeated his image of Jean Journet (departing for the Conquest of Universal Harmony) in a lithograph he made in order to accompany a song, and it was distributed like a broadsheet (62).

Nowhere is the connection between Courbet's style and popular forms better evoked than in caricatures of his paintings. Caricatures are a valuable tool for the history of art, for they often have a way of focusing on the essentials. A deliberately crude caricature of *A Burial at Ornans* by Bertall (63), whose many other works show a

63
ertall,
aricature of
*Burial at
rnans. Le
urnal pour
re*, 7 March
851

much more sophisticated technique, represents most of Courbet's
figures as inverted white commas against a black background. They
reflect Courbet's stark contrast between faces in full light and their
heavy, dark clothing. Their alignment makes the feeling of monot-
ony and lack of dramatic structure to the picture clearly emerge.
The figures to the left are the two beadles whose red robes and
bulbous noses made them stand out and whose faces Courbet had
accentuated with particularly coarse handling. They seemed to epit-
omize the absurdity of Courbet's countrymen. Finally, the size of the
caricatural signature is completely outlandish. On the original
painting, the signature was certainly quite large, too, but not out of
proportion to the painting as a whole. (Courbet later effaced it, but
it now shows through, although it is almost never visible in repro-
ductions.) The caricature implies, then, that Courbet's painting can
only have been produced by a gigantic egomaniac, and it is at this
moment, we might say, that the Courbet 'legend' began.

Bertall's cartoon of *The Peasants of Flagey Returning from the Fair*
(64) makes Courbet's figures look like wooden mannequins and
stuffed animals. Here, with far more detail than in the parody of the
Burial, we are very close to the aesthetic *naïveté* of popular art,
hence to the notion of Courbet as a 'worker-painter'. From the point

64
Bertall,
Caricature of
*The Peasants
of Flagey
Returning
from the Fair.*
*Le Journal
pour rire,*
7 March 1851

of view of the Parisian élite, the lower classes are no cleverer than children. A third supporter of Courbet (in addition to Buchon and Champfleury), the Fourierist François Sabatier (1821–91), referred to Courbet's additive composition as an appropriate pictorial form for modern times, the equivalent of 'democracy in art'. His affirmation has a dual implication. First of all, by drawing on the pictorial vocabulary associated with 'the people', Courbet gave them a voice in the realm of visual culture. Second, by refusing traditional compositional strategies, Courbet himself defied centralized authority. Those traditional strategies can be exemplified through comparison of the *Burial* to a large painting by Thomas Couture (1815–79), who in 1847 had exhibited *The Romans of the Decadence* (65). This representation of ancient sexual excess and debauchery was presumed to allude to the corruption of contemporary society. In it Couture tied together a vast display of many figures through linkages in body position and gesture, all framed within a stage-like architectural setting reminiscent of the Venetians. In other words, he chose to use the traditional 'rhetoric' of academic history painting. Courbet, by contrast, represented contemporary society directly: he refused allusion and allegory in favour of an actual 'piece' of it, and he chose a way of organizing his painting that both honestly reflected his actual procedure and looked like popular art.

In his review of the *Burial* Sabatier had suggested that death was the great equalizer, an idea he shared with Max Buchon, who compared the painting to medieval images of Dances of Death. As we saw, popular imagery tended to moralize about the eternal verities; peasant morality tended to be conservative. And peasant politics generally resisted industrial capitalism and outside authority. Who can say that the large and stiffly painted figures of *The Stonebreakers* have nothing to do with the rustic style of rural art? Who can deny that Courbet's comparison between youth and age is related to rustic moralizing? Especially when comparing it with the other paintings he showed at the Salon, one could easily come to those conclusions. *The Steps of Life* is an allegory of unchanging human destiny. Yet by comparison to the paintings of Millet, popular imagery does not make its figures heroic; its forms suggest an unshakable matter-of-factness closer to Courbet. This conservatism, then, is ultimately radical, for it brings everything back to an earthly common denominator. *A Burial at Ornans* confronts us with an irresistible fact of life – the materiality of death.

At about this time Courbet took to writing letters to the editors of newspapers that had mentioned him. Although his move was virtually unprecedented at the time, it now seems logical that Courbet tried to seize some initiative in debates where he was the subject. He would do so often throughout his career. He had already compared the street fighting of 1848 to his own 'war of words', but now Courbet actually came out with published statements under his own name meant to appear in highly visible journals. In one he claimed never to have had a teacher, to be simply the student of nature devoted to the preservation of his independence. He seems to follow through the idea of the 'bohemian' path he had outlined earlier to Francis Wey, although it was hardly necessary to do so publicly unless his ulterior aim was to get his name in the paper and further personalize his artistic profile. A few months later, in November 1851, he wrote again, this time in response to a conservative journalist at the *Messager de l'assemblée* who had called him a socialist and placed him at a left-wing political meeting. This time Courbet verged on belligerence, and he insisted that his letter be published; to make

sure it would be, he sent it to two papers simultaneously. While expressing thanks for being disassociated from the conservatives, Courbet focused on the epithet 'the socialist painter'. He asserted: 'I accept that title with pleasure.' But he added: 'I am not only a socialist but a democrat and a republican as well – in a word, a partisan of the entire revolution and above all a Realist, … a sincere lover of the veritable truth.'

By claiming to be a democrat and a republican as well as a socialist, Courbet insisted that he was less interested in party politics than in the general principles to which those terms refer. But, by professing to be a partisan of the entire revolution and above all of Realism, he established a hierarchy in which Realism commanded the highest loyalty. He made socialism, democracy and republicanism seem like

65
**Thomas
Couture**,
*The Romans of
the Decadence*,
1847.
Oil on canvas;
472×772 cm,
185⁷⁄₈×304 in.
Musée d'Orsay,
Paris

facets of that greater revolution, a revolution described by a single
word – Realism – that was not yet known to designate a political
position. However, it happens that this was the first statement in
which Courbet had ever used the term Realism, and he is using it in
a political context. It is also one of the first statements in which the
word functions as the name of a school of art or category of thought.
It had been mentioned by one critic in the same year who said the
Burial would be 'the Hercules Column of Realism in modern history',
but there it is not clear that the writer is thinking of an identifiable
school with specific theories and adherents. Thus, when Courbet
later said the title of Realist was thrust upon him without him seek-
ing it, we know he was not being completely honest. Looking back
on the *Burial* a few years later, Courbet claimed the painting to have
been the 'debut of my principles'. He does not necessarily mean that

with the *Burial* his art became programmatic, as it would be in some key later works. It is more likely that the experience of the *Burial* and the attacks on it helped to clarify the basis of his art for him and affirm his acceptance of its ramifications. But the statement does indicate Courbet's consciousness of principles to which in 1851 he already gave the name Realism.

A far cry from the uplifting messages of religious doctrine, *A Burial at Ornans* implies that human life and the soil of the earthly grave are formed of the same primal matter, as rendered by the lumbering brushstrokes of a relentless and deliberately heavy hand. Hence, the values embodied in Courbet's art are not simply popular values, for the people themselves would have been satisfied with a more conventional religious representation. What I have called Courbet's artistic language may have been derived from a kind of vernacular imagery, but its effects add up to more. Popular art itself is not Realism. It would be more suitable to view Realism as the consequence of taking knowledge and sustenance from the experiences of ordinary people in confronting the major issues of the day. What theme is more basic to all existence than that of death? Any treatment of this theme instantly and automatically acquires philosophical implications. Although Courbet's painting does not provide specific answers, it does exemplify an approach. He chose to represent physical and visual facts as they are experienced in everyday life by ordinary people, and he gave them the scale usually reserved for the painting of heroic subjects. The political consequences of Realism were probably not among Courbet's principal concerns until he actually found them in responses to his art. As he discovered, political regimes often restrict artistic freedom (in late 1851 he thought he was being followed by the police), and in his case, political interpretations had defined his position as an artist. Courbet had no qualms about exploiting politics to promote his artistic claims. If the 'entire revolution' to which he referred could be termed a revolution in consciousness informed by the Realist attitude, then Courbet would turn out to be far more revolutionary than anyone yet knew.

The other paintings Courbet exhibited at the Salon of 1850–1 were a portrait of his friend, now patron, Francis Wey, a portrait of the Romantic composer Hector Berlioz, for which Wey had probably arranged the commission as a way of linking Courbet to a famous name, and two landscapes of the Doubs region. Once again these were mostly people and places Courbet knew. Even before the Salon was over, he was working on a picture of his sisters in a local landscape, *The Young Ladies of the Village* (66). He told Champfleury this painting would confound his judges, for it would show him to have 'made something graceful', a belief which today seems reasonable enough. Yet, again, the figures are not well integrated into the landscape, even though in an earlier sketch, where they are proportionately much smaller, he had been far more successful. The decision to so enlarge them surely meant he wanted a subject painting rather than just a landscape with figures. The three ladies are: to the left Zélie, offering a piece of country tart to a young shepherd girl, in the centre Juliette, with a parasol (notice how she is leaning it unfashionably on her neck rather than on her shoulder), and to the right Zoé, the youngest. The painting might be viewed as a contrasting pendant to *The Stonebreakers*, to which it is similar in size. Here we witness a scene of charity and prosperity whereas the earlier work testified to exploitation and physical hardship.

But just as for *The Stonebreakers*, critics considered Courbet's figures vulgar and dirty. That is because rather than using smooth modelling and transitions from light to dark through glazing (thin, semi-transparent layers of paint that build form gradually), he painted in what looked like a relatively coarse manner, placing contrasting lighter colours such as flesh tones on a darker background, which he allowed to show through where he needed shadow. Courbet painted the landscape even more freely, using generous impasto at certain points. For landscape, such sketch-like

66
The Young Ladies of the Village,
1851–2.
Oil on canvas;
95×261cm,
 63¾×102¾in.
Metropolitan
Museum of Art,
New York

techniques had already gained acceptance, particularly in the Barbizon School. Figure painting was another matter. So when *The Young Ladies* was exhibited in 1852, Courbet's critics were just as annoyed as before, rather than being confounded. Furthermore, the painting's subject matter itself seemed incomprehensible. The main point was delivered by the usually open-minded Romantic novelist and art writer Théophile Gautier (1811–72), who wrote cruelly that the sister to the left (Zélie) looked 'like a cook in her Sunday best'. These girls were putting on airs and were overdressed for their station. They looked like those 'country youngsters who are abandoning their families to seek their fortune in Paris'. Gautier could not have known that the third sister, Zoé, would in fact come to Paris as a lady's companion in 1856. But he thought he did recognize the ludicrous attempt of many provincials to appear fashionable, despite outmoded dresses that were limp and dreary by current Paris standards. And he found pretentious the airs they affected while playing the role of charitable graces (as Courbet had intimated), for he knew that no genuine lady would stroll about with a peasant basket.

Courbet's use of the word *demoiselles* in his title instead of *jeunes filles* gave away his sisters' aspirations – and perhaps his own hopes for them. For the word at one time reserved for aristocratic ladies had come to evoke independent unmarried women ranging from spinsters to prostitutes, depending on the context in which the term was used. Of course, the sisters were of neither extreme; the point is simply that in the milieu of their particular village, they considered themselves *grandes dames*. Yet since, for the Parisian critic, their efforts to reflect a better class of people were so obviously inept, Courbet's intentions in choosing them for art were unclear. Even now, we cannot know if the scene was a parody meant to mock Parisian ways, or if the artist was playing it straight, making a homage to provincialism that Parisian critics found either nonsensical or too painful to consider. In either case, the girls were an embarrassment: they simply fit no social category for which there was a tradition in painting. Art, after all, was reserved for representations either of those in power themselves or of their

'constructions' of 'others' – their conceptions of others as 'types'. There was no tradition for painting others as others saw themselves. And in times of political instability and social change, as we have seen, challenges to cultural conventions were particularly threatening.

Before the opening of the Salon of 1852 Courbet had sold *The Young Ladies of the Village* to the wealthy Count de Morny, the illegitimate half-brother of Louis-Napoleon, the French president. In 1851 Courbet had also been working on a large (but never finished) painting, *The Departure of Firemen Running to a Fire* (68), for which he received the cooperation of the War Ministry. Apparently the government authorized the captain of the local fire station to let Courbet paint on the premises. The captain even sounded the alarm so Courbet could observe actual preparations. This ambitious painting was a first for Courbet not only because of the official cooperation, but also as his first night scene and his first urban setting. As an obvious prototype he took Rembrandt's famous work, *The Night Watch* (67), which also showed an urban militia. The painting's reference to Dutch art was all the more appropriate since art had flourished under the seventeenth-century Netherlandish Republic. When Courbet began the painting the Second French Republic (the Republic of 1848) had not yet succumbed to its president's *coup d'état*. The brigade is framed, on the left, by a working-class mother with her children who have come to admire the spectacle and, on the right, by a bourgeois couple of passers-by. As an expression of community, the painting also looked back to *A Burial at Ornans*, in which there is a sense of a collective will and custom to which Courbet was profoundly sympathetic. In *The Departure of Firemen Running to a Fire* Courbet heroized ordinary citizens whose efforts benefited all of society. As such, the painting certainly embodied democratic ideals. This connection to politics is confirmed by the painting's derivation, like all of Courbet's paintings to date, from his personal experience. In this case, it alludes to the first day of the 1848 uprising, which Courbet witnessed in the company of Baudelaire and Charles Toubin (another collaborator on *Le Salut public*). Towards evening insurgents had set a police station

aflame, and a fire brigade rushed to extinguish it. The heroism of the firemen, then, is placed in the context of the overthrow of monarchy and the founding of the Second Republic. So Courbet's reason for leaving *The Departure of Firemen Running to a Fire* unfinished becomes easy to understand. On 2 December 1851 Louis-Napoleon suspended the National Assembly, dismissed the Council of State and declared martial law. (It was about this *coup d'état* that Karl Marx later wrote that history always repeats itself, the first time as tragedy, the second time as farce.) Although Louis-Napoleon also declared popular elections, they became a rubber stamp for the creation of the Second Empire and the president's installation as Emperor Napoleon III. Any painting that glorified the Republic would have been censured, and any republican artist would have been disheartened. But in addition, Victor Frond, the commander who let Courbet use the fire station and served as the model for the captain in the painting, became *persona non grata*. Frond had been a militant republican, and he fought vigorously against the coup. Shortly after it he was arrested and exiled to Algeria. A few days later Courbet himself was worried about his own security. Proudhon had been in jail since 1849 for his verbal attacks on Louis-Napoleon, Max Buchon had fled to exile in Switzerland, and Urbain Cuenot was arrested in Marseille and would be sent to Algeria. Courbet's suspicion that his letters were being opened and that he was being followed by the police may not have been unfounded.

67
Rembrandt van Rijn,
The Night Watch (The Militia Company of Captain Frans Banning Cocq), 1642.
Oil on canvas; 359×438 cm, 141³⁄₈×172¹⁄₂ in.
Rijksmuseum, Amsterdam

68
*The Departure
of Firemen
Running to a
Fire*
(unfinished),
1851.
Oil on canvas;
388×580cm,
152¾×228¾ in.
Musée du Petit
Palais, Paris

Yet the arrest of Cuenot did not prevent Courbet from showing a large portrait of him at the same Salon as his *Young Ladies of the Village*. Perhaps, thanks to his sale to Count de Morny, he enjoyed some protection. In fact, he obsequiously approached Morny (probably the best connected man in France through his investments as well as politics), whom he encouraged to support art through continued patronage, even though he had little respect for his ideas. Morny seems to have agreed to talk to the government about commissions, since Courbet's own effort to do so had failed. But apparently Courbet was told he would have to change the kind of pictures he made because he was still perceived as a political force. Nonetheless, Courbet felt that his business was growing, along with his reputation, and that he had no reason to fear the government, which would eventually develop a taste for Realism simply because it was inevitable. For this opinion, Courbet was relying on the evidence of his exhibition of 1852 in Frankfurt, Germany, where the *Burial* had caused a sensation. There, the receipts for entrance fees were lucrative, and Courbet claimed that he was so much a source of conflict and disagreement that signs had to be posted in cafés and casinos forbidding discussion of his works. Of course, he revelled in such attention, for he recognized that 'when I am no longer controversial I will no longer be important'.

In 1852 Courbet was notorious enough that a young writer named Théophile Silvestre interviewed him for a book on living artists. On that occasion the Parisian photographers Laisné and Defonds made the first known photograph of him (69). Their picture shows the artist sporting a considerable beard, lean and fashionably dressed, and striking a confident pose. Courbet spent three weeks explaining his works and his ideas to Silvestre, as well as composing an essay to help Silvestre's enterprise. Although the latter's collection of biographical sketches did not appear for four years (1856), when it did he quoted liberally from Courbet's essay of 1852. The lines quoted elaborated considerably on Courbet's public statements of the previous years. In them is the embryo of Courbet's manifestoes of a few years later. Now Courbet claimed not to be of any party but simply to be his own man:

69
Victor Laisné
and E Defond
Gustave
Courbet,
1852

I am a Courbetist, that is all; my painting is the only true one; I am the first and the only artist of this century; the others are students or drivellers. *Everyone* may think the way he wants, *I do not care about it*. I am not only a *painter*, but also a *man*; I can make my judgement in morality, politics and poetry, as well as in painting. I am *objective* and *subjective,* I have made my synthesis. I do not care about anybody and I worry as little about opinions as about the water that passes under the Pont-Neuf [Paris' most famous bridge]. Before everything else, I do what I have to do. They accuse me of vanity! I am indeed the most arrogant man in the world.

Such declarations make it easy to understand how Courbet could be caricatured. But they must also be understood as his own polemical response to the denigrating hyperbole employed by his critics. Silvestre was amused by Courbet's 'low-class' manner and accent, and he completely dismissed his intellect, crediting Courbet simply with passion, instinct and ego. But reading beyond the patronizing tone of Silvestre's sketch, we find that Courbet's grand ambitions and broad vision of his significance and accomplishment were perfectly consistent with his statement to *Le Messager* of 1851. For they took a position above specific politics, and they stressed the general theme of independence, now expressed through his reference to manhood – a concept Courbet would use repeatedly for its ability to combine his notion of humanity with his sense of freedom.

Courbet's subsequent pictures were closer to social studies than to political statements, even though in the past the line between the two had often been hard to discern. His first painting after *The Young Ladies of the Village*, was *The Wrestlers* (70), a highly unusual and original choice of subject from the urban scene. Courbet based the painting on professional wrestlers who had been in Paris the previous winter. Their presence had engendered a relatively large number of popular prints (71), and their public matches, especially those outdoors, clearly appealed mainly to the working classes. Adding to the sense of strangeness of Courbet's figures was the greyish cast he had given them. The colour is especially noticeable because of its contrast to the luminous brown-green background. For many of Courbet's critics, this colouring connoted filth and vulgarity. He was attacked as the 'virtuoso of bestiality'. For others, it suggested racial difference. Several caricatures emphasized the darkness of skin in a way that, in the black-and-white medium of prints, was automatically read as a representation of Africans (72). Théophile Gautier was nearly at a loss for words; the figures repelled him as 'simply detestable'. Courbet really seemed to be bringing art down into the gutter.

Courbet's interest in representing such figures in the high medium of oil painting on a large scale was certainly related to his general

Des lutteurs de la salle Montesquieu, Arpin le Terrible Savoyard, et Marseille.

desire to bring motifs from the everyday lives of ordinary people into the realm of historical painting. But he continued to use awkward poses and to refuse to integrate his figures with their background. The result in *The Wrestlers* was a powerful impact on the viewer and a sense of intense physical exertion that would have been less effective had Courbet shown them in one of the more acceptable wrestling holds authorized by official rules. These sweaty, 'sooty' fighters seemed almost ready to jump out of the picture space and invade the viewer's world. Courbet had a choice between the realism of acceptable sport and the psychological impact of less controlled and orchestrated conflict. Here the muscles bulge and the veins seem about to pop. In his own references to the painting, Courbet described it as a picture of nudes, no doubt deliberately refusing to distinguish between his choices and the way an academic painter might have treated the theme. In fact, he hoped such a painting might appease his critics by concentrating their attention on matters of aesthetics. It is certainly true that a tradition of figures in conflict as vehicles for displaying anatomical artistry went back to antiquity. We might cite the metopes of the Parthenon and famous Renaissance examples such as Michelangelo's *Battle of Cascina* and Antonio Pollaiuolo's bronze statue of *Hercules and Anteus* (73). But of course, Courbet's systematic point would have been to demystify

71
Wrestling in the Salle Montesquieu. Wood-engraving in Edmond Texier's, *Tableau de Paris*, 1852

72
Quillenbois, *Battle between the Worshippers of Venus*, carica-ture of *The Wrestlers*. *L'Illustration*, 21 July 1855

73
Antonio Pollaiuolo, *Hercules and Anteus*, c.1475. Bronze; h.45 cm, 18 in. Museo Nazionale del Bargello, Florence

74–75
The Bathers,
1853.
Oil on canvas;
227×193 cm,
89⅜×76 in.
Musée Fabre,
Montpellier
Right
Detail

such traditions by embodying them through reality. Moreover, the theme of struggle could have political ramifications, harking back to the social struggles of recent years, although if Courbet meant to evoke such circumstances here, he has done so in the most generalized manner.

Of similar size to *The Wrestlers*, and considered its companion, was *The Bathers* (74) showing two women at a woodland brook, one of whom is seen nude from the rear (75). Again, the figures stand out with astounding power and presence, so provocative in this case that, according to Courbet, Emperor Napoleon III struck the canvas with his riding crop. The standing woman, who was originally stark naked, seems to be testing the water. One could interpret her gesture as an attempt to keep her balance in a pebbly stream or as an exclamation relating to its temperature. Her companion, probably a servant, responds with a gesture that seems ridiculously affected. One theory about the painting holds that the standing woman was copied from a photograph of a posed model – possibly one of many made by de Villeneuve (76) at around this time. In the photograph the woman is using her arms and body to stabilize her pose for the extended exposure, whereas, when transposed into the

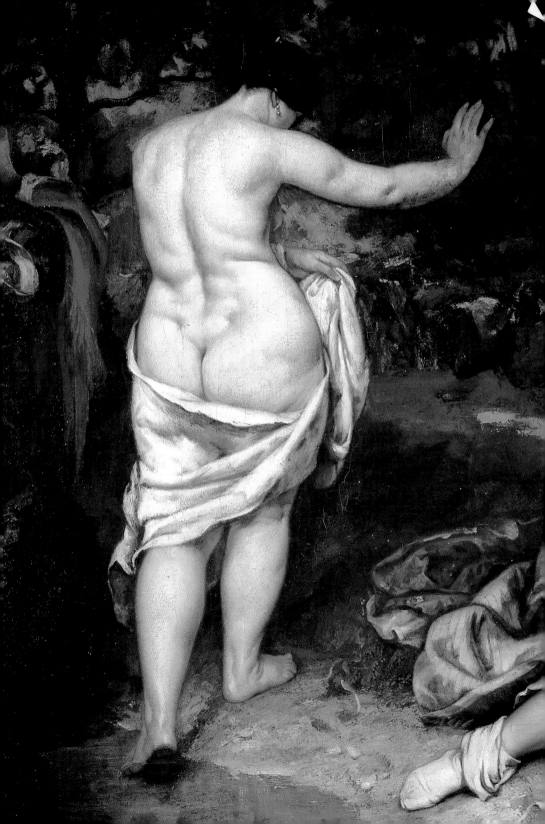

painting, the gesture no longer has a purpose. Another theory recognizes the woman as a popular studio model of the day whose face was much admired. No artist had as yet chosen to feature her generous derrière. These parodies of academic gestures and of the tradition of female bathers were deliberate, and they help us to understand why Courbet regarded this painting as his first essay in irony. But, in addition, the painting clearly mocks certain social practices by its clear identification of the standing woman with the bourgeoisie. Despite the corpulent females in paintings by the great seventeenth-century Flemish master Peter Paul Rubens (1577–1640), and despite greater tolerance for feminine body fat in the nineteenth century than today, Courbet's woman was even in her own time regarded as overfed and anything but lovely. Gautier called her a 'Hottentot Venus … turning towards the viewer her monstrous croup'. However, most observers recognized Courbet's extraordinary pictorial talents. His loose and suggestive handling was far more acceptable in the areas of the painting corresponding to landscape, which was in fact widely admired. They simply disagreed, sometimes violently, with his wilful decision to apply his skills to vulgar subjects. Delacroix, always an admirer of Courbet's vigorous brushwork and startling relief, was shocked by his 'abominable vulgarity and uselessness of thought'. He could not understand the point: 'What do these figures mean? A fat bourgeoise … makes a meaningless gesture … No one can comprehend the exchange of thought between these figures.' Delacroix, primarily a painter of narrative scenes, could not discern any story to justify the distasteful representation of such coarse contemporaries.

For the social critic Proudhon art was to be a truthful mirror held up to society in order to help accentuate its positive qualities and correct its flaws. Courbet, whom we heard called the Proudhon of painting, had visited his radical mentor while the latter was in prison, and he was present at Proudhon's release in 1852. It was during his imprisonment that Proudhon had composed his *Philosophy of Progress* (which was published in 1853 and almost immediately banned), a book that Courbet took seriously when he composed his famous *Studio of the Painter* a few years later.

76
Julien Vallou
de Villeneuve,
Standing nude
model, c.1854

Proudhon held that beauty could be either dark or bright and could be found at any level of the social ladder. Any figure, beautiful or ugly, could serve the aims of art, which he saw as essentially social. For him, a Realism that would make known the facts of contemporary reality would lead to the improvement of society. In lines written specifically about *The Bathers*, he proposed: 'Let the people, recognizing its misery, learn to blush at its cowardice and to despise tyrants; let the aristocracy, exposed in its fat and obscene nudity, receive on each limb the lashes of its parasitism, insolence and corruption. Let the magistrate, the soldier, the merchant, the peasant – all conditions of society – seeing themselves each in turn in the epitome of their dignity and their baseness, learn through both glory and shame to rectify their ideas, to correct their habits, and to perfect their institutions … This is how art must participate in the movement of society, both provoking it and following it.' Proudhon's inventory of different occupations gives a rationale for the variety of subjects Courbet had chosen, particularly those that depart from the country life that Courbet directly knew. It might seem that Courbet's *Departure of Firemen Running to a Fire* was one of those paintings that showed the glory of contemporary heroism, whereas *The Bathers* showed the physical results in obesity and triviality of an absence of proper occupation. An art that mirrors life could have salutary results as well as advance its creator's career.

In contrast to the female image Courbet presented in *The Bathers*, at the same Salon he exhibited a single figure of a woman called *The Sleeping Spinner* (77). This painting seems to have won reasonable popular affection, despite some continuing criticism of vulgarity and dirtiness. Although the woman looks somewhat like Courbet's sister Zélie, the evidence of an oil sketch makes that supposition impossible to confirm, and Courbet referred to her as a cowherd. In any case, the image based on a sleeping figure is certainly far less

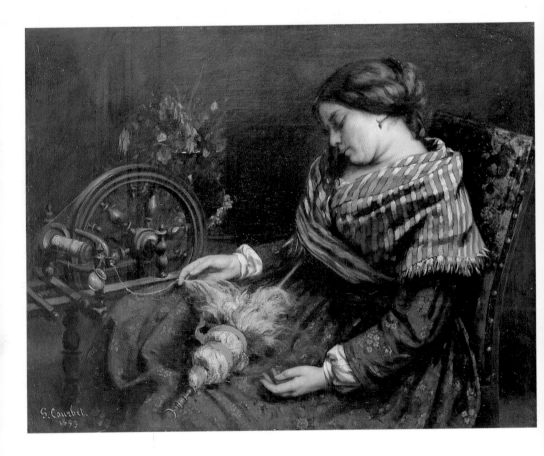

77
The Sleeping Spinner,
1853.
Oil on canvas;
91×116 cm,
35⅞×45⅝ in.
Musée Fabre,
Montpellier

aggressive than in Courbet's other major pictures, for in her inactivity the woman submits passively to the gaze of the beholder. Moreover, Courbet's warm reds, blues and browns create a harmonious effect that the harsh contrast between brightly lit flesh against dark clothing or landscape had made impossible in his work to date. The theme of the woman spinning wool in her home is also a comforting one, for it refers to a traditional form of rural labour and to a traditional female role. The woman's dress and her apparent leisure – for she seems able to afford to catnap – identify her with a class somewhere between the haggard peasant and the excessive bourgeoise. Although the task is repetitive, it can lull its performer to peaceful slumber. Indeed, the large spindle on her lap has been interpreted as phallic; sleep is not just the result of fatigue but a welcome escape into fantasy, as well.

The theme of spinning and weaving was not without a history in art, and in this case that history may be relevant. Velázquez's famous *The Weavers* represents the myth of Arachne, who made such a convincing facsimile of the goddess Athena that she was punished by being turned into a spider. Velázquez makes a play on the parallel between tapestry and painting by using a painted tapestry to represent the myth. In *The Sleeping Spinner*'s chair upholstered with fabric, in her striped shawl and in her flowery dress Courbet represents the results of a handicraft not so far from the painter's own art. The generosity with which he has massed his paint, the harmoniousness of his colours and the warmth of atmosphere he has created call attention to painterly virtues. In this scene, then, Courbet represents labour *cum* art, that is comparing and linking the two directly, a theme that would become of central concern to him in the near future.

Among the visitors to the Salon of 1853 was a young banker's son from the southern city of Montpellier named Alfred Bruyas (1821–77). Bruyas fancied himself a patron of the arts, and his head was swimming with utopian ideas that included the widespread notion of the leadership role of artists in bringing about social transformation. Social theorists since Henri de Saint-Simon

(1760–1825) believed that artists, along with industrialists and scientists, were beings whose vision made them a force for change. The three groups would constitute a new trinity for a modern priesthood in a now secular world, leading humanity towards a bright future. The word 'avant-garde', derived from military termin-ology (in English, 'vanguard'), refers to the spearhead or leading wave in historical developments which many historians and social theorists regarded as inevitable. Bruyas possessed a collection of contemporary art based mainly on commissioned works, including many portraits of himself. But when he saw Courbet's *The Bathers*, he instantly recognized what he called an example of artistic freedom. He purchased the picture along with *The Sleeping Spinner* and immediately became Courbet's close friend and most important financial resource by offering him several further commissions.

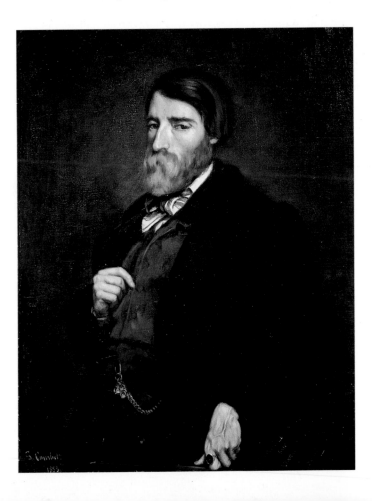

78
Portrait of Alfred Bruyas, 1853.
Oil on canvas; 91×72 cm, 35¾×28⅜ in.
Musée Fabre, Montpellier

In a portrait Courbet made of Bruyas (78) in 1853 the new patron is shown with his hand leaning purposefully on a book entitled *Modern Art. Solution.* Bruyas is dressed as the successful bourgeois, yet the face is a bit sallow and the eyes give him a tentative look. Perhaps Courbet was trying to convey some sense of a thoughtful and sensitive man behind the ambitions he and Bruyas shared. Bruyas manifested these ambitions through writings on art as well as through collecting. The theme of his writings was to show how art could be 'the solution' – a common phrase in contemporary social theory – to the social problems of his time. His solution lay in Realism – an honest, unaffected vision that was the prerequisite to progress and the basis for education.

It was around this time that Courbet began to refer to his paintings as belonging to 'series'. For example, *The Stonebreakers* and *The Peasants of Flagey Returning from the Fair* belonged to a 'roadside' series, in which he now planned, though never executed, another work showing a Gypsy woman with her children along the roadside. 'Seriation' as it was called by certain theorists was a mode of reasoning central to the analytical propositions of Fourier as well as to the writings of Proudhon, for it was a way of discerning patterns from among various forms of data. For Courbet it must have been a way of introducing an ostensibly scientific method to the art of painting, since its emphasis on comparison and on the discovery of similarities might be regarded as a particularly visual form of reasoning. In any case, Courbet's use of the concept implied an underlying rationale to his choices of subject and was also meant to appeal to the utopian idealism of Bruyas. In the years following the Salon of 1853 Courbet continued to paint themes from rural life. During the winter of 1853-4 in Ornans he made a large picture called *The Grain Sifters* (79), which he called a sequel to *The Young Ladies of the Village.* The painting also complemented *The Sleeping Spinner* as a representation of the domestic labours of rural women. As in *The Young Ladies* the models for the figures were Courbet's sisters. Their dress is simple without being poor or tattered; the main figure wears a little yellow scarf. With the boy (whom some have seen as Courbet's six-year-old illegitimate son) looking into the

cupboard of a mechanical device for cleaning grain, the cat curled up and the relatively confined space, the scene is certainly domestic. It probably depicts the preparation of grain that will be used for baking the family bread. The strong central figure, holding high the large sieve, is as close to a heroic labourer as Courbet would ever get. Eschewing the Rembrandtesque drama of Millet to which he himself had once been partial, Courbet's lighting here is even and clear, except where shadow produces bold modelling, as in the sifter's rust-coloured dress. Courbet seems far less interested in overtly playing on emotions than in matter-of-fact historical testimony.

Probably around this time Courbet began a painting called *Preparation of the Dead Girl* (80), a complex composition which again focused on rural customs. The painting was left unfinished and was long thought to represent bridal preparations because of a false title it was given and alterations performed on it that were meant to facilitate its sale after Courbet's death. In reality, it shows preparations for a wake. X-ray photographs reveal that the main figure was originally nude. Her feet are being washed and her hair is being coiffed. The mirror propped up against her arm enables the woman behind her to see the results of her efforts. The burial cloth is being prepared on the left side of the painting; on the other side flowers are being arranged and the table is being set. The unfinished state of this painting helps us to see how Courbet painted directly with colour on to his dark ground. There are several reasons why Courbet may not have finished the composition. For one thing, it was complex, and it may have been giving him trouble. We have already seen how difficult it was for him to integrate figures into their spatial setting, a problem exacerbated by a method that disregarded meticulous preparation. For Courbet rarely made preparatory drawings. With as many figures as the composition demanded, the task of creating a coherent structure must have been more frustrating than usual. But at the same time Courbet was distracted by projects that were involving him and by Bruyas, to whom he was writing frequently and whom he visited in Montpellier from May to September 1854.

79
The Grain Sifters,
1854–5.
Oil on canvas;
131×167 cm,
51⅝×65¾ in.
Musée des
Beaux-Arts,
Nantes

In several letters to Bruyas, Courbet had been further elaborating his ideas on art. Moreover, he wanted to hold an exhibition in Paris with Bruyas's financial backing. The incentive for Bruyas would have been to exhibit his own collection along with Courbet's work. The idea for the exhibition came when Courbet was invited to lunch by the Chief of the Beaux-Arts Administration of the government, Count Alfred-Emilien de Nieuwerkerke (1811–92). Nieuwerkerke wanted to commission a painting from Courbet for the forthcoming Universal Exposition to be held in 1855. However, he also wanted Courbet to soften his radicalism, and he expected him to follow the standard practice of submitting a preliminary sketch for approval. In a famous account to Bruyas of this luncheon, Courbet described his outraged reaction:

I immediately answered that I understood absolutely nothing of all that he had just told me, mainly because he claimed to represent a Government and I felt myself in no way included in his Government, that I was a Government, too, and I challenged his to find something it might do for mine that I might find acceptable.

I added that I considered his Government to be the equivalent of any private person, and that if my pictures pleased him, he was free to purchase them. I said I would ask only one thing of him: that he grant art its freedom in his exhibition, and that he not use his 300,000 francs to support 3,000 artists against me.

I added that I was the only judge of my painting, that I was not only a painter but a man, that I had been painting not in order to make art for art's sake, but to accomplish my intellectual freedom and that I had succeeded through the study of tradition in freeing myself from it; and that I alone, of all my contemporaries among French artists, had the ability to express and to translate in an original manner both my personality and my social environment.

The link between this statement and the words he had earlier written to Silvestre is obvious, except that these words, especially those of the last paragraph, are even closer to Courbet's later *Realist Manifesto* of 1855. In addition to the theme of independence and

80
*Preparation [...]
the Dead Gir[...]
c.1850–5.
Oil on canv[...]
188×251·5[...]
74×99 in.
Smith Colle[...]
Museum of [...]
Northampt[...]
Massachuse[...]

manhood, Courbet now made the expression of his environment a central part of his artistic aim.

Given the government's attempt to exercise control, Courbet's primary insistence on the theme of independence from government is understandable. One can only be a man when one is master of one's own fate – in contrast to the dependent status most nineteenth-century males would have attributed to women and children. The comparison between governments and private persons is straight out of Proudhonian theory, which certainly bolstered Courbet's sense of self-confidence and importance. However, Nieuwerkerke's attempt to win over the painter had encouraged that attitude as well, and Courbet now decided to act like a government, that is, to set up an exhibition of his own. For this enterprise, he believed he needed Bruyas's partnership. He told Bruyas: 'You have in your hands the means that I have always lacked and will always lack. With your background, your intelligence, your courage and your financial means you can save us in our lifetime and allow us to enter a new era.'

In Courbet's next letter to Bruyas, he became more practical, discussing rental of a site for an exhibition across from the Universal Exposition grounds and the construction of a tent-like structure topped with a banner (81). He hoped an 'Exhibition of paintings by master Courbet from the Bruyas collection' – his proposed title –

81
Letter to Alfred Bruyas showing a drawing of an exhibition tent, Ornans, January 1854. Bibliothèque d'Art et d'Archéologie, Fondation Jacques Doucet, Paris

82
The Bourgeois of the Town Speaking to the Wandering Jew (detail), 1850s. Woodcut in Jules Champfleury's *Histoire de l'Imagerie populaire*, 1869

would make Paris stand on its head and earn 40,000 francs to boot. Courbet began to see everything in the light of this project. He must have known that one of the principles underlying Bruyas's collection was autobiography – hence Bruyas's many commissions of his own portrait – and so he described his own self-portraits as an autobiographical series too. The *Man with Pipe* (see 30) was especially important, for he now saw it as 'an awesome element in our solution' since it showed a man who 'seeks to live by his own principles'. But that was reading back into an older painting. Now, he said, 'I have only one more [self-portrait] to make, that of a man sure of his principles, that is, a free man.'

The Meeting (with Bruyas and his valet; 83), sometimes known as *Bonjour, Monsieur Courbet* (and sometimes mocked as 'Fortune bowing before Genius'), is one of Courbet's most fascinating pictures. On one level it transcribes the experience of summer light in the South of France. Its luminosity and rich, gestural handling of paint are forerunners of Impressionism and offer a more pleasing version of Courbet's so-called 'rustic' handiwork exhibited in his earlier art. The painting also embodies a programme that reveals a great deal about Courbet's self-conception at this moment. As art historian Linda Nochlin discovered, the composition of the group is based entirely on the lower left-hand corner of a popular print showing *The Bourgeois of the Town Speaking to the Wandering Jew*

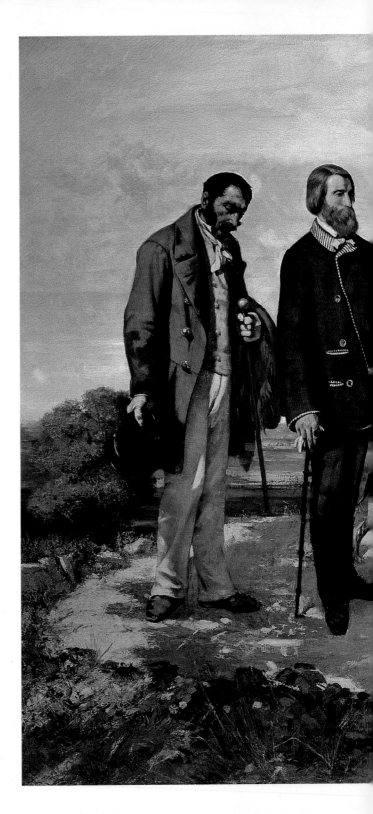

83
The Meeting,
or *Bonjour,*
Monsieur
Courbet,
1854.
Oil on canvas;
129×149 cm,
$50^3_4 \times 58^5_8$ in.
Musée Fabre,
Montpellier

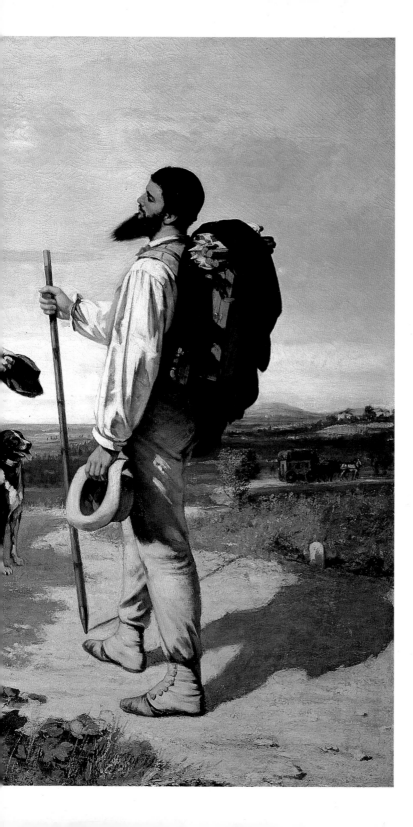

(82). The Wandering Jew was a legendary folk figure who had been much popularized through Eugène Sue's play on the subject which appeared in 1844. The theme inspired an opera by Fromental Halévy in 1852. Their stories emphasized the perennial outcast and victim of persecution, a role in which Courbet could easily cast himself. Yet the Wandering Jew had an additional particularity: condemned to eternal wandering for mocking Christ on the road to Calvary, he was the only surviving witness to his time. The idea of leaving 'realist' testimony to posterity was thus inherent in the Wandering Jew theme. It is for that reason that, despite meeting the Jew outside the city gates, the village leaders had matters of profound concern as the basis of their interrogation. In addition, Courbet had already used the figure of the Wandering Jew himself as the model for his *Portrait of Jean Journet* and the print that followed it (see 62).

Most of all, the theme of independence underlies Courbet's conception of *The Meeting*. With his painting gear on his back, Courbet exemplified the tradition of the travelling artisan, such as journeymen or the so-called 'compagnons' who went from town to town practising their unique crafts. The 'compagnon' movement in the 1840s was an idealistic revival of ancient practices which attempted to maintain the independence of labourers. Members contacted others from the group as a support network when they arrived in town. Their status as artisans alluded to Courbet's self image as worker-artist or master-painter – recall his use of the word 'master' in the proposed title of his exhibition with Bruyas. The term 'master-painter', with which Bruyas frequently referred to Courbet, was derived from the tradition of the craft guilds. Its artisanal connotations reflect a refusal of the more spiritual aspirations of the newer Romantic term 'artiste'. Courbet's confident pose as a man 'sure of his principles' is epitomized by what he termed his 'Assyrian profile', with its self-assured bearing of the head and pointed beard, as if alluding to himself as a kind of nomadic primitive making a monumental art reflecting his own epoch. Even before leaving for Montpellier, Courbet had thought about the encounter with Bruyas. In anticipation of his arrival, he wrote: 'Yes, my dear friend, in my lifetime I hope to realize a unique miracle. I hope to live by my art

all my life without having ever departed an inch from my principles, without having betrayed my conscience for a single moment, without having made a painting even as little as a hand to please anyone or to be sold.' And now, Courbet exclaimed, 'I am right, I am right! I have met you. It was inevitable because it is not we who encountered each other, but our solutions.' For Courbet, then, *The Meeting* represented far more than the encounter of two individuals and it went far beyond the narcissism suggested in Quillenbois's caricature (84), captioned: 'The adoration of M. Courbet, a realist imitation of the adoration of the Magi.' He and Bruyas personified sets of principles or, better, roles. When brought together they could save the independence of art, and ultimately the world.

84
Quillenbois,
Caricature of
The Meeting.
L'Illustration,
21 July 1855

L'adoration de M. Courbet, imitation réaliste de l'adoration des Mages.

The summer spent with Bruyas was an exhilarating working vacation. Always gregarious, Courbet won many hearts by mastering the game of pall-mall, which resembles modern croquet. He also seems to have flirted with the ladies. Besides discussing his many plans with Bruyas, Courbet made more portraits of him and of other local patrons with whom he enthusiastically socialized. He also did some landscapes for Bruyas's friend Sabatier, the admiring critic, with whom he now began a warm friendship. He really was now making a living from his work alone. If *The Meeting* does in fact represent an

actual event, it might thus be a picture of Courbet's return from a session of painting outdoors. Most unusual among the works made during such campaigns was a seascape he painted for Bruyas at Palavas, on the Mediterranean coast (85). It is an early example of Courbet's technique employing almost exclusively the palette knife, which he used to spread the medium in horizontal coloured bands across the canvas. Here the sense of Courbet's technical process is particularly satisfying, rather than disconcerting as it had been for so many critics of his earlier work. In the painting he represented a figure doffing his hat to the sea. A biographer who knew Courbet

85
The Sea at Palavas, 1854.
Oil on canvas; 27×46 cm, 10⅝×18⅛ in.
Musée Fabre, Montpellier

affirmed later that it was none other than the artist shouting: 'Oh Sea! Your voice is formidable, but it will never drown out the voice of fame as it proclaims my name to the entire world!' Even if the story is apocryphal, it speaks of Courbet's sense of self-confidence and optimism at having found a supporter like Bruyas. And it also reveals the enormous ambition they both shared through their belief in the redeeming and revolutionary purpose of art. Courbet was now full of himself as the saviour of both art and society. His next step would be to elaborate that role in much more explicit detail.

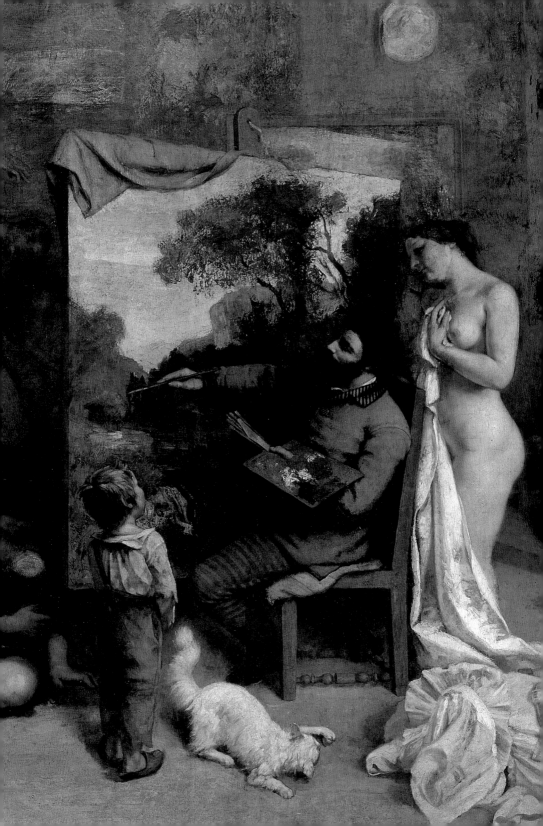

Few paintings are so central to the history of modern art as Courbet's *The Studio of the Painter* (87). Its image of the independent artist at the centre of all society stood for the ideal of individual freedom that most people admire in art, as did Courbet's own audacity in painting it. Yet it is worth remembering that Courbet created this mythic role for the artist following a series of paintings in which he stressed the mortality of humans and catalogued their particularities in various social conditions. So, despite its grandiose gesture and transcendent philosophy, *The Studio of the Painter* represents a compensatory myth for the limitations of modern man.

86
*The Studio
of the Painter*
(detail of 87)

Even bigger than *A Burial at Ornans*, *The Studio of the Painter* was first conceived as a powerful statement for the Universal Exposition and was to become the centrepiece of the private exhibition Courbet had been planning with Bruyas. When both paintings were rejected from the Universal Exposition, probably for reasons of excessive size, almost all of his other submissions having been accepted, Courbet knew he would have to go through with his one-man show. He rented a site right opposite the fairgrounds, for which he managed to get government approval, and he also obtained permission to charge for entry.

Precedents for paid admissions to private exhibitions were rare, and these in any case could only be brought off by artists already very much in the public eye, for they relied on the ability to attract a large enough audience to be profitable. Moreover, they also served to enhance the artist's notoriety and further undermined the traditional patronage system. Another factor possibly motivating Courbet's effort was that charges for *public* exhibitions were beginning to be implemented, opening the way to private exhibitions like Courbet's, which could not have survived without entrance fees. So the painter hired an architect friend to construct an iron, brick and

87
*The Studio
of the Painter*,
1855.
Oil on canvas;
361×598 cm,
$142\frac{1}{4}×235\frac{5}{8}$ in.
Musée d'Orsay,
Paris

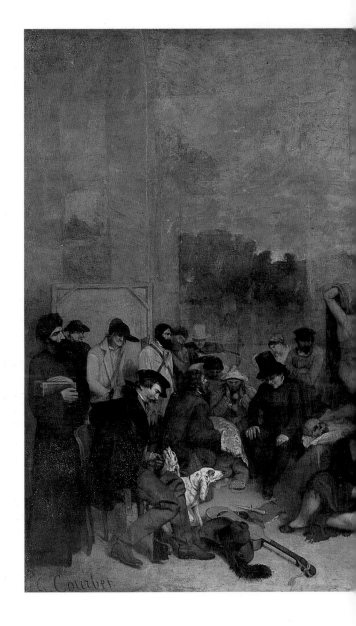

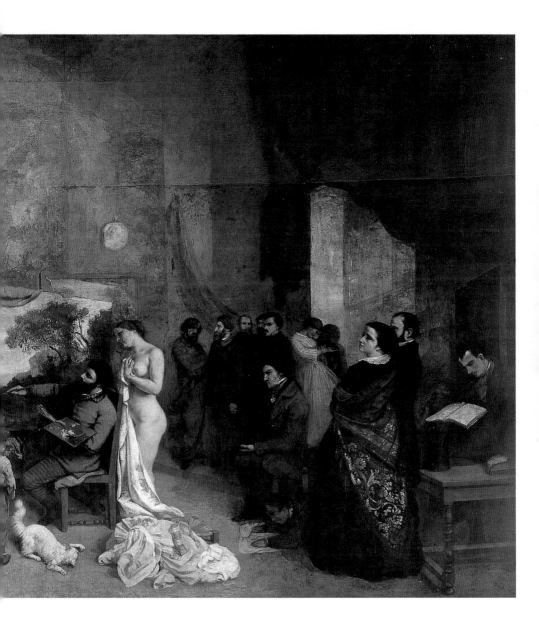

mortar pavilion in a lilac garden – Courbet referred to it as a
'temple' – rather than raising a tent. Between his exhibits as part
of the Exposition and those of his private show, Courbet would have
far more paintings on view than any other artist.

Short on time, Courbet's preparations for *The Studio of the Painter*
consisted primarily of rounding up images of those he wanted to
include. He asked Bruyas to send up to Paris one of the portraits he
had made of him in Montpellier along with its companion, the *Self-
Portrait with Striped Collar* (88), on which Courbet had already
based his own profile in *The Meeting*. He also requested a photo-
graph of a nude, undoubtedly another one by de Villeneuve (89). He
probably had many portraits in the studio or nearby, such as the
one he had just made of Champfleury (90). In all there were thirty
figures, including the artist. *The Studio of the Painter* is thus another
programmatic self-portrait, far more elaborate than *The Meeting*, but
incorporating its triumphant ideas by reusing the same 'Assyrian'
self-portrait view. Its official title was *The Studio of the Painter: A
Real Allegory Determining Seven Years of My Life as an Artist*, one
that clearly indicated both didactic and autobiographical intent.
Most of the figures are arranged on either side of the central group
(86), in which a nude model (based on the photograph) stands
behind the artist and a Franche-Comtois peasant boy gazes in
rapture at the painting on his easel. The central group thus divides
the painting into two sections, or three, if we count it as a section on
its own. Courbet wrote two detailed letters about the painting, iden-

88
*Self-Portrait
with Striped
Collar*, 1854.
Oil on canvas;
46×38cm,
18⅛×15in.
Musée Fabre,
Montpellier

89
Julien Vallou
de Villeneuve,
Standing nude
model with
drapery,
c.1854

90
*Portrait of Jules
Champfleury*,
1854.
Oil on canvas;
46×38cm,
18⅛×15in.
Musée d'Orsay,
Paris

tifying many of the figures and explaining their reasons for being in the composition. His letter to Champfleury provides the most detail:

[*The Studio* is] perhaps even larger than the *Burial*, which will show that I am not dead yet, and nor is Realism, since Realism is a fact. It is the moral and physical history of my workshop, first stage; there are those who serve me, who support me in my idea, who participate in my action. There are those who live on life and who live on death. It is society at its top, bottom and middle. In a word, it is my way of seeing society in its interests and its passions. It is the world come to be painted at my place. You see that the picture has no title [*ie*, there is no story or explicit subject matter]. I shall try to give you a more exact idea of it through a dry description. The scene takes place in my atelier in Paris. The painting is divided into two parts. I am in the middle, painting. To the right are all the shareholders, that is to say, friends, fellow workers and amateurs from the art world. To the left is the other world of the trivial life, the people, misery, poverty, wealth, the exploited, the exploiters, people who live on death … I will list the characters beginning at the extreme left. At the edge is a Jew I saw in England making his way through the febrile activity of the London streets, religiously carrying a money-box on his right arm; while covering it with his left hand he seemed to be saying, 'It is I who am on the right track' … Behind him is a priest with a triumphant look and a bloated red face. In front of them is a poor withered old man, a republican veteran of '93 … , a man of ninety years, holding his ammunition bag, dressed in old white linen made out of patches and a visored cap. He looks down at the romantic cast-offs at his feet. (He is pitied by the Jew.) Next come a hunter, a reaper, a strong-man, a buffoon, a textile peddler, a workman's wife, a worker, an undertaker, a death's head on a newspaper, an Irishwoman suckling a child, an artist's dummy … The cloth peddler presides over all of this: he displays his finery to everyone, and all show the greatest interest, each in his own way. Behind him, lying in the foreground, are a guitar and a plumed hat.

Second part. Then comes the canvas at my easel with me painting it seen from the Assyrian side of my head. Behind my chair is a nude female model. She is leaning on the back of my chair to watch me paint for a moment. Following this woman come Promayet with his violin … Then

behind him are Bruyas, Cuenot, Buchon, Proudhon (I would like to have the philosopher Proudhon who is of our way of seeing; I would be pleased if he would pose. If you see him, ask if I can count on him). Then it is your turn towards the foreground of the composition. You are seated on a stool, legs crossed and a hat on your lap. Next to you and closer to the foreground is a woman of the world and her husband, both luxuriously dressed. Then towards the extreme right, sitting on the edge of a table, is Baudelaire reading a large book … [But] I have explained it all to you quite badly. I started on the wrong side. I should have begun with Baudelaire, but it would take too long to start again. You'll have to understand it as best you can. The people who want to judge will have their work cut out for them, they will manage as best they can.

The figures to the right (91) were the easiest for followers of Courbet to recognize, for there are many of his friends and supporters, and in most cases they were based on portraits he himself had already made. Starting behind the nude model, moving from left to right, is Alphonse Promayet, the musician from Ornans who had given lessons to the painter's sisters and was shown playing the violin in *After Dinner at Ornans*. Next is Alfred Bruyas, looking to our left. To the right of him is Pierre-Joseph Proudhon, of whom Courbet had not yet made a picture and who, despite Courbet's wish, did not have time to sit for him. Courbet therefore obtained a lithograph made by Charles Bazin in order to get his features right. After Proudhon is Urbain Cuenot, the home-town friend whose politics had led to his arrest in 1851 and subsequent exile. His head is half-hidden by that of another boyhood chum, the Realist poet Max Buchon. Seated directly below Buchon is Jules Champfleury, to whom Courbet was writing and whom he may well have given a prominent position in the painting because he hoped he would be his spokesman. Behind Buchon are a couple of lovers who have not been satisfactorily identified. I suspect the woman may be Courbet's estranged mistress, Virginie Binet, who had given birth to Courbet's son but who at this very time had announced she was marrying another man. Continuing to the right are the prosperous couple probably identifiable as François Sabatier, the Fourierist critic who had admired the *Burial*, and his wife, the singer Caroline Sabatier-

91
The Studio of the Painter
(detail of 87)

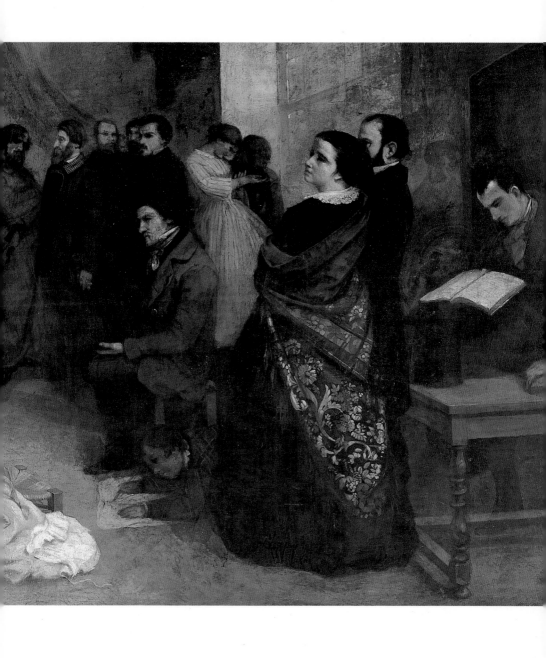

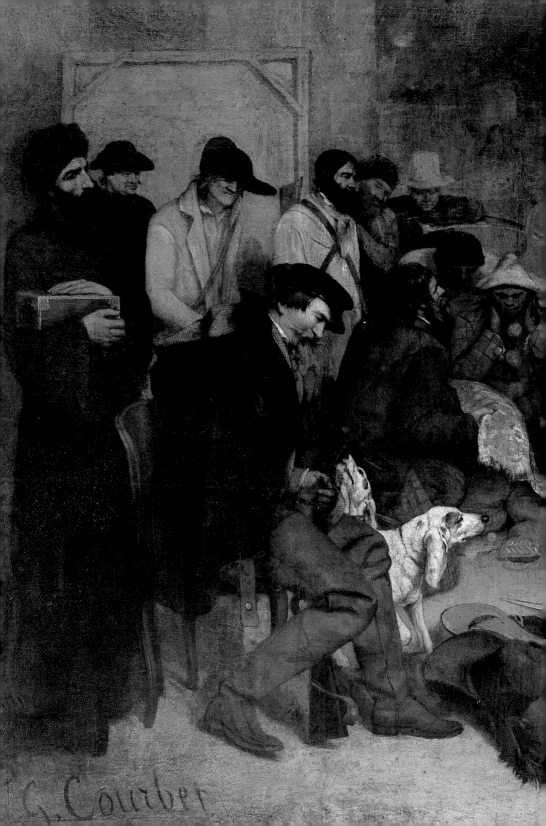

Ungher, both of whom were Courbet's patrons. Finally, a bit removed to the far right, is Charles Baudelaire, based on Courbet's portrait of a few years before. Courbet had also put in Baudelaire's mulatto mistress, Jeanne Duval, but Baudelaire got him to paint her out. (Some traces of the figure are still visible.)

Courbet's reference to all these people as 'shareholders' in his enterprise suggests they had supported and invested in him both intellectually and in some cases monetarily. Courbet's allusion to Proudhon deserves particular attention. We saw how Courbet's attempts to articulate his ideas reached a crescendo in the letters to Bruyas and how they were informed by many of the utopian ideals that had been in the air for years. Yet Proudhon is the only social thinker to whom Courbet gave a position in this painting at all. What Courbet did not come right out and say was that Proudhon's *Philosophy of Progress* had given him the idea for the left side of his painting (92). This book contained Proudhon's first practical references to the role of art in society – his lines on *The Bathers* which we earlier reviewed. In the preface Proudhon appealed to all elements of society to work together 'to recommence our social and intellectual education' in order to be 'governed by science' rather than 'fatality'.

92
The Studio of the Painter
(detail of 87)

93
Napoleon III
in the 1860s

He was particularly opposed to Napoleon III's foreign policy, which he believed encouraged a kind of nationalist fragmentation that would benefit international capitalism at the expense of European unity and the best interests of humanity. In 1853, the year Proudhon's essay was published, France had entered the Crimean conflict, taking the side of Ottoman Turkey against the Russians. War was officially declared in 1854 and financed by government-backed loans. An examination of the figures to the left of the central group in *The Studio* will show how Courbet has assembled the whole range of social ideologies and nationalisms in order to present them with the uplifting educational lesson embodied by the artist at work. Not only were his old pacifist leanings re-emerging; for him, art was a better means for resolving conflict than was war.

At the great Courbet retrospective exhibition held at the Louvre in 1977–8, the centennial of Courbet's death, curator Hélène Toussaint

for the first time identified most of the figures to the left of Courbet's composition. Since Courbet did not refer to them by name in his letters, we must surmise that he was using those particular individuals not as themselves but to embody ideals or principles to which he alluded in his letter to Champfleury. Moving again from left to right, this time beginning at the far edge of the painting, the figure of the old Jew was based on Achille Fould, the Minister of State in Napoleon III's government (and the man who had given final approval for Courbet's exhibition). Fould was a prominent Jewish banker who was instrumental in the Second Empire's industrial expansion, of which the Universal Exposition (94) was supposed to be a showcase. The priest, under the traits of the ultra-royalist Catholic journalist Louis Veuillot, stood for the traditional Catholic bourgeoisie. Both figures are presented more or less as rural viewers would have seen them through their ingrained anti-Semitism and anti-clericalism. The identity of the next figure has not been entirely settled, but this 'republican of '93' to use Courbet's term, surely stood for the persistent ideals of the French Revolution. The four male figures in the back row have been identified as Giuseppe Garibaldi, Lajos Kossuth, Thaddeus Kosciuszko and Michael Bakunin. The first three represent Italian, Hungarian and Polish insurrectionary movements that hoped to be encouraged by Napoleon III; the fourth was a Russian anarchist who was a promoter of Slavic nationalism and rebellion. The woman next to them has been connected to a Romanian independence movement. The strongman (source not identified) looks Turkish; the clown, based on a figure by Pisanello, refers to Asia. The Irishwoman and her child refer to the British Isles and the social conditions engendered by the Industrial Revolution which had occurred there first, as well as the great Irish potato famine of the mid-1840s. Other figures are more closely related to domestic issues: the undertaker looks like a certain journalist (Emile de Girardin) and the textile peddler like a politician (the Count de Persigny, who was Napoleon III's Minister of the Interior), both of whom could be viewed as notorious opportunists. Finally, the hunter, the most prominent figure on its side of the composition, is clearly Napoleon III himself (93).

Contemporary references to this figure as a poacher no doubt allude to Louis-Napoleon's poses as a reformer prior to his election in 1848 and to the way he 'stole' the government from the people by the *coup d'état* of 1851. But Courbet was not burning his bridges; for the general viewer these allusions were well disguised.

Despite the overabundance of detail in his letter, and the wealth of information we now possess, Courbet appears deliberately cryptic when coming to an overall interpretation of *The Studio of the Painter*, providing only a few clues. We still have a great deal to reconstruct. Courbet seemed to enjoy the idea that future 'judges' would have their 'work cut out for them'. It was the 'moral and physical' story of his atelier, 'first stage'; it was society at its various levels; it was 'the world come to be painted' at his studio. To another friend, he wrote: 'Perhaps you would like to know the subject of my painting. It will take so long to explain that I want to let you guess when you see it. It is the story of my atelier, what goes on there morally and physically. It is fairly mysterious, it will keep people guessing.' Thanks to Courbet's use of Proudhon, we can understand at least that the common thread linking the figures to the left is that they are all living in the past. That is why they are associated with the artistic 'romantic cast-offs' such as the guitar, dagger and plumed hat in the foreground, and the death's head, as well as the

94
Galleries built for the 1855 Universal Exposition of Fine Arts. L'Illustration, 1855

outmoded academic mannequin just behind Courbet's easel. Their ideas are exclusive, divisive and conflicting, and had led humanity to its current political and economic impasse. Thus, Courbet certainly gave the lie to the glory the Universal Exposition was supposed to uphold. But he also used the occasion to expose his alternative, for the Emperor as well as visitors from around the world to see.

Courbet referred to the left of his composition as the 'first part'. With the 'second part' he introduced himself and his supporters, implying a sequence in which the next stage of history would be exemplified by the rest of the painting. In this stage the problems arising from the society on the left must be harmoniously resolved. The figures to the left even by their disjunctive arrangement suggest the chaos of the present world, whereas the greater spatial coherence and focus of the right side of the painting, and its relationship to the central group, lead to a visual sense of resolution. The concept of stages of development in human history was a commonplace in current social theory, as was the belief that progress towards the final stage was inevitable – simply a matter of time. From Johann Gottfried von Herder to Friedrich Hegel, German philosophers had accepted the notion that history moves not in cycles but through various stages towards an ultimate direction. The most important French historian of the first half of the nineteenth century, Jules Michelet, presented humanity as a self-creating force. His *History of the French Revolution* (1847–53) held that the democratic will of the French people was ultimately irresistible, and he followed its expression through innumerable documents of everyday life. Michelet's contemporary, Count Alexis de Tocqueville, saw all human history in terms of this ineluctable evolution towards democracy, which he studied closely in the famous *Democracy in America* (1835–40). These underlying beliefs in a dynamic rather than static world provided the ground for social theories that described the final (democratic, most of them believed) phase of social development with utopian terms such as Harmony, Humanitarian, or Positivist. Indeed, Positivism, which in the next chapter I shall relate to the general attitude underlying Realism, was also a particular theory of society advocated by the eminent scientist-turned-philoso-

pher Auguste Comte in his *Course on Positive Philosophy* (1830–42). Comte described three phases (following Hegel) of social evolution, which he labelled the Theocratic, the Monarchic and the Positivist. Like Hegel, Comte believed that each stage had its own particular cultural forms. Proudhon, who had been profoundly affected by certain followers of Hegel he had met in Paris in the 1840s, adopted a similar scheme for his analysis of the history of art in order to argue that Realism was the appropriate artistic form for democratic society. Comte had always insisted that the impartial observation of reality practised by science had a social purpose; Proudhon's thesis for art was identical, and in his assessment of Courbet he specifically compared the painter's approach to Comte's.

What interested Courbet in such theories, of course, was the role of art. His statement that all the world came to be represented through his studio suggests how he took all of reality as his raw material and 'processed' it in a way that would catalyze future historical flow. We know that the concept of avant-garde called on artists as prophets, thanks to their visionary powers. In his letters to Bruyas, Courbet was elated by the belief that art could transform the world. As art historian Klaus Herding has pointed out, the great Romantic and liberal poet Victor Hugo (1802–85) had given this notion an internationalist twist in a poem of 1851 entitled 'Art and the People'. Hugo hailed art as the 'thought of mankind/Which can break any chain!/Art is the sweet conqueror!' and he named suffering nations such as Poland, Italy and Hungary – as would Courbet. In *The Studio*, then, the painter tried to use his own evolution as a specific and exemplary demonstration, for all to behold, of how artistic leadership would benefit the entire world.

Writing to Bruyas in March 1855, just before the opening of the Universal Exposition, Courbet referred to his own development as having two phases. The first could be represented by *The Stonebreakers*, the *Man with Pipe* and *A Burial at Ornans*. The second was embodied by *The Meeting*, the *Self-Portrait with Striped Collar* and *The Studio of the Painter*. *The Studio*'s title refers to 'seven years of my life as an artist', indicating that while embodying

the latest phase – that of self-consciousness – the painting was to show how that phase had evolved from the earlier one. Seven years takes us back to 1848. The remark in the letter to Champfleury that he should have begun his explanation with Baudelaire takes us back to the same year, too. Recall that in 1848 Courbet hoped to become the representative in painting of a new school of thought. The liberating effects of the political revolution certainly encouraged that direction, and he began his first Ornans subject, *After Dinner at Ornans*, to be followed by *The Stonebreakers* and the *Burial*. Baudelaire had been a major presence in his activities at this time. In the *Burial*, which the painter called his 'début' and his 'statement of principle', he represented the black dress of modern life which Baudelaire extolled in his *Salon of 1846*, and he expressed the material nature of human existence by representing death as burial in the ground rather than apotheosis of the soul to heaven. In addition, 1848 was the year Baudelaire and Courbet had both become interested in Proudhon's ideas. Recall that Baudelaire had copied some lines from *System of Economic Contradictions, or the Philosophy of Poverty*, in which Proudhon held that art was an ideal form of labour through which human virtue became manifest. As society evolved, all labour would tend towards the aesthetic.

Proudhon's ideas provide essential insights into the process Courbet envisioned himself performing at the centre of *The Studio*; they also illuminate Courbet's emphasis on the notion of manhood (in this case, manhood as 'humanhood', for the moment suspending the issue of gender). Proudhon's formulation built on concepts adapted from Hegel and his younger followers as well as from utopians such as Charles Fourier. However, Proudhon himself was the most obvious point of contact with social theory for Courbet – the one immediately recognized by the public – and he was the figure present in *The Studio*. Proudhon's theories posited that man by his very nature is a working animal, a being whose material nature determines his physical destiny: 'Work is the first attribute, the essential characteristic of man.' Proudhon shared this idea with the young Karl Marx, who also spent time in Paris during the 1840s. Unlike that of other beings, man's labour is the expression of his mind's ability to create: 'Man is

a worker, that is to say, a creator and a poet.' Ultimately, man's work enabled him to liberate himself from material existence in order to approach the spiritual: 'Man [becomes] God's rival ... ; he speaks, he sings, he writes, ... carves and paints images, ... he appropriates and assimilates nature.' On Hegel's model, Proudhon thus recast traditional notions of morality in the mould of the day-to-day realities of human existence. For him, the tension in human nature between the physical and the moral, between desire and aspiration, between base need and the potential to rise above it, underlay the entire human economic edifice, for it explained the work drive. Courbet's remarks about the moral and physical in his studio may derive from such thinking. His earlier claim to be living the life of an ascetic may confirm it.

The connection Proudhon made between art and economics is not simply that labour is involved in art production but that labour is the expression of human virtue, always striving to rise above the material, in a sense to rival God. For him, economic value was to be based on moral worth. (That is why property was theft.) He wrote: 'Art, born of work, is necessarily founded on its utility and corresponds to a drive ... Every worker must become an artist in the speciality he has chosen.' Work was the means of taking possession of one's freedom; religion was oppressive, and art, as the ideal result of labour, was the expression of liberation.

At this point one should recall how at the root of *The Studio of the Painter* and related exhibition projects lay Courbet's preoccupation with patronage. Proudhon's ideas allowed Courbet to transform such personal concerns into universal theory, providing an antidote for his feelings of dependency. Courbet's choice of the workshop as the place where the world would come before him makes sense when we consider the notion of man as a labouring being. It is interesting to note that Proudhon believed the workshop was the true locale for education. In *The Studio of the Painter*, for the first time in any publicly exhibited self-portrait (there is only one precedent, in an early charcoal drawing), Courbet showed himself engaged in producing a painting – or at least he is posing as the painter painting.

Despite references by critics to Courbet as a 'worker-painter', Courbet himself had never overtly appropriated that concept for his visual persona until *The Studio*'s self-portrait became the centre-piece of a visual enactment of the meaning of his art. The historical stages of development which Courbet's tripartite structure implied also take on a certain logic when viewed with the help of Proudhon's ideas, for they suggest how the artist could exemplify society's highest attainment. In attributing this role to himself personally, of course, Courbet went so far beyond anything Proudhon had imagined that the philosopher was a bit annoyed: Courbet seemed to be taking him literally for the purposes of self-aggrandizement.

Yet the artist at the centre of *The Studio* is dressed as a successful bourgeois rather than a lowly artisan. His bearing is proud rather than humble. Turning away from the naked model, Courbet has located his activity within the image of a Franche-Comtois landscape – he is framed by the painting on his easel. Behind him on the floor is a child who appears to be drawing from life. Gazing into the landscape in the foreground is another little boy who seems totally convinced by Courbet's Realism. These children, with their naïve rather than conventionalized vision, provide a confirmation of Courbet's authenticity. Even the playful cat, an animal often associated with artistic liberty, and a favourite pet of Baudelaire, participates in the creative ritual. It has often been observed that Courbet devoted much more attention to making this central group's presence in the painting realistic than he did to the rest; the personages on either side are relatively thinly painted and dimly lit. Delacroix was struck by what looked like a 'real sky' in the middle of the painting. He felt that effect called into question the realism of the remainder. In that way Courbet enhanced the feeling that the landscape he was working on was both an authentic vision of nature and a physical object produced by labour. He represented himself both literally appropriating nature, as Proudhon would say, and living from his work.

In his ability to survive independently thanks to his patrons, Courbet exemplified not just the free artist but the liberated human being. As such, Courbet felt well suited to set the example for society in

95
Francisco de Goya y Lucientes, *Portrait of the Family of Charles IV,* 1800–1. Oil on canvas; 280×336 cm, 110$\frac{3}{8}$×132$\frac{3}{8}$ in. Museo del Prado, Madrid

96
Rembrandt van Rijn, *La Petite Tombe* or *Christ Preaching the Remission of Sins,* c.1652. Etching; 15.5×20.7 cm, 6$\frac{1}{8}$×8$\frac{1}{8}$ in

general, and for the Emperor in particular. If society would follow Courbet, it would be saved. So not only has Courbet placed himself at the centre of society as one who had attained its highest point but, as art historian Klaus Herding has shown, he has adopted the position of the lesson-giver. Artistic exhortations to the ruler had a long tradition, especially in literature. Generally the presence of the ruler in images of the artist's studio implied the artist's dependence on his patronage, as in Velázquez's *Las Meninas* (see 28). Courbet's *The Studio* is closer to Goya's *Portrait of the Family of Charles IV* (95), in which the spread of democratic beliefs allowed the painter to share space with his monarch as a relative equal and to represent the king as part of a family of ordinary mortals.

Yet never had a visual artist given himself the kind of role Courbet now assumed. And in the end his own persona is closer to Christ preaching the remission of sins, for example, at the centre of Rembrandt's famous print of *La Petite Tombe* (96), and his composition is closer to Rembrandt's structure than to any other precedents. We are reminded that, despite both Courbet's and Proudhon's ostensibly anti-religious attitudes, their own utopian conceptions of society were still deeply structured by a religious framework. In that sense *The Studio of the Painter* exemplifies the very sort of ideological construct it ostensibly sought to attack. For the religious and political systems Courbet believed had enslaved mankind, he now substituted the hegemony of art. The notion of artist as saviour and the redemptive function of art are ultimately very far from what we now recognize as modern revolutionary thinking about state structures and economic organization. Both Courbet and Proudhon certainly experienced the alienating effects of modern power distribution – of the alliance between the autocratic state and the capitalist economy – but their solution, as Karl Marx caustically pointed out in his attack on Proudhon (called, in a pun on the title of Proudon's book, *The Poverty of Philosophy*), was nostalgic. Nonetheless, Courbet grounded his own role and his hopes for human salvation in the lives of ordinary people and everyday activities. Courbet was loyal to his roots, and his message to the world was as simple as a demonstration of what the free worker could accomplish. Such a

worker operated with a liberated consciousness, as we can tell because the easel painting produced by Courbet – who stood for all workers – revealed a Realist vision. Perhaps Courbet's most succinct explanation of this process came in a statement made several years later and to which we will return: Realism was, he declared, 'the negation of the ideal ... the *Burial at Ornans* was in reality the burial of Romanticism ... By reaching the negation of the ideal and everything that follows from it, I arrive at the complete emancipation of the individual and finally at democracy.' As Courbet had already indicated in his letter to *Le Messager* of 1851, the attainment of Realism would be nothing less than a revolution in human consciousness, from which all other political revolutions would eventually flow.

Courbet's exhibition produced many heated reactions. A few writers recognized the painting's relevance to contemporary politics with observations such as one by the critic Charles Perrier that the left side contained a 'personification of our epoch'. As before, there was an occasional appreciation of his solid pictorial talents. But the aspect of the painting that caused perhaps the most discussion was the perplexing term 'Real Allegory' which Courbet had used in the long title for the picture. Champfleury was particularly annoyed: how can a Realist painting be allegorical? One might offer the following tentative answer: although Courbet may well have intended the two words to confuse and mystify, they bring into play the notions of realist and visionary; they certainly apply to his combination of the sensuous and the didactic, of actual experience and intellectual projection. It is possible that Courbet meant that this particular allegory was real because its lesson and its prediction for the future were based on what he believed was fact. But, in addition, the painting was an allegory of the real in the sense that reality was the basis for the vision exemplified by the painting on his easel, with the process of its representation rooted in the physical – as shown not only by Courbet's active engagement in the act of painting but by the raw pigments prominently displayed on his palette and in the very physically present sky and other elements of the landscape. This aspect of the painting was featured in the caricature

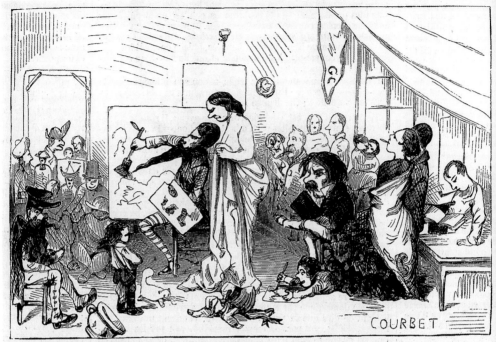

M. Courbet dans toute la gloire de sa propre individualité, allégorie réelle déterminant une phase de sa vie artistique. (Voir le programme, où il prouve victorieusement qu'il n'a jamais eu de maître... de perspective.

97
Quillenbois,
Caricature of
The Studio of
the Painter.
L'Illustration,
21 July 1855

by Quillenbois (97), in which Courbet is shown using a house-painter's brush while his beard gets into the act as well. (The beard is a reference to the word *barbouiller*, which means to daub clumsily and contains the word for beard, *barbe*, one of Courbet's obvious attributes. The caption reads: 'Mr Courbet in the full glory of his own individuality, real allegory determining a phase of his artistic life. See the programme, where he triumphantly proves he has never had a master ... of perspective.') So even the caricature recognizes, however humorously, that *The Studio of the Painter* gave meaning to the act and process of Realist vision while spelling out its consequences. The painting is, we may conclude, a grand strategy to deploy the banalities of the real towards a utopian rhetoric of freedom.

Avenue Montaigne, 7, Champs-Élysées.

———

EXHIBITION

ET VENTE

DE

40 TABLEAUX & 4 DESSINS

DE L'OEUVRE DE

M. Gustave COURBET.

———

Prix : 10 centimes.

———

The various explanations of 'Real Allegory' are all useful, and their multiplicity would have appealed to Courbet, who had challenged future viewers to decipher his riddle. Furthermore, Courbet's play on words and their contradictions can prepare for the dualism in his other major work of 1855 – the pamphlet *On Realism*, better known as *The Realist Manifesto*. Indeed, just in case one is tempted to view *The Studio of the Painter* too literally, for example as a visual statement of the Proudhonian relationship between labour and art, *The Realist Manifesto* makes clear that his overall aims were much more far-reaching.

The Realist Manifesto served as the introduction to the checklist of paintings for Courbet's solo exhibition, the final title of which was: 'Exhibition and Sale of 40 Paintings and 4 Drawings from the Work of Monsieur Courbet' (98–9). It both offered a rationale for the value of objects being put up for sale and could be read, as it is today, as an expression of the modern artist's creed. It is important enough to reproduce in its entirety:

REALISM

The title of Realist was imposed on me just as the title of Romantic was imposed on the men of 1830. Never have titles given an accurate idea of things; if it were otherwise, works would be superfluous.

Without attempting to comment on the greater or lesser appropriateness of a name that nobody, it is to be hoped, can be expected to understand clearly, I will limit myself to a few words of explanation in order to avoid future misunderstandings.

I have studied, apart from any preconceived system and without biases, the art of the ancients and the moderns. I have no more wished to imitate the one than to copy the other; nor was it my intention, moreover, to attain the useless goal of *art for art's sake*. No! I simply wanted to

98
The Realist Manifesto, 1855. Title page

99
The Realist Manifesto, 1855. Courbet's statement and checklist

LE RÉALISME.

Le titre de réaliste m'a été imposé comme on a imposé aux hommes de 1830 le titre de romantiques Les titres en aucun temps n'ont donné une idée juste des choses ; s'il en était autrement, les œuvres seraient superflues.

Sans m'expliquer sur la justesse plus ou moins grande d'une qualification que nul, il faut l'espérer, n'est tenu de bien comprendre, je me bornerai à quelques mots de développement pour couper court aux malentendus.

J'ai étudié, en dehors de tout esprit de système et sans parti pris, l'art des anciens et l'art des modernes. Je n'ai pas plus voulu imiter les uns que copier les autres ; ma pensée n'a pas été davantage d'arriver au but oiseux de *l'art pour l'art*. Non ! j'ai voulu tout simplement puiser dans l'entière connaissance de la tradition le sentiment raisonné et indépendant de ma propre individualité.

Savoir pour pouvoir, telle fut ma pensée. Être à même de traduire les mœurs, les idées, l'aspect de mon époque, selon mon appréciation, en un mot, faire de l'art vivant, tel est mon but.

G. C.

draw forth from a complete knowledge of tradition the reasoned and independent understanding of my own individuality.

To know in order to be capable, that was my idea. To be able to translate the customs, the ideas, the appearance of my epoch according to my own appreciation of it, [to be not only a painter but a man,] in a word, to create living art, that is my goal.

Compared to many of Courbet's statements in letters, this one is succinct, comprehensive and clear. (It is said he may have had help from Champfleury.) It was also extremely influential. It certainly takes up his earlier theme of complete independence, including the slap at art for art's sake, whose advocates denied the use of art for social purposes in favour of total freedom. Courbet asserted that freedom and the social function of art went hand in hand. However, Courbet was even more insistent now on the interrelation between self-knowledge and independence, for only through them could the

Il faut joindre à ces quarante tableaux que j'ai pu avec peine rassembler pour cette exposition, onze autres exposés au Palais des Beaux-Arts. Il me reste à regretter un tableau qui aurait servi à faire saisir l'enchaînement de mon idée artistique; ce tableau (*Après-Dîner à Ornans*) fut exposé aux Tuileries et médaillé par le gouvernement; il appartient aujourd'hui au musée de la ville de Lille. Je n'ai pu l'obtenir de cette ville.

1) C'est par erreur que, dans le livret du Palais des Beaux-Arts, il m'est assigné un maître : déjà une fois j'ai constaté et rectifié cette erreur par la voie des journaux ; c'était durant l'exposition de 1853. Je n'ai jamais eu d'autres maîtres en peinture que la nature et la tradition, que le public et le travail.

Paris. Typ. Morris et comp., rue Amelot, 64.

artist represent his own times authentically. One must be master of oneself in order to see clearly. Recall how, in the writings for Silvestre and the interview with Count Nieuwerkerke which first proclaimed his ideas, Courbet claimed to be 'not only a painter, but a man'. (He dropped this phrase from some but not all versions of *The Realist Manifesto,* including the one reproduced here, but the idea of manhood is still present through the link between self-determination and capability.) Proudhon had explained how recognition of man's material grounding endowed with moral value his efforts to rise to the spiritual. Art was a paradigm for that enterprise. Realism, the translation of one's own times, depends on freedom because it depends on bringing one's own vision to the representation of experience. One cannot be subservient to any other point of view. So, while on the one hand we have the assertion of an objective art, on the other hand we have individuality as its key. In a single stroke, then, Courbet appropriated for Realism the

ideal of artistic freedom and self-expression formulated by the earlier, so-called Romantic generation. He had made a synthesis of the 'objective' and the 'subjective' in which neither was lost, but, rather, in which both became interdependent and mutually reinforcing. For only by means of Realism could one overcome preconceptions; and only by means of freedom could one's vision be authentic, hence automatically Realist.

The exhibition and its manifesto provoked a spate of essays focusing on the notion of Realism. It was as if those for whom words were the medium had been caught by surprise at Courbet's verbal intervention and had to have the last word themselves. Most of them came from among Courbet's supporters and friends. One of the first and most influential essays, called 'On Realism', was Champfleury's open letter of September 1855 to George Sand. Champfleury could not accept Courbet's definition of Realism, for he held that the term was simply too broad to be pinned down. He had earlier told Buchon that Realism was a joke, since it had existed in the art of all times – it could not be co-opted to the kind of purpose Courbet had in mind, namely the description of a specific artistic movement. Champfleury pointed out that the Greek poet Homer could be called a Realist and that the 'hyper-romantic' German composer Richard Wagner had recently been attacked as 'tainted with realism', concluding: 'All those who put forward new aspirations are called *Realists*'; there could be Realist doctors, chemists, manufacturers or historians.

It is hard to fathom Champfleury's motivation, for his somewhat technical objection failed to recognize that words used for other artistic movements – take Romantic, Classicism, or Renaissance ('rebirth') – had meanings prior to acquiring their more specific duty as historical descriptors. Realism had already been mentioned by certain critics of the 1830s as a possible source of renewal for art. Perhaps, then, Champfleury felt that realism alone could not constitute art; or perhaps he resented the term's appropriation by a single individual. Emphasizing Courbet's pictorial rather than intellectual abilities, he termed Courbet 'a born *painter*', 'a robust and powerful worker' whose art could be measured against the greatest painters

in history. A man of conviction, Courbet was like the millionaire who hung wooden clogs from his living room ceiling so all could see from whence he came. But when it came to Courbet's declared aims, Champfleury turned to Proudhon, citing the axiom from the *Philosophy of Progress* that any figure, beautiful or ugly, could serve the purposes of art. Champfleury may have implicitly accepted Courbet's aim to represent his epoch through his own eyes. But in refusing 'realism' as too broad a term, he ignored Courbet's claim to articulate his own meaning, assuming he was incapable of doing so.

This denigration of Courbet's intellect was implied even by his most unconditional supporter. In 1856 Max Buchon published a pamphlet entitled *Collection of Essays on Realism* in which he advocated an art for the people; if artists wished to move the people and make them their public, they would have to 'reject ... ideas in favour of pure feelings ... To be understood by the people, one must make oneself one of them.' In order to make Courbet a perfect example of this new direction, Buchon had to play down the painter's ideas. Spontaneity was his most characteristic trait: 'If you saw Courbet at work for an instant, you would say that he produced his works ... as an apple-tree produces apples' – that is, by pure, natural force. While accepting the historical importance of Courbet's art, Buchon admitted the difficulty of 'the intellectual elaboration of his ideas' for those who did not know the artist. 'As a means of education and study, Courbet has never had anything but his magnificent eyes ... [He] is not very familiar either with history or the sciences or books, which doesn't prevent him from having a profound knowledge of nature and men.' In other words, Courbet operated strictly from instinct – he exemplified the pure feeling that was Buchon's key to a popular art.

These two essays and others that appeared in various periodicals reveal how Realist theory emerged as a response to Realism's negative press. Critics accused Realism of being an art of the physical world so transparently and uncreatively represented that it ignored the poetic aspiration to rise above nature. Such critics held that beauty resided beyond the material realm; the Realists seemed to

limit themselves to the ugly. A lithograph by Daumier nicely satirizes this point of view (100). A decidedly unattractive critic declares: 'This Monsieur Courbet makes his figures much too vulgar; there is no one that ugly in nature.' Realist theory defended the creative dimension in Realist art by identifying creativity with instinct and the subjectivity of all vision. Hence, what the Realists themselves objected to in other art was not subjectivity but insincerity, the opposite of authenticity. As Fernand Desnoyers wrote in *L'Artiste* of 1855: 'Realism is the true painting of objects. There is no *true* painting without colour, spirit, life or animation, physiognomy or feeling.' To be authentic is to be true to one's feelings. The Realists did not deny the role of honest subjectivity; on the contrary, Realism's protest against falsehood would always be coupled with advocacy of individual expression. So announced Edmond Duranty in a short-lived journal called *Réalisme* (1856–7): 'Realism is the reasonable protest of sincerity and hard work against charlatanism and laziness

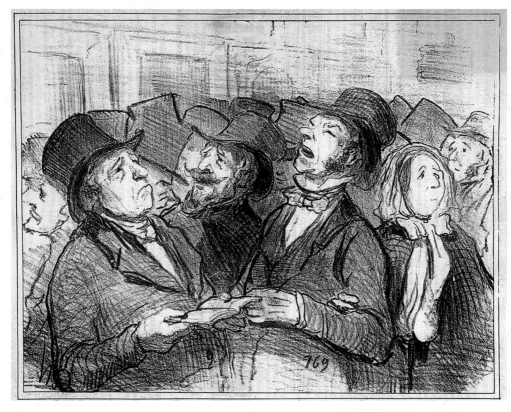

… in order to wake up people's minds and return them to a love of truth.' To speak of Realism as a school was a contradiction, for Realism 'signifies the frank and complete expression of individuality; it is an attack upon convention, imitation, any kind of school'. Finally, in a 'Philosophy of the Salon of 1857', Jules-Antoine Castagnary (1830–88), a lawyer and critic who later became one of Courbet's staunchest supporters, was even more far-reaching: 'Visual art can be neither a copy nor even a partial reproduction of nature, but rather an eminently subjective product, … expressing a purely personal conception. Nature, the raw material of art, merely provides the artist with imagery for representations … Above all, art is an expression of the human self solicited by the external world; … it is one of the highest acts of human consciousness.' So, a common theme of the Realist defence was that it was innately impossible for imagination to be absent from representation. It thus tied Realism to the creative truths advocated by Romantic ideals stressing the subjectivity of individual expression, while rejecting Romanticism's artistic conventions – especially its literary and escapist themes. Courbet's claim in *The Realist Manifesto* that his art was *both* the representation of man in his appearance and his epoch *and* the expression of the painter's individuality were Realism's two inseparable pillars. Despite the refusal of many other Realists to give Courbet credit, his *Realist Manifesto* was ultimately the most fundamental statement of Realist theory. It is recognized as such today.

100
Honoré
Daumier,
Critics.
Lithograph in
Le Charivari,
8 June 1855

The final, and in some ways most telling, 'essay' on Realism was one that never saw the light of day. This was the project, known to us from a few pages of general notes, which Baudelaire informally called 'Puisque Réalisme il y a' ('Since Realism There Is'). The notes contain the barest outline of what would have been a serious and critical response to Champfleury's letter to George Sand. Baudelaire confirmed the idea that Realism was Champfleury's hoax, since it had always been a part of art, and he described Courbet as intoxicated by the word and as carried away 'with compromising grandeur on an innocent farce'. He ended with the cryptic lines: 'Analysis of nature, of Courbet's talent, and of morality. Courbet saving the world.' Even to begin to understand the meaning of these phrases, it

is necessary to recall Baudelaire's essay on the Salon of 1846, in which the relationship between art and morality was a prominent concept. At the beginning of that essay Baudelaire held that art was the expression of the 'ethos' – the moral attitude – of its own age. Courbet would certainly have agreed. At the end of the essay, in the passage Champfleury had thought relevant for the *Burial*, Baudelaire extolled the beauty and the heroism of modern life.

The remark in Baudelaire's notes about Courbet saving the world obviously recognizes the role Courbet attributed to himself in *The Studio of the Painter*. But it, too, can be tied to Baudelaire's *Salon of 1846*. Baudelaire had dedicated his *Salon* to the bourgeois, who, he argued in his preface, had a fundamental need for art. Art was both essential to make the bourgeois worthy of his dominant role in society, and at the same time it was the reward for his achievement of pre-eminence. While offered half-ironically, Baudelaire's underlying thesis was that the uplifting and transcendent role of art fulfilled a crucial social function. Baudelaire himself had thus clearly thought about and perhaps even led Courbet to the notion of art as the salvation of mankind. So even if Courbet had gone so far that Baudelaire had reservations, Baudelaire knew enough to take him seriously. Courbet had forever changed the role of art in society by insisting that its vision be rooted in reality and that its purpose be related to society. That shift was now reflected in every significant discussion of art that followed. In other words, thanks to Courbet, the very terms of what we now call the 'discourse' of the art world were forever redefined.

So Courbet's daring manifesto, his unprecedented exhibition and his ostentatious painting had a shock effect. And they firmly established the existence of Realism as a movement and a theory in mid-nineteenth-century art. However, as Champfleury and Baudelaire both had intimated, the term 'realism' had a long history in art and literature. Realism may have seemed shocking, but it hardly came out of the blue.

'Realism' is a broad and confusing word. In ordinary discussion 'realist' usually suggests a vision that looks more closely than usual

at empirical facts even when they are unpleasant or not generally taken into account. It may imply a pragmatic acceptance of limitations imposed by human nature or material conditions on the attainment of lofty goals. In the arts 'realism' carries many of the same implications, but there is much more. In realist painting there can be a tendency to forget one is looking at a surface with colours placed on it to produce a physical image. Viewers often seem to think they see the thing itself. (Here I am referring to 'optical' realism rather than to psychological realism, which may often require departures from the former.) This was especially possible in Courbet's painting, since his effort at simplicity eliminated the recognizable – that is, *conventional* – signs of artifice that reminded viewers they were experiencing art. All too often, critics responded to Courbet's paintings as if the figures he represented were themselves actually present. However, when they objected to his pictorial handiwork, as well, they were responding to *unconventional* signs of artifice that were either appropriate to Courbet's subject matter (a certain 'artisanal coarseness') or expressive of his manual process. Indeed, one must always keep in mind that it was Courbet's extraordinary handling of paint and refusal to adopt an academic manner that both made his characters appear so real and present and made his own 'personality' seem palpable, too.

Since the traditions Courbet confronted were deeply entrenched, one needs to know something about them in order to assess his significance. To be sure, even in the most idealized, academic styles, there had to be some resemblance to reality for a picture even to begin to be comprehensible – there had to be recognizable figures or objects. But that resemblance was a matter of convention that was largely regulated by the art professors of the Academy, whose teachings consisted primarily of copying ancient statues and the Old Masters. Artists who wanted to go further towards resemblance to physical reality therefore had little choice but to break with tradition. Thanks to Courbet, 'Realism' (now with a capital 'R') would refer specifically to the movement in mid-nineteenth-century art and literature, when artists overtly proclaimed the accurate and serious portrayal of modern subjects from everyday life as their artistic aim.

That was a major point of *The Realist Manifesto*. But even as we stress that faithful representation of reality was the aim of Realism, we must not fall into the trap of believing in perfect or objective imitation. Indeed, in his manifesto Courbet insisted that his images of modern and everyday reality would bear the unmistakable stamp of his singular personality. In many respects his contemporaries would define his art by the consequences of that attitude, that is, by the presence of his persona in his works.

It was natural, of course, that this 'Realism-as-a-movement' relied on strong elements of optical, and sometimes psychological, realism for its fulfilment. It is surely no accident that, for example, the introduction of photography in 1839 provided a basis for judging technical accuracy of realist rendering. However, realist representation was not an innocent choice, just as the invention of photography might well have been considered useless and remained obscure if the visual reproduction of what the eye ordinarily sees had not acquired value. In other words, Realism in art was not merely the neutral result of the latest visual language, which came closer to what looked like 'objectivity', but of an attitude that empowered it, an attitude that was social as well as artistic. No one better exemplified such an attitude than Courbet. It is true that since the Renaissance representation of 'nature' and 'the natural' were among the aims of art but, until the modern era, the natural was thought to be most perfectly embodied by God or the shadow of some ideal, as in Plato's famous 'myth of the cave'. Not until the nineteenth century did it come to be equated with the material world and with accessibility to ordinary people. In order to assure the latter Courbet not only painted in a manner often derived from popular traditions, he extended his voice beyond traditional boundaries through choices of subject matter and forms of production and self-promotion, including *The Realist Manifesto*, taken more from commercial than from current artistic practices.

The academic painter who believed he was drawing 'nature' was trying to picture an imaginary concept more perfect than its actual material embodiment in the objects of earthly existence. Artists who

concentrated on simply 'reproducing' actual physical appearances (assuming for the sake of argument that such reproduction is even possible) were considered inferior. Their art was deemed closer to copying than to creativity, and its appeal to ordinary people was considered a confirmation of low artistic status. At the Academy the highest rank went to history painting, which represented gods and goddesses or ancient and religious heroes in terms of an ideal beauty based on Greek and Roman art. Artists who specialized in portraiture or in everyday life, even those as great as Rembrandt or Velázquez (and later Courbet), were said to practise that lower category called Genre Painting (see the discussion of Dutch genre painting in Chapter 1). So when Courbet and the Realists claimed that true 'history' was found in everyday events and that it was impossible to paint anything you could not directly know and see, they were accused of advocating the ugly over the beautiful and of obliterating the 'poetic' enterprise of visual art. For the Realists' traditionalist opponents, it was as if the Realists were dragging their audience through the mud of what everyone could already know without the benefit of art.

Yet the Realist attitude did have distinguished roots. The authors of the eighteenth-century French *Encyclopédie* had claimed that progress was possible only if one scrupulously observed and recorded all information about the world. Their approach exemplified the philosophy of the eighteenth-century Enlightenment (of shedding light on truth) and was already being practised in England, where practicality and invention were spawning the beginnings of industrial revolution by the 1750s. A parallel spirit can be found in the politics of democracy and the theory of individual rights, which led in the arts to the questioning of institutional authority in aesthetic matters and to the demise of instruction by traditional examples. Both factors – economic and ideological – underlay the empowerment of the middle classes and, as they entered the art market, the old traditions of history painting suffered in favour of portraiture, landscape and still life – categories on which Courbet's livelihood depended. Here were themes that were visually accessible, and that were useful, too, serving both as

decoration for the homes of the bourgeoisie and as commemoration of their new social status. Moreover, Courbet promoted them through business intermediaries and maintained his position in the public consciousness through various forms of publicity.

These new attitudes might be called Positivist and Utilitarian as opposed to Idealist. The Idealist believes that 'truth' lies somewhere beyond the surfaces of material things, and can be defined only by faith and exemplified in poetry (as opposed to prose). The Positivist believes that 'truth' resides in the visually self-evident material world of objects, which must be examined closely for the practical purpose of promoting human progress. In the nineteenth century Positivism was seen as a substitute religion – a modern basis for faith. In this sense Courbet's spirit can certainly be compared to Positivism.

For Courbet, or any artist, to want to be 'of his own times' presupposes an understanding not only that the periods of history somehow differ fundamentally from one another but that the most recent period has a value at least equal to those that preceded it. It also signals a practical awareness that, in order to succeed, one must accept the values of one's peers in an increasingly middle-class society. Such a consciousness of historical relativity was overwhelming in the philosophical and historical writings of Courbet's time. For example, the great German metaphysician Hegel, in his *Phenomenology of the Spirit* (1807), saw the need to reconcile universal principles with the empirical and historical particularity of actual human existence. He held that material reality had to be an essential component in any system of thought. It was noted earlier that Hegel accepted the notion of historicism, that is, a natural evolution of society and art in phases through historical time, each moment of which has its characteristic forms. There is no proof that Courbet read the major books in which such thought was expressed, but he certainly had contact with many of its disciples. In particular, the historian Michelet not only advocated popular democracy as the ultimate goal of modern society, but he located that impulse in the lives of ordinary people. His *Le Peuple* of 1847 was a profession of

faith in the political inspiration of the lower classes and included its artistic impetus as well.

For Courbet or anyone to insist that observation of reality – as opposed to academic training – was the primary basis for visual art, major changes had to have occurred. It was in literature that the lives of ordinary people were first taken as the basis for serious art. The novel, with its wide accessibility to an increasingly literate public, surpassed theatre and verse as the dominant literary form. In his preface to *The Human Comedy*, Honoré de Balzac (101) claimed to transpose into literature the (pre-Darwinian) evolutionary principles of Geoffroy de Saint-Hilaire, who believed that the diversity of species we now know was the direct result of the milieus in which they grew. Cataloguing this diversity became a popular current in mid-nineteenth-century France. Its visual counterpart, as was mentioned, was a proliferation of illustrated series, such as *The French Painted by Themselves* (1839–42), as well as, eventually, Courbet's own 'series' imagery. (Many novels themselves were serialized in popular journals or newspapers, which added to their readership.)

As literary historian Erich Auerbach has shown, Balzac documented the details of middle-class provinciality in order to make its degradation overwhelming for the reader. In typical passages of description, for example in *Le Père Goriot* (1834), he used the sight and even odour of places to explain the character of their inhabitants. Thus, Madame Vauquer's boarding house 'smells stuffy, mouldy, stale; it is chilly, it is humid to the nose, it penetrates the clothing; it has the odour of a room used for dining; it stinks of the service, of the pantry, of the hospice.' Eventually, Madame Vauquer (102) herself appears: 'Her oldish, fattish face, from the middle of which juts a parrot-beak nose, her small, plump hands, her figure as well filled out as a churchwarden's, her loose, floppy bodice, are in harmony with the room, whose walls ooze misfortune, where speculation cowers, and whose warm and fetid air Madame Vauquer breathes without nausea. Her ... whole person, in short, explains the *pension*, as the *pension* implies her person ... When she is there

the spectacle is complete.' Here the story of petty greed unfolds, as if it were the only possible result of its claustrophobic environment. Balzac's analysis approaches a medical diagnosis, but it is also laced with contempt, for which his anti-heroic, endlessly descriptive style becomes a vehicle.

Courbet shares Balzac's visual concentration on tangible, 'metonymic' detail as a strategy for producing what Roland Barthes termed the 'reality effect' in order to address a primarily middle-class audience convincingly. In metonymy (as opposed to metaphor) the physical part or attribute stands for and characterizes the whole, as the tool may stand for its user, the loose bodice for Madame Vauquer, or the tobacco pipe for Courbet. Metonymy is thus a more concrete form of representation than metaphor, for the latter is

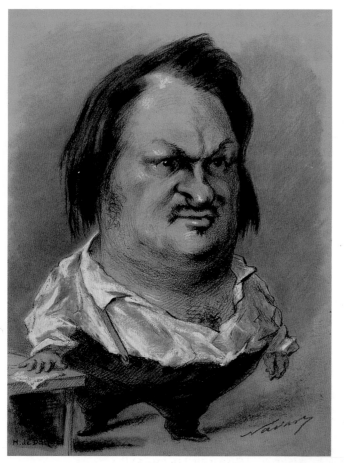

Enfin toute sa personne explique la pension, comme la pension implique sa personne.

101
Nadar
(Gaspard Félix
Tournachon),
Caricature of
Honoré de Balzac

102
Bertall,
Madame Vauquer.
Illustration for an
1843 edition of
Honoré de Balzac's
Le Père Goriot

based on a comparison between two things that are not so physically related. In Courbet's description of the figures in *The Stonebreakers* the accumulation of such detail became the basis of empirical experience rather than the evidence in an overtly moral brief (see Chapter 2). Cracked wooden clogs and torn clothing are as much the attributes of the labourer's life as is the dilapidated furniture or clothing of Madame Vauquer's, but, unlike Balzac, Courbet does not overtly adduce them as attributes of personality or worth. For Courbet existence is defined by outward facts that are confirmed by ordinary people; for Balzac morality is at its centre, to which he, as omniscient narrator, bears witness. Courbet's language is material at heart; things speak for themselves in ways that make their significance unmistakable. Balzac's language does not hide his ulterior, moral motive. Yet both share an acceptance of visual, physical evidence as a basis for 'truth'. As a result, Realism acquired extraordinary moral power, whether made explicit or not.

Despite their sense of alienation from the society they described, such novelists as Stendhal and Balzac shared with Courbet the assumption that man must be represented as embedded in the concrete political, social and economic conditions of his time. For the former that condition was deplorable; Courbet tried to make it a source of liberation. Other Realist authors, such as George Sand and Champfleury, would continue to adopt a moralizing tone, but with a more positive view of the society they described. Not until Gustave Flaubert's *Madame Bovary* of 1857 and the powerful social novels of Émile Zola (1840–1902) would authors disguise their voices as neutral and scientifically impersonal. Indeed, when Flaubert was brought to trial for his controversial novel, the main complaint was not over his representation of the erotic adventures and fantasies of his provincial heroine but that there was no voice in the narrative to condemn them. For all of these writers, however, the story of ordinary people of the middle or lower classes was told through meticulous description, making the plot seem an inevitable consequence of the conditions being described. In his preface to the murder novel *Thérèse Raquin* (1867) Zola compared his writing to the work of surgery (again the medical analogy!), which aimed to expose the

underlying causes of human action. Courbet lies somewhere in between, with no exact parallel in literature. On the one hand he presented reality so matter-of-factly that he seemed to rub people's noses in its 'objective' existence; but Courbet's art is certainly not impersonal as Flaubert's seemed to be. On the other hand it was not a reality to which Courbet felt morally superior, as did Balzac; on the contrary, it was his very own, with which he identified, and which he demanded be taken seriously, however it might trouble his audience.

The Realist Manifesto makes clear, then, that Courbet's painting was not meant simply to pass for reality or to imitate reality, but that, through what we recognize as its Realist style, Courbet intended to engage in a discourse about both reality and art. Indeed, Realism emerged at the very time when the notion of universal truth was giving way to relativism. So it is unthinkable for us to define it as a form of representational objectivity; it is inseparable from its social impact. 'Objectivity' would be timeless and neutral; Realism is grounded in its historical motives and effect. It is the vision of a particular moment which has come to be exemplified through the art of a particular individual, the painter Gustave Courbet.

These points are driven home by two satirical cartoons that suggest how certain crucial characteristics of Realism were understood as linked to such a context. A lithograph of 1855 by Honoré Daumier shows *The Combat of the Schools: Idealism versus Realism* (103). It graphically enumerates essential traits of the two schools as seen through each other's eyes. The idealist is a slim, aristocratic fellow, whose round eyeglasses and lack of teeth make him seem rather elderly. Nude apart from his Roman helmet, and thus identified with the classical repertory of themes, he brandishes a large palette and a strangely shaped spear in his defence. The spear is in fact a maulstick, an instrument that artists use to steady their brush, hence a device that implies precise draughtsmanship and careful finish. The Realist, on the other hand, is dressed in plaid trousers and a skimpy waistcoat, clothes which might be fashionable had he not so outgrown them. The outfit, the wooden shoes and the scruffy hair all suggest an impoverished member of the rural lower classes.

103
Honoré Daumier, *The Combat of the Schools: Idealism versus Realism.* Lithograph in *Le Charivari*, 24 April 1855

104
Bertall, *We're Stuck in Realism. Le Petit journal pour rire,* 1859

Surely they allude to elements in the public's image of Courbet. His small square palette is of the portable type used for outdoor sketching rather than for formal studio work, and the large brush he wields like a cudgel looks as if it would better serve for house-painting than for canvases.

The second cartoon, done in 1859, is by the ubiquitous satirist Bertall (Charles Albert d'Arnoux) and called *We're Stuck in Realism* (104). It shows an oversize eye examining the worn-out sole of an old shoe through a magnifying glass. Bertall appears less concerned than Daumier with the kind of people associated with Realism than with the optical effect of their close-up examination of reality. However, the reality on which his Realist eye focuses does have social implications, for the worn-out shoes would most likely be those of the poor and the underprivileged. Whether or not the cartoonists approve of Realism, both have represented its artistic forms as embedded in a specific and material context and as having a social and economic dimension. Both, in other words, exemplify the Realist attitudes of historical relativism and material consciousness and thus, whether critical of Realism or not, both embody the change in vision that Courbet's Realism had already wrought by the second half of the 1850s, when both cartoons were done.

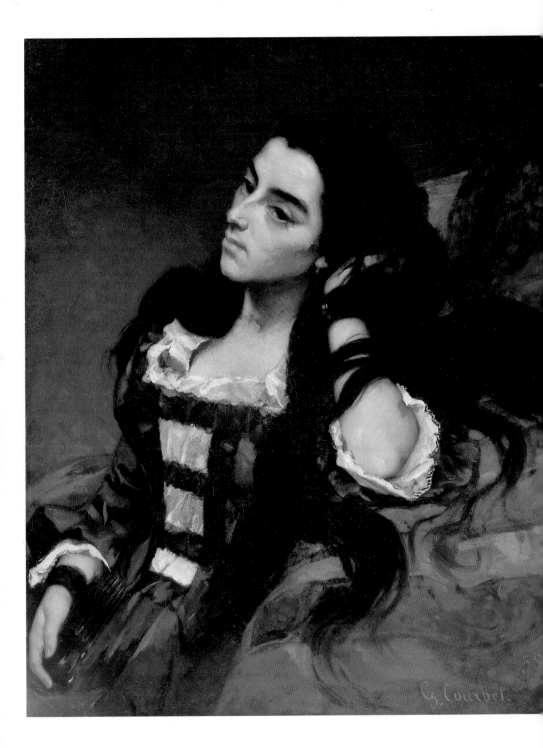

Until now I have played down two important themes in Courbet's
painting: landscapes and the nude. Yet both were prominent in *The
Studio of the Painter* and increased in importance as Courbet's
growing reputation attracted more private commissions. Following
The Studio, Courbet pursued the entrepreneurial aspect of his career
more intensely than before, both in order to satisfy monetary needs
incurred by investments in the stock market, land purchases, and
the construction of a new studio in Ornans, but also because fame
had made it easier for him to exhibit in the French provinces and
abroad and made him more desirable to patrons. We shall now dis-
cover a Courbet acting more in concert with the enterprising eco-
nomic attitudes of the middle-class provincial than with the populist
spirit that had seemed dominant during the previous, politically
volatile years. From the 1,500 francs he received for *After Dinner at
Ornans* in 1849 or the 2,000 he was offered for *The Sleeping Spinner*
in 1853, he was able by the mid-1860s to get between 2,000 and
15,000 francs for paintings, depending on the subject and size. In
fact, Courbet spent a great deal of his time on travels to Belgium,
Holland and Germany, where he had been developing a significant
following for more than ten years and where his presence contrib-
uted to the promotion of sales. He also made numerous visits to
places in France such as Normandy and Saintonge, where collectors
invited him to stay and where he produced work for members of
local society. The period from 1855 until his direct involvement with
politics at the downfall of the Second Empire in 1870 was the most
productive of Courbet's career, if measured in sheer numerical
output and commissions. However, rather than following strict
chronology during those fifteen years, it will be more constructive
to concentrate on Courbet's two principal themes one at a time.

In *The Studio of the Painter*, Courbet represented himself turning
away from the naked studio model (who uses a piece of studio drap-

105
*Portrait of a
Spanish Lady,*
1855.
Oil on canvas;
81×65 cm,
31⅝×25½ in.
Philadelphia
Museum of Art

ery to cover herself) in order to concentrate on his landscape. It might be said that in so doing the painter exemplified Proudhon's theory of the conquest of desire as both a means *towards* and a consequence *of* art production – the virtuous man rising above the material to attain the spiritual. If the woman thus stands for that which Courbet must strive to overcome, then she reveals a common gender stereotype – woman as the embodiment of things of the flesh and of male desire. In addition, the model's subordinate position to the painter, admiring and supporting his action, also corresponds to a traditionally subservient female role within a patriarchal structure. Hence, *The Studio of the Painter*, Courbet's essay in self-definition and definition of art, may have been liberating for the artist, but it not only perpetuated traditional binary thinking – the opposition between genders and related pairs of opposites – it was completely grounded in it.

If Courbet's public posture in this painting suggests the high moral-ity of art, however, the reality of his private activities was consider-ably different. Women were both a major theme of Courbet's art and a major fixation of his life, and one might even propose that *The Studio* makes its simplification as a defensive response to a role of women so complex and subversive that it could barely be confronted except through rigidity and dogma – which on the psychological level amount to denial. That is, Courbet's cherished idea of manhood preoccupied him all the more for its being so vulnerable to his personal relationships with women and challenged by emerging feminist calls for women's equal rights. For Courbet lived at a time when female liberation was an important cause – from George Sand's (106) romantic association of virtue with the heartfelt long-ings of her heroines, to the militant Flora Tristan's (107) claims, in writings of the 1830s and 1840s, in favour of divorce and free love. In other words, Courbet's insistence on the theme of masculinity can be understood as a compensatory response to the threat to his viril-ity he may constantly have felt as both an artist and a mid-nine-teenth-century male. Representations of women as muses, or their association with nature in pictures where they adopt the classical pose of the reclining nude, displaced fears and obsessions that

106
George Sand

107
Flora Tristan

erupted in everyday life over to the manageable realm of art. Coexisting with such works, however, are others in which Courbet confronted lust and sexuality in the raw.

Anecdotal evidence of Courbet's relations with women abounds in his letters to suggest a man of powerful sexual appetites and little long-term commitment. In one, he bragged about his conquests in a brothel in Montpellier. In another he said he was having sex with a maid. And others speak of women's crushes on him – totally un-requited, of course. He was more serious about a Spanish lady, whom he visited in Lyon and perhaps represented in a portrait of 1855 (105). There, leaning on her arm and with her jet-black hair in disarray, she has an exotic and seductively languorous look. If she represents Courbet's ideal, she is far from the healthy, homespun style of his sisters. Naturally, our modern psychological scepticism might find such a man insecure – too much in need of proving his masculinity. By the standards of the nineteenth century, however, he is hard to judge. Moreover, the letter to Champfleury on *The Studio of the Painter* tells a more complicated story. Courbet said he had been abandoned by Virginie Binet, his mistress of fourteen years who had borne him a son then six years old. Under pressure of poverty, she had married another man and left for the Channel port of Dieppe. She may be the woman in the romantic images of lovers or the sleeping nudes Courbet painted in the early 1840s. But even if she was, there is no evidence that Courbet supported her financially or that they lived together, and he never once mentioned her to his parents. Moreover, he is known to have declared that marriage and the life of a painter would never make a good mix. Thus, even though Courbet actually portrayed himself as a wounded man in a painting of unsure date which he exhibited in 1855, his attitudes make it hard to be sympathetic to his esca-pades as those of a wounded lover trying to rebound from disap-pointment. Should we feel sorry for a man whose raucous café life and sexual antics may reveal profound loneliness; or should we be appalled by such aggressively self-centred masculinity? There is no simple answer.

From the beginning of his career, Courbet had painted female nudes, including some exceptionally alluring ones in his early years. *The Bacchante* (108) and *The Sleeping Nude* are both images that lend themselves easily to voyeuristic sexual fantasies. In that, of course, they were unexceptional; they fall entirely within traditions of male representations of women. It was Courbet's masterful ability to recreate in paint the sensuousness of the flesh that was the basis of his figures' powers of seduction, and it may be possible to argue – at least in explanation if not necessarily approval – that he frankly accepted the fact of woman as an appropriate, perhaps exemplary, object of Realism since, for the heterosexual male, no other form could be so physically compelling. As Courbet became more self-conscious about the political implications of his Realism, his nudes could also become vehicles for social commentary, as in *The Bathers* (see 74). While still defined by its associations with luxury and voluptuousness, the nude could become a critique of excess and dissipation rather than the means to its satisfaction. Also, as discussed, Courbet located several very positive images of women in domestic settings, such as those of *The Sleeping Spinner* (77) or *The Grain Sifters* (79). Rather than revealing themselves to the male gaze, their poses make them seem heroic or self-sufficient.

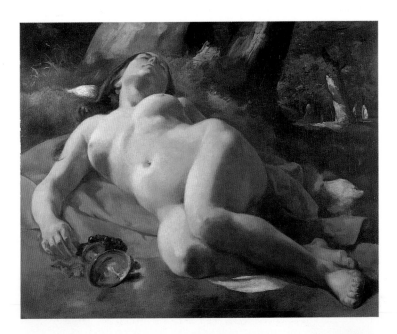

In 1855, Courbet made a painting of the proprietress of a bar standing behind her counter. *La Mère Grégoire* (109) places the viewer in the bohemian culture of Parisian cafés and brasseries. Based on a character from a popular song, 'Madame Grégoire', by the Romantic poet Pierre-Jean de Béranger, she was not only the purveyor of drink but a procuress. Courbet's portrayal of her continued his pattern of disrespect for notions of propriety and could by extension be taken as politically provocative, since Béranger was well known for his republican sentiments. However, it was in a large painting begun the following year and exhibited at the Salon of 1857, *The Young Ladies of the Banks of the Seine (Summer)*, that Courbet overtly availed himself of the theme of women of easy virtue (110). Once again using the word *demoiselles* in his title, this time to mock the idea of proper young ladies, Courbet represented two fashionable Parisiennes resting during the summer heat in a flowery spot along the shady river bank. It is one of Courbet's most sensuous and opulently painted works to date; the brightly coloured wildflower carpet on which the women lie, the turquoise water and the lush foliage all evoke the freshness of the countryside. At the same time, these elements are vehicles for a style of painting based on summary touches of rich colour that would make Courbet worthy of the Impressionists' admiration. It had become common for Parisians to make outings to the suburbs along the Seine and, although related scenes had already appeared in illustrations and prints on themes of Parisian leisure, they were unprecedented as the subject matter for a large painting. In general terms of suburban leisure, indeed, Courbet's was the first of what became a highly popular topic for painting, especially among the Impressionists, from Édouard Manet's *Déjeuner sur l'herbe* (121) and Claude Monet's *On the Bank of the Seine, Bennecourt* (111) to Georges Seurat's *A Sunday Afternoon on the Island of La Grande Jatte*.

108
The Bacchante,
1844–5.
Oil on canvas;
65×81cm,
25⅝×31⅞in.
Private
collection

Yet once again a painting by Courbet caused something of a scandal. For his so-called ladies were identifiably members of a certain class of courtesan, commonly referred to as *grisettes*, *cocottes* or *lorettes* (112). Although these women were higher on the scale than common brothel girls or streetwalkers, they were nevertheless available.

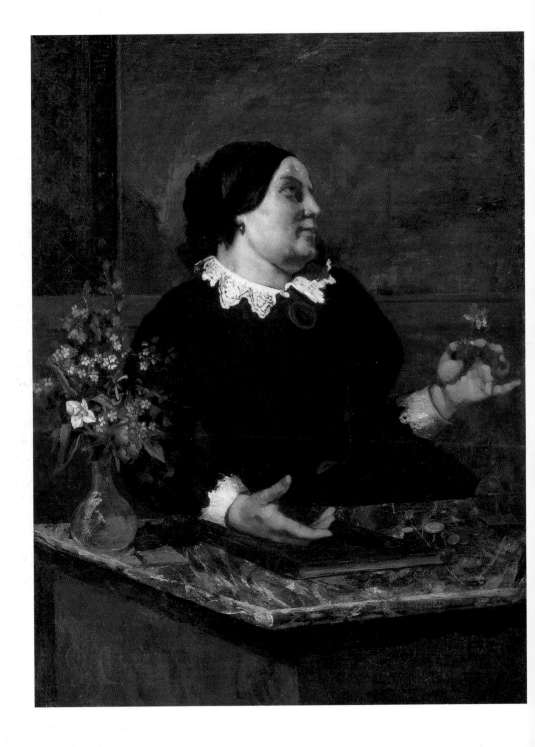

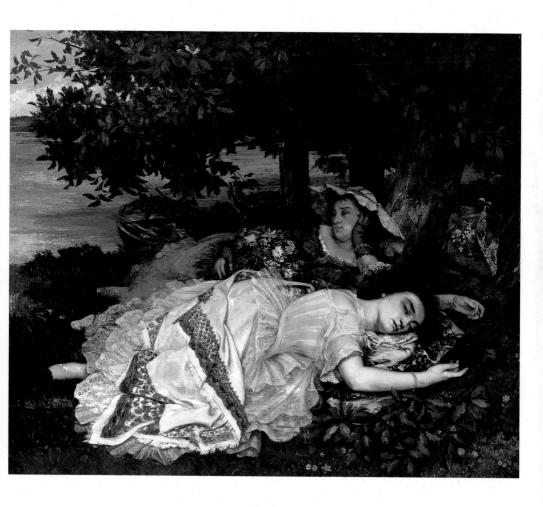

109
*La Mère
Grégoire,*
1855.
Oil on canvas;
129×97·5 cm,
50⅞×38⅜ in.
The Art
Institute of
Chicago

110
*The Young
Ladies of the
Banks of the
Seine
(Summer),*
1856–7.
Oil on canvas;
174×200 cm,
68½×78¾ in.
Musée du Petit
Palais, Paris

Their clothing is up-to-date and luxurious, but they wear it without particular elegance. Courbet had never before painted such rich silks and muslins as those worn by the figure in the foreground – how comical that they are her undergarments! The woman has covered herself with a fashionable patterned shawl similar to the one that graces certain portraits by the very proper Monsieur

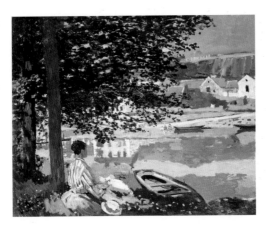

Ingres. She is stretched out on her dress, which she has removed because of the heat. No woman of high social standing would condone such an appearance. But in any case, why keep on her gloves? In addition, the boat which brought them to their private mooring has a man's straw hat lying in it. They must have been accompanied; these may be women on their own, but they are not without men.

Grisettes might be shop girls or housemaids, or recent arrivals from the provinces, who would spend an entire day or evening with a man. Courbet knew this class of woman well: he later abruptly ended a two-year affair with one of them, named Léontine Renaude, in 1862. While *The Young Ladies of the Banks of the Seine* might have a touch of the autobiographical, therefore, it is more obviously a means for Courbet to continue creating controversies that would keep him in the public eye. Prostitution was so widespread during the Second Empire that it was integral to Paris' reputation as a centre for pleasure and love, but never had these kind of facts been overtly admitted into the arts. Although 1857 was the year

Baudelaire published his collection of poems, *Les Fleurs du mal*, in which the theme of illicit love is prominent, it was also the year in which he was condemned for some of those poems on grounds of offence to public morals. Of course, Courbet's general theme of women in a landscape was of long-standing tradition, but whereas the nudity of goddesses transformed desire into an idealized state,

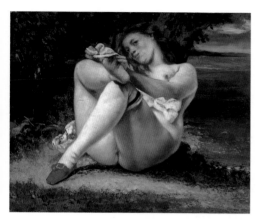

Courbet's painting once again demythologized such traditions by embodying the same concepts in contemporary form. The part of the title that calls them ladies 'of the banks of the Seine' (and not 'on' the banks, as so often mistranslated) sounds like ladies 'of the rue Saint-Denis' (a red-light district) or some other such location.

The existence of several oil sketches and studies related to the painting suggests either that the composition itself was long in planning, or that the subject was long on Courbet's mind. In contrast to the theme of charity in *The Young Ladies of the Village* (see 66) and the parodic pantomime of *The Bathers* (see 74), this painting does not seem to have as specific a message to convey beyond its honest and probably shocking reflection of current practices. Courbet's frankness alone was enough to cause a stir. Moreover, in some other, private paintings, Courbet's lewd intentions were undisguised. His *Woman with White Stockings* of 1861 (113), with its view looking up a girl's thighs as she dresses after a swim, recalls photographs of prostitutes posing with their stockings on (114). These paintings are perfectly consistent with many others of Courbet's career in that

they derive from his own experience which, regardless of the consequences, he took as a suitable basis for his art.

The overlap between Courbet's life and art is exemplified by his stay at Saintes near the Atlantic coast. In 1860 he had met Castagnary, the lawyer who, as an art critic, was to become the chief proponent of Naturalism (as an artistic movement consequent upon Realism). Castagnary introduced Courbet to a young collector named Étienne Baudry who had inherited a large and handsome house and gardens on an estate called Rochemont. Like Courbet's earlier patron Bruyas, Baudry not only dabbled in the arts, but he sympathized with left-wing politics. He undoubtedly wanted to amuse his neighbours by inviting a notorious guest. Courbet stayed in the area from June 1862 to April 1863. One of the main reasons for the length of his stay was that on the day of his departure he had been betrayed by his mistress, the aforementioned Léontine Renaude, who appeared at the railway station with another man brazenly waiting in the wings. (The man was the brother of the photographer Nadar.) Courbet expressed his fury in letters both to the man and to Léontine. He also tried to get a friend to spy on her to see if she was affected by his censure. But perhaps Léontine had only been trying to make Courbet jealous. She wrote back, addressing him as 'Fat Dog' and threatening to come to Saintes and make a scene. For his part, Courbet raved about the parties Baudry and his friends were organizing. At one, he is said to have drunk three bottles of Bordeaux wine, two bottles of Burgundy, one bottle of local wine and a bowl of coffee half filled with fine cognac – and all of that before dessert! After dessert he apparently threw it all up. But he also threw himself into work, and, after a fling with a travelling actress, he was soon in love again, this time with a local woman named Laure Borreau. She was the wife of the proprietor of a ladies' fabric shop. Indeed, after leaving Baudry's and after a brief sojourn at the nearby hamlet of Port-Berteau, Courbet moved into the Borreau house at Saintes. He was so successful with the ladies that they carried him in triumph at a fête in his honour and, supposedly at their demand (on hearing of his impending departure), he wrote to Étienne Carjat and Nadar (Gaspard Félix Tournachon, 1820–1910) to send him photographs

115
Étienne
Carjat,
Gustave
Courbet,
c.1862

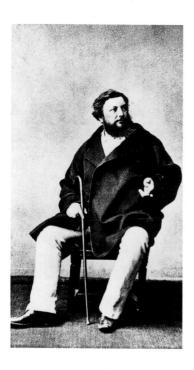

they had made of him in his studio (115). A painting of a nude dated to this period and called *Sleep (Françoise)* – despite the name, the identity of the model is not known – shows a sleeping woman with her stockings on, the same ones as in *Woman with White Stockings*. Far more than in the traditional totally undressed nude, this painting's implications of post-coital repose are obvious. From all accounts this period seems to have been one of the happiest in Courbet's life. Confirmation of his manhood through sexual exploits and the adulation of his friends were certainly keys to such well-being.

The most remarkable aspect of the paintings Courbet made during this stay in the Saintonge region was the emergence of his skill in the painting of flowers. Baudry had a deep interest in horticulture, and Courbet arrived at a time when his extensive gardens must have been resplendent. Moreover, a friend of Baudry's seems to have believed in flower symbolism and ordered two painted bouquets for himself. Responding to these stimuli, Courbet executed a prodigious series that are among the most superb bouquets in all of nineteenth-

116
The Trellis,
1862.
Oil on canvas;
110×135 cm,
43¼×53¼ in.
Toledo Museum
of Art

century art. The most famous is *The Trellis* (116), in which Courbet shows a girl, herself in a flowered print dress, arranging blooms on a trellis. There is a wide-ranging variety of buds from lilies and primroses to carnations and peonies and, although it is possible they were in season all at once, it is unlikely they would be growing all together in a single spot. Rather, Courbet's artistic licence has brought them together in much the same way as one would do for a bouquet. Indeed, the use of a trellis as their backing creates an almost abstract formulation of compositional organization. It is worth noting that the 1860s saw a revival of French interest in still life and, with it, a surge in the painting of flowers. Influential writers increasingly recognized that humble subjects, even the everyday objects of still life, could be vehicles for grand art, and the nine-teenth-century revival of French still-life painting was thus an obvi-ous aspect of the decline of the so-called grand tradition under the Realist impetus. Moreover, still life came to epitomize not just the art of painting but the creative process as a whole. Baudelaire had alluded to such ideas in certain remarks on Delacroix as well as through the title of his own collection of poems, *Les Fleurs du mal*.

Many of Courbet's flower pieces were intended for an exhibition organized by his liberal political friends for the benefit of the poor in Saintes. In other words, works that seem to originate far from the political limelight may actually owe their existence in large part to their saleability for a social-political cause. But perhaps precisely because the connection to politics of most of Courbet's work at Saintes was indirect at best, one of his artist friends there, Louis-Augustin Auguin (1824–1904), berated him for neglecting his prepa-rations for the coming Salon. Courbet had been angry at the arts administration for its failure to accord him proper honours at the Salon of 1861. He seemed to believe he would win a decoration for works on stags and huntsmen (to be discussed in the next chapter), which should have interested the Emperor, whose love of hunting was renowned. He had in fact been scheduled to receive a second-class medal, but apparently the Emperor himself had the painter's name struck from the list. Surely this blow to the artist's ego, com-bined with the encouragement of fun-loving liberal friends, lay

behind the satirical painting of drunken priests he made in Saintes in 1862–3. Called *The Return from the Conference* (117), Courbet's effort at provocation was so blatant that it seems more than just an attempt to remain in the public eye. Perhaps it should be seen as a reassertion of intransigent independence – of manhood, after all – after being rebuffed by someone (Napoleon III) he had foolishly courted.

Seven priests are shown returning from one of the well-watered weekly dinners they usually attended near Ornans. One of them is on a donkey led by a young abbé and is so fat that the poor beast cannot keep up his haunches. Two other priests help the fat one keep his balance. This group is clearly based on the classical theme of the drunken Silenus (118). A group of women behind the priests transport their baskets on their heads with sobriety and conscientiousness, in contrast to the profligate clergymen. A little statue of the Virgin is standing in a tree trunk, but they ignore it. The scene is set in a landscape reminiscent of the Loue valley, even though Courbet was working on the piece in Saintes. Courbet called the painting 'critical and comical in the highest degree', and he hoped it would have an impact similar to *A Burial at Ornans*, which harboured an implicit critique of religious ideology. This time the attack was untrammelled and may have been aimed at Napoleon III's recent rapprochement with the Church. The Emperor was trying to strengthen his authority during a time of economic crisis that had led to a republican resurgence in public opinion and recent elections. Courbet followed the process he had introduced in the *Burial*, by having his friends pose one by one, wearing a priest's robe sewn by Auguin's wife. Since most of them were left-wing republicans, they must have enjoyed being part of Courbet's farce. It has even been suggested that they instigated it, Saintonge being a notoriously anti-clerical region.

As a medallist, it did not at first occur to Courbet that this new painting might be excluded from the Salon. Yet not only was it refused from the official exhibition, it was not even hung in the Salon des Refusés – an exhibition for rejected works that was set up that year after artists and others angrily protested that the jury had

become outrageously restrictive. (Even Édouard Manet's *Déjeuner sur l'herbe* was allowed in there.) It was not a question of Courbet's qualifications to exhibit; rather, the painting was deemed immoral. A government wishing to cultivate the Church could hardly allow the offence. Moreover, there may have been a general, not simply a factional, consensus against the painting. A harsh attack in a letter from Champfleury ended the long association between the two, although it was already on the wane. He told their mutual friend, Max Buchon, that Courbet was 'shooting in the dark'. Courbet's response was true to form: he claimed to have been testing the limits of freedom under the Second Empire and to have planned all along for *The Return from the Conference* to provoke a refusal. Its notoriety would help him earn money when he toured the painting abroad to show it for a fee. He arranged a tour of England with an American entrepreneur who was to split the proceeds with him. Eventually, long after Courbet's death, the painting was purchased by devout Catholics who destroyed it.

Shortly after Courbet's return from Saintes, his relations with the philosopher Proudhon dramatically intensified. Proudhon was enthralled by *The Return from the Conference*, and he planned a four-page essay in its defence. A caricature by Cham showing *Proudhon Collaborating on Courbet's Anti-Religious Pictures* (119) records their (at least temporary) meeting of minds. Proudhon's essay turned into a long book on art called *On the Principle of Art and its Social Destination*, which was published just after the philosopher's death in 1865. Courbet was thrilled by Proudhon's interest in him, and he wrote him detailed letters enumerating his ideas on art. The philosopher even complained that Courbet was 'killing' him with his lengthy correspondence and that the painter would do better to leave the thinking to those who can express themselves clearly in words – again the myth of Courbet's intellectual ineptness.

At the time of these exchanges, Proudhon was also working on a book on the role of women in modern society: *Pornocracy, or Women in Modern Times* (published posthumously in 1875). For although he

117
The Return from the Conference, 1863.
Oil on canvas; 229×330 cm, 90¼×130 in.
Formerly Leroux Collection, Paris (destroyed)

118
Agostino di Musi (Agostino Veneziano), *The Drunken Silenus*, early 1500s.
Engraving; 18·5×25·8 cm, 7¼×10⅛ in

119
Cham, *Proudhon Collaborating on Courbet's Anti-Religious Pictures. Le Charivari*, 24 April 1863

had already given indications of his ideas on the topic, they had come under heavy attack from certain feminists. These ideas may shed light on a painting of *Venus and Psyche* which Courbet made in 1864. Courbet's standard representation of the nude, with the obvious exception of *The Bathers* (74), was to show her asleep, thus powerless to resist the fantasies of the male gaze. Perhaps he was fascinated with their own unconscious state, just as he had explored states of reverie in his self-portraiture. (A curious painting he exhibited in 1867 called *The Somnambulist* suggests the persistence of somnolence among his themes.) Could these women's fantasies correspond to his own about them? Now in this new painting he made the theme of voyeurism explicit. The *Venus and Psyche* presents voluptuous nudes – a blonde asleep and a brunette lifting a curtain to view her. Courbet wrote to his Paris dealer that he had never painted in such a manner before. Since the original painting is currently lost (perhaps destroyed during World War II) we are forced to judge Courbet's meaning by a later version of the theme (120). With its almost caricatural expression and exaggerated painterly technique it makes a blatant display of female sexuality that contrasts sharply with contemporary nudes, whether of the academic variety or Manet's forthright but unerotic *Déjeuner sur l'herbe* (121) from the Salon des Refusés of the same year. Courbet seems to want to rub our noses in voluptuousness in a way sure to be accused of coarseness. In fact, again the painting was excluded on grounds of impropriety.

As art historian Petra Chu has pointed out, nude female couples could be associated with brothel scenes in the culture of the Second Empire. Indeed, Courbet's composition may have suggested certain lesbian practices encouraged by madams to keep their girls busy during slow hours and to compensate for doubling up in beds under cramped conditions. Or it may parody lesbian *tableaux vivants* that were staged to whet male clients' appetites for sex. Under such circumstances, the exclusion of Courbet's painting from public view may not seem like such an aberration. The puritanical Proudhon, however, saw the *Venus and Psyche* as a highly moralizing satire of much the same sort as *The Return from the Conference*. Accusing his

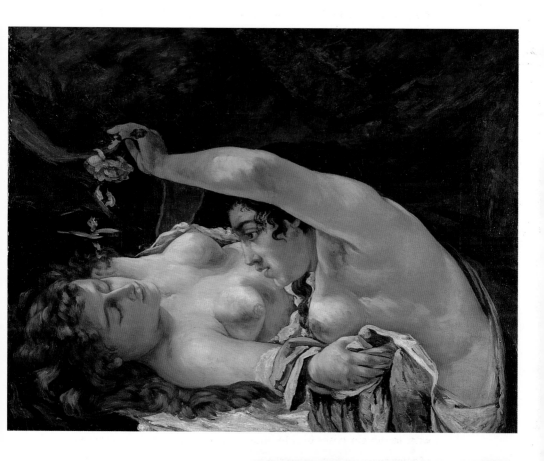

120
*Venus and
Psyche,*
1866.
Oil on canvas;
77×100 cm,
30⅜×39⅜ in.
Kunstmuseum,
Bern

121
Édouard Manet,
*Le Déjeuner sur
l'herbe,*
1863.
Oil on canvas;
208×264·5 cm,
82×104¼ in,
Musée d'Orsay,
Paris

contemporaries of debauchery, Proudhon hailed Courbet's honesty as a rebuke to the current double standard in both art and in life: 'You are a bunch of lechers and hypocrites … You are not interested in the art of painting the nude; you are not hungry for natural beauty, but for dirt. Here, this is how one paints the nude, and I defy you to do the same.' Indeed, Proudhon undoubtedly saw such a painting as advancing his own theory (now widely accepted) that Napoleon III's despotic power was secured by distracting the masses through material and sensual delights. In his *Pornocracy* Proudhon argued that women who refused to remain in the home in support of the family, which he deemed the true basis of all society, contributed directly to the subjugation of humanity through the pleasure- and consumption-oriented society of the Second Empire. His simplistic polemic divided women into two categories – the prostitute and the housewife.

In addition to his enthusiasm for participating in Proudhon's project for a book on art, Courbet wanted to paint a picture of the philosopher surrounded by his family. Recall Courbet's desire to have Proudhon pose for *The Studio of the Painter* and the attempts he made to obtain an image of him at that time. In 1863 he renewed those efforts by hiring a photographer to take Proudhon's portrait and by inviting Proudhon to visit him in Ornans. After the philosopher's untimely death in 1865, Courbet finally realized the project, claiming to have promised to make a 'historical portrait' of him. Courbet called his final composition *Portrait of P J Proudhon in 1853* (122), naming the year in which *The Philosophy of Progress* was published. That book, as we know, was the first in which Proudhon discussed Courbet's art and was an important resource for Courbet's own thinking about the meaning and structure of the *The Studio of the Painter*. The *Portrait of P J Proudhon* even harks back to the painter's less colourful style of the early 1850s. The philosopher is seated in the meditative pose of ancient philosophers on the steps of the little house he moved to on the rue d'Enfer, in a working-class neighbourhood south of the Latin Quarter. He is shown dressed in a worker's smock and surrounded by the tools of his trade – a pen and inkwell, books and manuscripts. He is accompa-

nied by his two daughters, one of whom does her school lessons while the other one pretends to be serving tea in the sand. In its first state, Courbet had included Madame Proudhon, née Euphrasie Piégard, a poor young trimmings-maker whom Proudhon had married when he was in prison at age forty. The separation between the philosopher and his family reflects not only Proudhon's personal solitude, which he confided once to Courbet in a conversation, but the principles underlying his theories about women as domestic and supporting members of a patriarchal system. Courbet was unable to pose Madame Proudhon in time to transfer her portrait to the final work, which was already hanging at the Salon. His provisional image of her was not a very good likeness, and eventually, partly at her request, he painted her out. In her place, Courbet put a still life with a sewing basket and dresses, alluding through that metonymy to her household role. Even though feminist writer Jenny d'Héricourt (1809–75) had attacked the contradiction between Proudhon's assertion of human equality on the one hand and his denial of full rights to women on the other ('Were women not human?'), Proudhon justified his theory on the basis of social needs and biological differences. Social stability, he argued, was founded on the acquisition of property, while family created the need for and

the means to maintaining its ownership. The active nature of the male made him the planner and conceiver, whereas the woman was the necessary mirror in which man would contemplate his own genius and judge his own action.

Just how deeply Courbet shared these attitudes is hard to know, since he was hardly above exploiting his relationship with Proudhon for his own purposes. Indeed, immediately following Proudhon's death, Courbet tried to seize the opportunity to appear much closer to the philosopher than he had been able to get during Proudhon's lifetime, with pronouncements ranging from 'The nineteenth century has just lost its pilot' to the declaration that they had been 'intimate' friends. Yet if the *Venus and Psyche* was a moral satire, and if the *Portrait of P J Proudhon in 1853* was an exposition of Proudhon's family values, they were ambiguous ones. The voluptuousness of the former is not without its seductive potential, and the latter has a melancholy loneliness, with which Courbet himself, constantly in pursuit of both women and his independent manhood, may certainly have sympathized. Yet despite Courbet's failure to form lasting relationships with women – indeed, perhaps because of it – art became the vehicle for representations that are both sympathetic and erotic. For many of them grant women the power both to be themselves and yet to be attractive to the male.

One of the most important of Courbet's images of modern woman is a large painting called *Woman on a Podoscaphe* (123). Here is a fashionable girl in a bathing suit, hair flying in the wind, pedalling a catamaran-like vehicle consisting of a seat fastened to two parallel pontoons. Courbet witnessed this 'modern Amphitrite', as he called her, during his summer at Trouville in 1865. The young woman posed for him with her paddle in a neighbour's living room, an approach that may have rendered this composition, which should have been based on action, a bit stilted. Courbet never finished the painting – perhaps after his initial enthusiasm he realized it was silly, especially when compared to Manet's images of modernity in the *Déjeuner sur l'herbe* and the famous picture of a reclining prostitute, *Olympia* (which was shown at the Salon of 1865). Nonetheless,

123
Woman on a Podoscaphe, 1865.
Oil on canvas; 173·5×210 cm, 68⅜×82¾ in.
Murauchi Art Museum, Tokyo

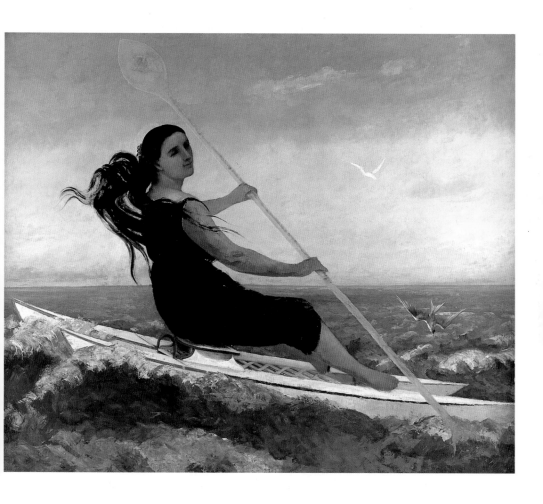

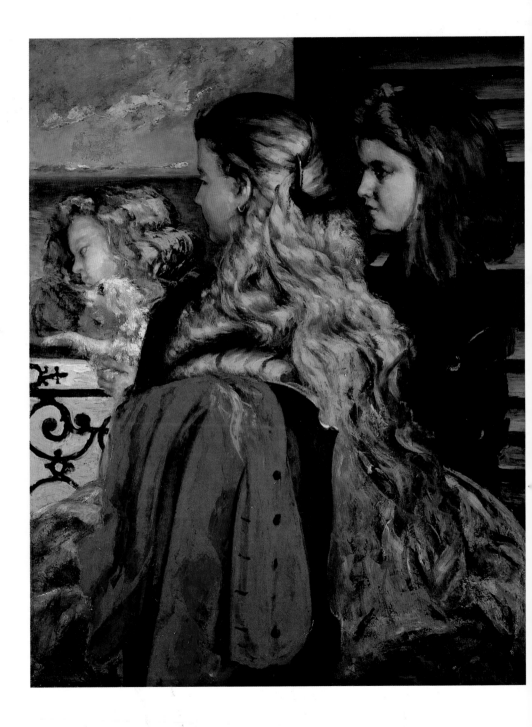

we can still conclude that if modernity was what Courbet most admired in this idea, then he certainly associated it with the emancipated woman. We saw that in one incarnation or another such women ranked high among his favourite subjects. While in Normandy, Courbet painted many fashionable portraits and also made more spontaneous pictures of young girls, such as *The Girl with Seagulls* and *Three English Girls at a Window* (124). Their free handling of paint reveals a manner that might seem to combine the style of Manet with the lighter touch of artists such as Eugène Boudin (1824–98) or Johan Barthold Jongkind (1819–91) who also worked on the Normandy beaches. However, Courbet's Normandy works still retained a sense of physicality and a boldness based on the use of relatively wide brushes that are his personal trademarks. *Three English Girls at a Window* is said to represent the three Potter sisters who had come over to be painted by Belgian portraitist Alfred Stevens (1823–1906). Courbet was particularly drawn to their fresh and brightly coloured tresses, which are the focal point of his composition. He also was entranced by Joanna Heffernan, the Irish mistress of the young expatriate American painter, James McNeill Whistler (1834–1903), to whom Courbet referred a bit presumptuously as his 'student'. (They did share many stylistic affinities.) Joanna had posed for Whistler's well-known *The White Girl, or Symphony in White, No.1*. Courbet represented *Jo, the Beautiful Irish Girl* in no less than four separate, closely similar versions, all of which show her gazing into a mirror while arranging her extraordinary copper-coloured hair (125). In these pictures, Jo's fascination with her own image mirrors that of the painter, whose only access to her, until she ran off with him, was through what has sometimes been called 'the mirror of art'. Wearing one's hair down conveyed the idea of loosening restraint even more in the nineteenth century than it does now, where the fashion has become less exclusively associated with youth. Courbet was now in his forties and in his letters had begun to draw attention to his advancing age and expanding girth. The nostalgia for youth that these images imply was deeply human; but rather than remaining paralyzed by his frustration, Courbet found a positive outlet in works

124
Three English Girls at a Window, 1865.
Oil on canvas; 92·5×72·5 cm, 36¹⁄₂×28¹⁄₂ in.
Ny Carlsberg Glyptotek, Copenhagen

125
Jo, the Beautiful
Irish Girl,
1865.
Oil on canvas;
54×65 cm,
21$\frac{1}{4}$×25$\frac{5}{8}$ in.
Nationalmuseum,
Stockholm

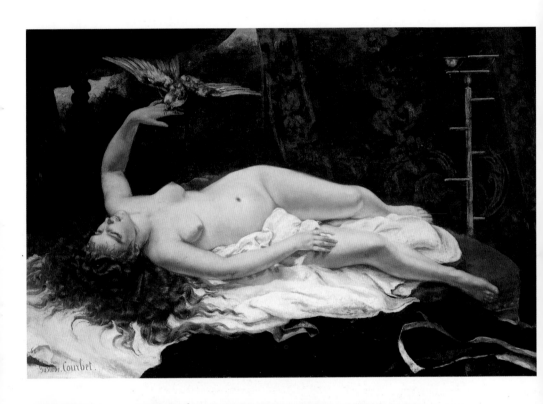

whose obsessive, nearly identical repetition suggest they were painted essentially for himself.

Courbet's famous *Woman with a Parrot* (126), exhibited at the Salon of 1866, exemplifies the combination of female independence and seductiveness. The pose recalls certain more academic works which friends of Courbet actually accused him of imitating. An example of the latter might have been *Woman Bitten by a Snake* (127), a highly suggestive sculpture by Auguste Clésinger (1814–83) that had been purchased by the State. Courbet's woman lies with her (again) long hair spread out and mingling with the bedsheets, framed by a bedpost on one side and a parrot perch on the other. With her hips

126
Woman with a Parrot,
1866.
Oil on canvas;
129·5×195·6 cm,
51×77 in.
Metropolitan
Museum of Art,
New York

127
**Auguste
Clésinger,**
*Woman Bitten
by a Snake,*
1847.
Marble;
56·5×180 cm,
22¼×70⅞ in.
Musée d'Orsay,
Paris

128
Édouard Manet,
Olympia,
1863.
Oil on canvas;
130·5×190 cm,
51⅜×74⅞ in.
Musée d'Orsay,
Paris

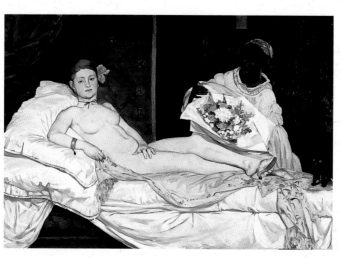

turned towards the viewer and the presence of the colourful bird – an exotic companion that links her to odalisques (harem women) and other fantasies of sexual availability – there can be no doubt of the painter's erotic intention. Yet the woman's powerfully modelled body and her absorption in her play distances her psychologically from the viewer at the same time as it obviates any physical resistance to the viewer's gaze. Unlike Manet's controversial nudes, which affront that gaze and resist male domination by means of the model's own consciousness and individuality – compare his *Olympia* (128) – *Woman with a Parrot* forsakes Courbet's usually confrontational tactics for a somewhat more traditional, though forcefully rendered, effect. Of course, Courbet's manner of offending had been

very different from Manet's, though both were often accused of dirty and clumsy technique. Courbet's terrain was normally the political, and after his recent refusals he may have wished to demonstrate that his ability to paint had not diminished. Indeed, this particular painting's impact resides primarily in its effect of optical realism, which depends entirely on Courbet's technical approach. That approach included once again the use of photography as a source, undoubtedly another picture by de Villeneuve.

Moreover, at the same time as he produced the *Woman with a Parrot*, Courbet was entertaining commissions that were far more risky and could never have been publicly shown. His newest patron, the Ottoman ambassador to Paris, a *bon vivant* named Khalil Bey, was an avid collector who appreciated frankly erotic art. He asked Courbet to paint a picture of lesbian nudes that was much more explicit than the *Venus and Psyche*. The painting of *Sleep* (129), a euphemistic title, this time showed a blonde and a red-head (said to be Joanna Heffernan), intertwined in the throes of sexual arousal. The earrings and hairpin near the women's feet suggest that they have not been peacefully slumbering; in her passion the dark-haired girl has quickly removed her dress. Accompanied by bright flowers in a porcelain vase on a console to the right and by jewels and crystal objects on an oriental lacquered table to the left, the nudes themselves are executed in a style even smoother and more brightly lit than the *Woman with a Parrot*, in which Courbet's usual dark tonalities persist. The ensemble reveals Courbet's unstinting attention to the elements of luxury that would please his patron's sophisticated taste. He again drew upon known sources, such as Japanese prints specializing in erotica (130) or pornographic illustrations. The tight and brightly coloured execution surely recalled Ingres's *The Turkish Bath* (131) done for Khalil Bey a few years earlier, with its proliferation of silky skinned nudes. When it was useful, in other words, Courbet revived the skills he had displayed when he had flirted with Troubadourism and Orientalism. But Courbet's technical gifts for creating the illusion of physicality endowed his composition with a powerful sense of realism, too, as he magnified the scale of heretofore minor works to that of life itself.

129
Sleep,
1866.
Oil on canvas;
135×200 cm,
53⅛×78¾ in.
Musée du
Petit Palais,
Paris

For the same patron Courbet made one of the most unusual and notorious works in the history of art, a picture of a woman's torso with the legs splayed out to reveal her pubic hair and vagina. Called *The Origin of the World* (132), this painting was surely made as much for shock effect as for erotic arousal, and although made for the private delectation of an individual connoisseur, it inevitably suggests a commentary on Courbet's own anxious relations with women. As Freudian psychology has taught us to consider female genitalia the locus of male castration anxiety, the painting seems a fitting confrontation with Courbet's own ambiguous attitudes towards women. Graphically exposing the very lack of phallus feared by the male, especially one so preoccupied with virility as Courbet, the painting might be regarded as a quasi-therapeutic repu-

130
Kitagawa
Utamaro(?),
Two Courtesans,
c.1790.
Coloured
woodcut in a
Shunga book

131
Jean Auguste
Dominique
Ingres,
*The Turkish
Bath*, 1862.
Oil on canvas
on wood;
diam. 108 cm,
42½ in.
Musée du
Louvre, Paris

diation *cum* recognition of that fear. However, as a representation of the object of male desire, depersonalized by the exclusion of a face or any individuating marks on the body, as in certain pornographic photographs of the period, the picture reduces desire to the crude essentials of a fetish. It is a painting which suspends its contradictory interpretations in a state of heightened tension created by its confrontational bluntness. Yet, while the composition's brutal and ultimate example of metonymy represents woman as a pure object of dominance and possession, its title points to her quite differently as an absolute necessity to which the male is subject and on whom he is dependent. Somehow Courbet made explicit the tension between desire and fear of loss of potency (requiring constant reassurance) that he must have experienced with women – as with other

132
The Origin of the World,
1866.
Oil on canvas;
46×55 cm,
18⅛×21⅝ in.
Musée d'Orsay,
Paris

figures of authority – and helped explain why he could have flirted with Proudhon's puritanical doctrines about women (a means of maintaining male power) while being incapable of actually adopting them in practice.

In his late pictures of nudes Courbet conflated the obviously symbolic resonances of the feminine ideal with the realism of palpable flesh and erotic desire. In some sense a companion to *The Origin of the World*, *The Woman in the Waves* (133), which shows the upper part of a nude woman's body, associates femininity, as exemplified by the model's ample breasts, with nature itself, which the indeterminate location in the sea can be taken to express. A painting of 1868 shows *Three Bathers* (134), one of whose hair resembles the middle Potter sister from *Three English Girls at a Window*. The nude seen from the front is reminiscent of the *Woman with a Parrot*, while the third, who is still clothed, looks back to the servant of *The Bathers* of 1853. In this painting, then, Courbet assembles at a woodland pool figures who constitute a retrospective of his range of female images from Ornans, Paris and Trouville. In *The Source* (135), also of 1868, Courbet appropriated a motif made famous by the arch-conservative painter Ingres. In both *Three Bathers* and *The Source*, as well as earlier nudes, then, Courbet reinvested the conventions of the nude with the authenticity of his inimitable, sensuous Realism. All representations of goddesses and other idealized nudes ultimately embody a fixation on female sexuality under the guise of spirituality. Courbet infuses his figures with a heightened charge of voluptuousness that subverts this spiritual pretence and brings us closer to understanding why the nude becomes an ideal in the first place – that is because, despite its displacement of desire, sexuality is still at its root. Yet at the same time, Courbet's late references to traditional representations of the nude acquire for his art an intellectual, that is, retrospective, component that he might once have avoided or denied. For, in deliberately placing his work in relation to such classics, he engaged in a dialogue which his insistence earlier in his career on the provincial and the popular had refused. Does that mean that Courbet had finally accepted, at least to a degree, values against which he had so vigorously fought?

133
The Woman in the Waves,
1868.
Oil on canvas;
65×54cm,
25³⁄₄×21¹⁄₄in.
Metropolitan
Museum of
Art, New York

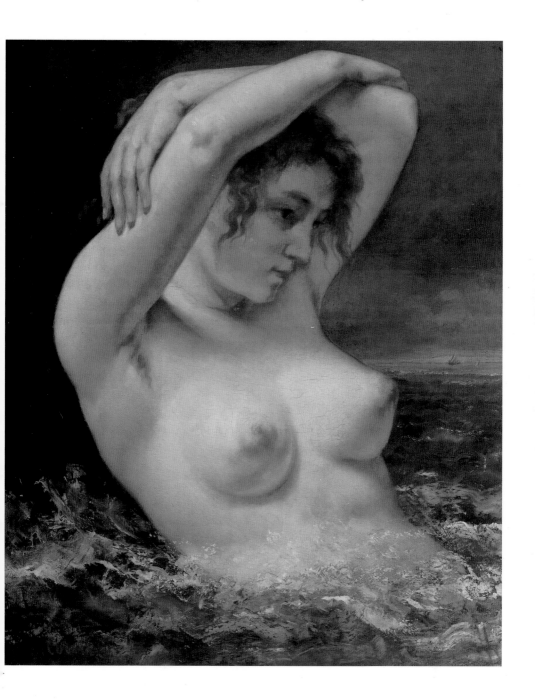

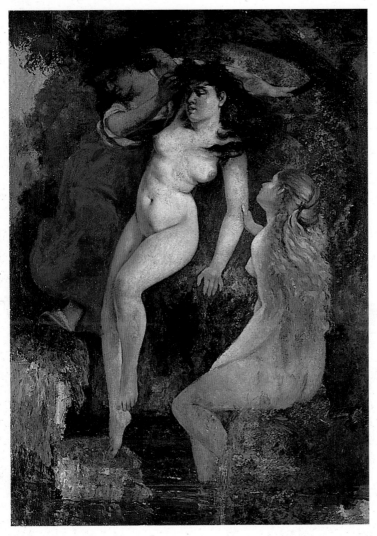

134
Three Bathers,
1868.
Oil on canvas;
126×96 cm,
49⅝×37⅞ in.
Musée du Petit
Palais, Paris

135
The Source,
1868.
Oil on canvas;
128×97 cm,
50⅜×38¼ in.
Musée d'Orsay,
Paris

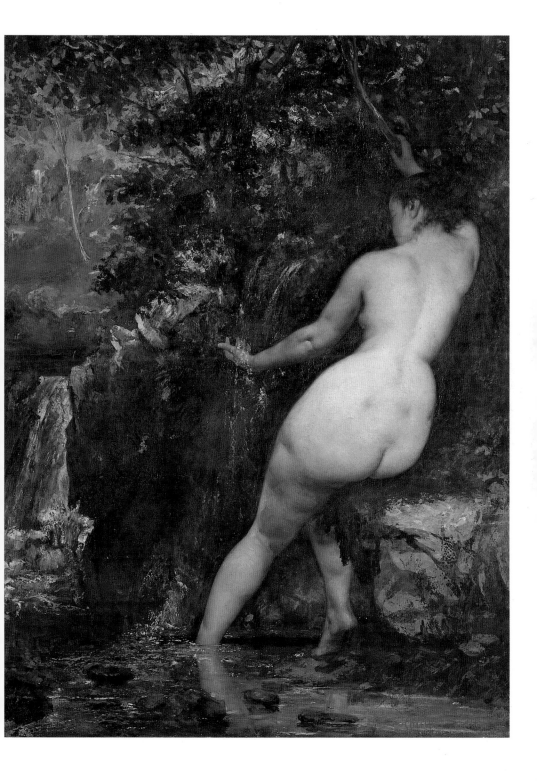

Or does it simply mean he had come to an understanding of his position in the history of art? Perhaps an answer lies in the issue of his manhood. Art became Courbet's vehicle for a suffusion of sensuality in a process far more subtle than that imagined by Proudhon but nonetheless related. Returning for a moment to *The Origin of the World*, we might propose that the site it represents, as the primary object of male desire, is ultimately a representation of the source of all creativity – procreativity as creativity *tout court*. Rather than turn his back on women – something he was incapable of doing – in order to devote himself to art, Courbet channelled the energies of his never-ending quest for fulfilment into an aesthetic vigour that affirmed his enduring manhood through potent performances of the brush. Women, then, were ever the vehicle for measuring that manhood.

At the centre of *The Studio of the Painter* Courbet communes
with nature, while at the same time he produces it with his brush.
He turns away from desire – the female model – to concentrate on
art, and representing art in general is the genre of landscape.
For, within *The Studio*'s complex apparatus Courbet has framed
himself inside the composition of a Franche-Comtois scene on
which he appears to labour. The new commitment to landscape
reflected a very practical attitude: what subject was more available
to him and easier to sell? Although in 1854 he had denigrated
non-figure painting as 'filler', landscape, including hunting scenes
and animals in landscapes, would soon constitute by far the
greatest volume of his output following *The Studio*. Indeed, land-
scape was the primary basis for Courbet's eventual success at the
business end of art. Since his meeting with Van Wisselingh in the
1840s he had maintained relations with dealers in various coun-
tries, and his travels to Belgium, Holland and Germany were
motivated in a large part by the search for patronage. While he
made portraits as well as landscapes during such forays outside
France, any works he made without prior commission were almost
always landscapes.

Courbet's representations of the outdoors provide us with
important insights. For one thing, landscapes always reveal under-
lying concepts, both personal and general, about nature and its
relation to humanity. Like all forms of representation, landscape
painting is to some degree symbolic; no matter how Realist an
artist makes it, the visionary element is present. In Courbet's case
we recognize a combination of attitudes related to that duality. His
images of nature embody a sense of personal rootedness and pride
of place; at the same time they could convert that love into a more
modern, generalized concept of the outdoors as the site of leisure.

136
*The Brook of
the Puits-Noir*
(detail of 141)

The classically trained artist, for whom history painting still stood at the top of the hierarchy, viewed landscape as a metaphor for a world interfused by a sense of human harmony with nature, a harmony dependent on human assurance of dominion. Thus, in classical landscape compositions, the human actor prevails; nature is his stage-like setting. In that tradition, heroic, historical or ideal landscape represented the only significant endeavour. Under the impetus of Realism, however, as well as with artists' experience of living and working in places such as Barbizon, and later at the coastal resorts of Deauville on the English Channel or others along the Mediterranean, landscape became the expression of a picturesque and pleasure-oriented concept of nature. The outdoors was pressed into service as a relief from the city and for the recreation of the leisured classes. Modern landscape painting reflected the ideology of a dominant urban society rather than a landed aristocracy. The new audience viewed the countryside as an idealized realm, which balanced the alienating materialism and conflicts of modern life. But for it to be effective, painting had to represent that realm realistically. Although the figure's dominance over the landscape setting diminished in Barbizon School paintings and Impressionism, all representations of nature were still serving human needs. Nature became both a moral and physical restorative, and its attainability, whether through trips to the country or through art, became a commodity. The visionary yearnings for utopia were packaged as materially available pieces of the realist world.

As Courbet's immediate predecessors, the painters of the Barbizon School deserve recognition here. Théodore Rousseau (1812–67) is perhaps the exemplary landscapist of the group associated with the farming village of Barbizon near the Forest of Fontainebleau. Drawn to the countryside by a love of nature nourished by its moral and literary associations, he found in the 'return to nature' an opportunity for both physical escape and emotional catharsis. Abandoning compositions in the Italianate style that still prevailed in France, he was inspired rather by the Dutch and English (*eg* John Constable, 1776–1837) to immerse himself in the dense physical substance of the forests, marshes and undergrowth where he often

137
Théodore
Rousseau,
*Valley of
Tiffauge*,
1837–44.
Oil on canvas;
64·7×103 cm,
25$\frac{1}{2}$×40$\frac{1}{2}$ in.
Cincinnati Art
Museum

sought a melancholy consolation. The bleakness of the scenery he
depicted certainly expressed feelings of alienation from society with
which many could identify. But just as important, his rough surfaces
and relative lack of finish satisfied a longing for communion with
nature by providing the illusion of its material accessibility. As art
historian Robert Herbert has shown for Rousseau's *Valley of Tiffauge*
(137), the most ordinary elements of nature give rise to an extraor-
dinary pictorial richness. Here, Rousseau directly foreshadowed the
handling of paint in works such as Courbet's *The Brook of the Puits-
Noir* (136 and 141). Thus, in Rousseau's painting especially, and in
that of the Barbizon School as a whole, the world is represented
through particular objects or figures which one apprehends first as
physical forms rather than as symbolic devices or narrative
elements. Through Rousseau's handling of the medium, the viewer
experiences the roughness of unimproved nature; one discovers a
precedent for Courbet's 'pictorial metonymy' too. Although such
forms were certainly vehicles for Rousseau's emotional expression –
hence his intentions may be highly Romantic – it was his ability to
invest the ordinary with such power that the Realists admired.

Rousseau's critical success among his peers cannot have gone unnoticed by Courbet.

In his figure paintings of the countryside, Courbet's approach had clashed with prevailing concepts that lay behind contemporary landscape painting. For rather than representing the country as an ideal place of escape and timeless virtue, as had the Barbizon artist Jean-François Millet, he represented it as a place rife with class stratification and economic practices like any other. Courbet's natural realm was also often filled with animals, who enjoyed its plenitude until the hunter intervened with his muskets and his dogs. Nature thus had the potential to become a microcosm of society as a whole rather than a special refuge. Even as he was elated by his own hunting successes, Courbet's hunting scenes reveal an ambivalence –

38
*The Valley of the
Loue in Stormy
Weather,*
1849.
Oil on canvas;
54×65 cm,
21¼×25⅝ in.
Musée des
Beaux-Arts,
Strasbourg

39
Camille Corot,
*The Roman
Campagna,*
c.1830–1.
Oil on canvas;
97·2×135·2 cm,
38¼×53¼ in.
Cleveland
Museum of Art

a realization that nature's reputation as a harmonious utopia leads to its invasion by human appetite. Courbet's landscapes and hunting scenes thus form a complex group across a wide spectrum. There are many that shamelessly cater to the urban myth of a picturesque and harmonious realm – a myth Courbet oftentimes seems willingly to have shared. Others embody the painter's reservations about that image – both its consequences and its very validity. As in his paintings representing women, Courbet's outdoor scenes evince the conflict between reality and fantasy. They also reflect the tension between his urge to renew the tradition of landscape as a genre of moral force and the less noble temptation to exploit its appeal to the art consumer.

One of few identifiable early landscapes, Courbet's beautifully balanced *Valley of the Loue in Stormy Weather* (138), is perhaps a smaller version of a lost painting exhibited at the Salon of 1849. It demonstrates Courbet's mastery of the current possibilities for landscape structure and effects as applied to the familiar territory of his home region. Its panoramic view emphasizes the grandeur of the valley and includes a compendium of elements – cliffs, valley, trees, water, dwellings and stormy sky – that combine the best of the landscapes from the Italianate traditions of Claude Lorrain (1600–82) and Nicolas Poussin (1594–1665), its most famous seventeenth-

century practitioners. Except for Courbet's higher viewpoint, the painting might be compared to one of the Roman Campagna by Camille Corot (139). Courbet's stormy skies may be compared to the dramatic effects in works by Barbizon painters such as Jules Dupré (1811–89) or Rousseau, and they also suggest Courbet's familiarity with the Dutch tradition, which the Barbizon painters had repopularized in France.

In one of his first large-scale landscapes, however, *The Château d'Ornans* (140), Courbet used his knowledge of these traditions to challenge them. The painting was done specifically for public viewing at the Universal Exposition of 1855, where it appeared rather than in Courbet's own Realism exhibition. Although the painting follows a balanced structure and retains a panoramic view recalling the earlier *Valley of the Loue*, its focal point is the undistinguished, if not downright squat and ugly, rectangular basin of a recently cast cement water well. Courbet's prominent insertion of this motif interrupts smooth readings of the composition as a harmonious and timeless realm. Moreover, the so-called Château d'Ornans was simply the name for the rock formation overlooking the Loue valley from the left, with a few houses constructed on the former site of a citadel destroyed under Louis XIV to thwart local resistance to central authority in the Franche-Comté. Even to this day, such place-names evoke deep memories and reinforce a sense of civic pride. In the context of the authoritarian regime of Napoleon III, then, Courbet's reference to the independent past of his region and the destruction of the fortress constitute an ironic gesture in keeping with his stance in more overtly political works.

The Brook of the Puits-Noir (of the Black Well; 141), also exhibited at the Universal Exposition of 1855, is the first, and one of the most beautiful paintings of a place which Courbet obviously adored and which he often repeated successfully for patrons. (A later variant was one of his first state purchases under the Bonapartist government.) In this quiet and sheltered spot deep in the forest a small tributary to the Loue River runs between large rocks that form an intimate gorge. Less obviously charged with emotion than

140
The Château d'Ornans,
c.1854–5.
Oil on canvas;
81·6×116·8 cm,
32½×46 in.
Minneapolis
Institute of
the Arts

141
*The Brook of the
Puits-Noir,*
1855.
Oil on canvas;
104·1×137·2 cm,
41×54 in.
National Gallery
of Art,
Washington, DC

the landscapes of the Romantics, this painting perfectly suggests a revitalizing refuge for the city dweller beset by noise, filth and crowds. While lacking the specific political reference of *The Château d'Ornans, The Brook of the Puits-Noir* nonetheless represents a specific place far from centres of power as a lush, refreshing Arcadia. In this environment the artist's sense of vitality, freedom and self-assurance are expressed through much looser handling than in *The Château d'Ornans*. And this handling fosters a perception of those surroundings as physically tangible, as accessible through immediate sensations produced by impastoed surfaces. As Courbet's flecked particles of paint seem to make his highlights ricochet through the woods, they convey more about his subjective process of creation than about the measurable visual perception we usually equate with Realism. The effect is to bring the human perceiver and the material environment together through a living dialogue that simultaneously expresses the vigour of nature as a source of vibrant energy and the viewer's own actively aroused response.

Courbet's consistent focus on Franche-Comté already raises the question of political content in all of his landscape painting. Of course, the same question might apply to painters less politicized than Courbet. For example, when Corot paints a scene from Italy, is he not validating a certain place as the location of contemporary yearnings? The 'return to nature' embodied by landscape painting

142
Dominique
Papety,
*The Dream of
Happiness,*
1842.
Oil on canvas;
370×635 cm,
145¾×250⅛ in,
Musée Antoine
Vivenel,
Compiègne

can be traced back as far as wall decorations in luxurious Roman villas, where they were visual equivalents of pastoral poetry and the notion of a golden age. The nineteenth-century concept of nature as a place of freedom and harmony relies on ideals such as expressed by the philosopher Jean-Jacques Rousseau, whose residence in Geneva made his ideas especially powerful in Franche-Comté, just across the Swiss border. Similar concepts were also manifest in literature and in important aspects of utopian thinking. For example, Charles Fourier's ideal communities were to be founded in remote, unspoiled places in order to afford their members an absolutely fresh start. Such concepts are reflected in a painting called *The Dream of Happiness* (142) by a follower of Fourier named Dominique Papety (1815–49) and may also underlie *The Fountain of Youth* by William Haussoullier (1818–91), a painting which Baudelaire admired in 1845.

In such works as these the classical figures derived from the style of Ingres, the bright colours and the allusions to antiquity led to a trend dubbed Néo-Grec, which was briefly practised by idealistic academic painters, and may be seen as the conservative's response to the utopian call of nature in an unstable and rapidly modernizing society. Courbet, of course, would have nothing to do with such academic daydreams. Indeed, *The Studio of the Painter* might be considered a rebuttal to them that places an existing and recognizable world rather than a fantasy at the centrepiece of his personal vision of redemption. In a 'Letter' to Théodore Rousseau (no relation to Jean-Jacques) in his Salon review of 1842, the critic Théophile Thoré argued that industrialization had fragmented society and that art, particularly an art of primal landscapes, such as in Rousseau's paintings, could restore humanity to wholeness. Along related lines, in 1851 the Fourierist critic, and soon-to-be friend of Courbet, François Sabatier claimed: 'Whether we want to or not, we must think about abandoning the cities. Providence seems to have charged landscapists with preparing us for this event by familiarizing and reconciling us with the countryside, man's natural home. You can be sure that this is why there are so many capable landscapists today. Landscape itself is becoming socialist; don't laugh: it

is just that socialism is nothing but the enhancement of the power of nature by reason and its harmonious ordering by science and love.' Such ideas were closer to Courbet's intention.

Not so far from the Néo-Grec golden age were Salon paintings with classical nymphs such as those done by Corot in the 1840s or the more freely brushed nudes and semi-nudes in forest settings done by the young Millet before he took up peasant themes. When Courbet himself first painted nudes, they were also in outdoor settings, although his figures were always more realistic because of their heightened eroticism or their contemporary identity. Their secluded settings often introduced the feelings of wellbeing and privacy that made losing oneself in love seem possible. The spirit of Jean-Jacques Rousseau was certainly close by, but so was the urban conception of nature as a physically restorative commodity. One might further suggest that many of Courbet's landscapes can be seen as 'feminized' places of yearning and desire, nurturing and physically fulfilling, that empowered his sense of masculinity – places of security where he felt particularly loved and free, places without repressive authority. Most of all, home was the source from which he drew sustenance and ideas in planning his challenges to authority, both political and aesthetic. So Courbet's art overall actually presents two complementary images of this countryside. His figure paintings subvert the rural myth of bucolic harmony and classlessness, whereas his landscapes are generally images of solitude and reflection from which he has absented figures that might spoil the primal Rousseauian harmony. The hunting scenes reveal ambiguities that fall into the gap between these two clearer-cut extremes.

Courbet's many trips home and his peripatetic voyages suggest his need for change and for contact with the countryside. Indeed, there were long periods when he spent little time in Paris. Of course, he used his stays outside the city to produce a stock of paintings he tried to sell through dealers and through participation in many exhibitions in other French cities and abroad. Such paintings were almost always landscapes, but those landscapes frequently included scenes of hunting or game animals. We know from Courbet's letters

that he enjoyed romping through the woods in hot pursuit of hare and other prey. He was even arrested once for hunting out of season. During a trip to Germany in the winter of 1858–9 he participated in a large hunt, as the guest of a painter from Besançon who had settled in Frankfurt. Courbet killed a 180-kg (400-lb), twelve-point (thirteen-year-old) stag – a twenty-five-year record, if we are to believe his claims. A year or two later he participated in an Imperial hunt (no doubt the Morny connection) in the Forest of Rambouillet. He made note of the classic styles of sounding the horn and riding that the chief huntsman still employed. Such experiences were sources for many of his pictures, to which he often gave titles taken directly from its rituals (for example, *Le Change*, *La Curée* and *L'Hallali*). Of course, there was an autobiographical element that fed the artist's irrepressible ego. But it should be observed that Courbet took the traditions of the hunt seriously enough to plan illustrations to articles that his friend Buchon would write on the history of hunting in the Jura region.

Often including large-size human figures, Courbet's paintings of the hunt combine figure painting and landscape. They represent a particular form of leisure activity that expands on and confirms many of the attitudes we have already seen towards both, including Courbet's vaunting of regional customs. But more importantly, the hunt allowed men to display their power over nature. In a letter of 1868 to Pierre Dupont, Courbet compared the poet and himself to 'Homer, Rembrandt, and associates, all tamers of wild beasts'. Recalling a theme we witnessed in *The Studio*, Courbet is saying that the artistic enterprise expresses human dominance over the instinctual. Some of Courbet's earliest hunting scenes, especially *The Quarry* (*La Curée*) of 1857 (143), are actually quite meditative, for they show hunters after the event surrounded by their kill. *The Quarry* is a large painting that the artist expanded by adding pieces to the right in order to include the dogs and at the top in order to aggrandize the landscape. Not only is the painting a literal enactment of Courbet's 'additive' compositional process, it reveals how his conception expanded from the simple motif of the hunter and his kill to a more complex and allusive work. In the shadows in the

143
The Quarry,
1857.
Oil on canvas;
210×183·5 cm,
82¾×72¼ in.
Museum of
Fine Arts,
Boston

144
*The German
Huntsman,*
1859.
Oil on canvas;
120×175 cm,
47¹⁴×69 in.
Musée des
Beaux-Arts,
Lons-le-Saunier

145
*The Hunting
Picnic,*
*c.*1858.
Oil on canvas;
207×325 cm,
81¹₂×128 in.
Wallraf-
Richartz
Museum,
Cologne

centre, the hunter – a self-portrait – leans against a tree, his gaze lowered, apparently lost in reflection. Next to him a boy solemnly blows the horn. A deer hangs from another tree to drain its blood prior to skinning and disembowelling (the stage of the hunt called *la curée*, literally, the curing); its head lies on the ground facing us in the foreground. Two large hounds, almost as if they were in conversation, warily check the deer as well as each other. The hunter is lost in reverie, surrounding himself with attributes of the hunt, as if he were either trying to project himself through imagination into the setting the artist has portrayed or to rise through reflection above its evidence of mortality.

With its format similar to *The Quarry*, a painting called *After the Hunt* of about 1859 contains a profusion of dead game on the ground, including a boar, a deer, a rabbit and a pheasant – an unlikely combination that suggests an array of samples rather than the result of an actual day's shoot. *The German Huntsman* (144) probably derives more directly from Courbet's experiences and is more conventionally understood as a hunter approaching his kill. A huge stag lies on his back as the hunting spaniel sniffs at him curiously. All these works suggest some ambivalence about the relationship between sport and the slaughter of animate beings, overpowered and defenceless. As meditations on the relationship of man and nature, they imply both the realm of freedom nature proffers and an ethic of responsibility and restraint.

Another painting deriving from Courbet's hunting experiences focuses more on the accompanying social rituals. *The Hunting Picnic* of *c*.1858 (145) evokes the kind of formal hunting party in which Courbet participated at Rambouillet. The figure seated in the centre wears garments similar to the hunter in *The Quarry* and again resembles Courbet himself. The others around him wait while the boy to the left sets out the picnic. Both men and ladies are superb in their sporting clothes, and the foreground of the painting offers an array of still life that surpasses any other in Courbet's *oeuvre*. Finally, to the right is another assortment of game, guarded by the dogs and worthy of the best of the Flemish game-piece masters such

146
The Battle of the Stags, 1861.
Oil on canvas; 35·5×57 cm, 14×22½ in.
Musée d'Orsay, Paris

as Jan Fyt (1611–61) or Frans Snyders (1579–1657), from whom Courbet may have paraphrased the growling hound of *After the Hunt*. But Courbet was not drawing on Flemish sources for their own sake. Rather, his homage to them was likely to please the German and Belgian patrons for whom he was painting at the time and within whose artistic traditions he was therefore positioning himself. The painting's relatively bright atmosphere, local colours, and realistic details distinguish it from its predecessor, the more sombre *Quarry*, while its emphasis on wealth and leisure complements the others in his series by presenting the hunt from a point of view those paintings had not yet considered.

Ultimately Courbet's hunting pictures present the hunt as a noble activity when practised with respect and restraint, qualities that testify to the hunter's humanity. Indeed, the proud animals themselves also became Courbet's theme, particularly in a group of paintings of stags which display them as powerful protagonists. In a

letter to Francis Wey, Courbet claimed the paintings would have as much impact as *A Burial at Ornans*. They were done on a monumental scale and 'there is not an ounce of idealism in them'. Describing *The Battle of the Stags* of 1861 (146), Courbet wrote admiringly: 'With those animals, none of the muscles show. The battle is cold, the rage deep, the thrusts are terrible and they seem not to touch each other ... Their blood is as black as ink and their muscular strength makes them able to cover thirty feet in one leap, effortlessly, something I saw with my own eyes.' This painting shows two large stags battling with their antlers, one butting at his opponent's thorax while the other appears to let loose a cry. A third stag, in the background, seems to react to the confrontation with emotion. Courbet was especially meticulous about the landscape, which he placed in the Jura region rather than in Germany, where he had hunted the stags, because he preferred the mixture of evergreens

147
Sir Edwin Landseer,
Hunted Stag,
1833.
Oil on wood;
40·5×90·8 cm,
16×35¾ in.
Tate Gallery,
London

148
The End of the Run, 1861.
Oil on canvas;
220×275 cm,
86⅝×108⅜ in.
Musée des Beaux-Arts,
Marseille

and oaks with winter leaves to the more barren winter landscape of Germany. A second painting, *The End of the Run* (148), shows a stag after hours of flight driven to the water, where he will finally succumb by drowning.

Curiously, Courbet, who avoided dramatic compositions and overt emotion in human subjects, allowed himself free reign in his representations of these victims of the hunt. Indeed, here he more closely approached Romantic painting than ever before, for animal scenes were among the favourites of Géricault, who loved horses, and Delacroix, who studied lions and tigers at the Paris zoo and was known for Arab hunting scenes. Yet while Courbet professed the scientific accuracy of his pictures, he knew they were related to the works of Sir Edwin Landseer (1802–73), whom he hoped to rival. The British painter was famous for anthropomorphic animals; he had made a sensation at the Universal Exposition of 1855, and his painting of a dying stag, to which Courbet's *The End of the Run* bears a strong resemblance, was illustrated in the *Magasin pittoresque* as early as 1851 (147). However, unlike Landseer, an animal specialist, or Delacroix, Courbet rarely represented domestic animals and certainly never exotic beasts. His animal pictures concentrate on the untamed domain that fell within the range of man – reality rather than fantasy. The relationship between hunter and hunted was the crucial element that drew his interest, for it offered concrete examples of epic human and animal exertion. He sought a nature-based (in this case, a woodland-based) history – hence the comparison with the *Burial* – rather than the rendering of topography specific to landscape painting. The nearly monochromatic sunset landscape dominated by rust tones in *The End of the Run* itself conveys a muted emotionality but, although such values are the projection of the artist's own feelings rather than inherent in his subject matter, Courbet's paintings of the hunt and of game animals do express a deep-seated belief in nature as an autonomous domain with a heroic life independent of the human exploiter. Indeed, without such a life, how could nature become a source of restoration and harmony for urban man?

Courbet had spent little time in Ornans since 1860, when he made his large pictures of stags. In 1861 he travelled to Antwerp, where he made a highly political speech before an international congress on the arts. In December of that year, while continuing to insist that no one can teach by imposing his views on others, Courbet was persuaded by Castagnary to open a teaching studio near his own. Its principle was to provide a haven for students where Courbet would encourage them to pursue their own individuality, but after general dissatisfaction with the results and complaints that the painter neglected to provide clear lessons, Courbet closed it down a few months later. Then came his extended stays in Saintonge during 1862 and 1863, after which he returned to Ornans in September for nearly two years. Writing to Bruyas during that period, Courbet lauded a painting of a wooded stream he was sending to him as 'a superb landscape of profound solitude done in the valleys of my countryside'. Courbet's ideal was clearly to be on his own in familiar surroundings – another way of describing freedom. Just as the sojourn in Ornans became a source of respite for Courbet himself, it became the occasion for a number of new landscape motifs in which his attachment to the countryside lay behind its representation as a restorative and sheltering realm.

One of those motifs was unique. *The Oak of Vercingetorix at Flagey* (151) represents a magnificently massive and firmly rooted tree that embodies strength and permanence and seems to envelop the viewer physically. The tree totally fills the field of vision, even spreading out with its boughs and leaves beyond the canvas edges. Its immediacy and warmth are enhanced by Courbet's vigorous paint handling, with an impasto that gives the bark its rough and encrusted appearance and with contrasting flecks of lighter and darker values created by patting the surface with sponges and the spatula-like palette knife to enhance the volume of the branches and foliage. We may compare Courbet's picture to Corot's famous *Souvenir of Mortefontaine* (149), painted at the same time. The latter of course alludes to poetic recollections of a place rather than to an actual presence, and the maidens gathering flowers create a feeling of timeless harmony. Corot's superb tree spreads its feathery veil

149
Camille Corot,
Souvenir of Mortefontaine,
1864.
Oil on canvas;
65×89cm,
25⅝×35in.
Musée du Louvre, Paris

150
Théodore Rousseau,
Oaks at Apremont,
1852.
Oil on canvas;
63×99cm,
24⅞×39in.
Musée du Louvre, Paris

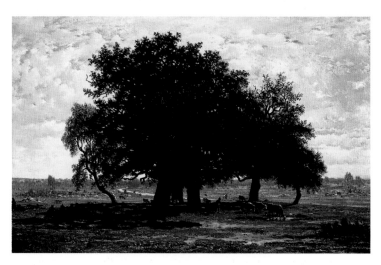

across the picture, but it seems to reach upwards rather than staying earthbound. In contrast to Courbet's forcefully direct techniques, Corot used soft, fine-tipped brushes to create a sense of delicate, sketch-like drawing with liquid paint quite different from Courbet's massing and impasto. In comparison to another well-known painting, *Oaks at Apremont* (150) by Théodore Rousseau, for whom trees symbolized human feelings, we perceive Courbet's tree as a physical fact rather than a metaphor of nature. Moreover, Rousseau uses a shepherd guarding his flock to imply a quasi-religious narrative in

151
The Oak of
Vercingetorix
at Flagey,
1864.
Oil on canvas;
89×111cm,
35×43¾in.
Murauchi Art
Museum,
Tokyo

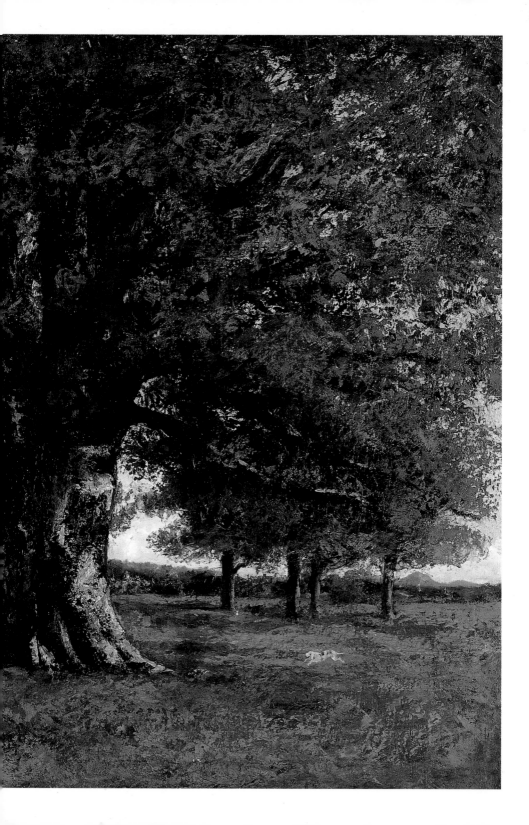

which man finds solace under sheltering branches. In *The Oak of Vercingetorix*, Courbet's tree simply exists visually in such a way as to seem to perform that sheltering function physically. The barely visible dog and the hare he is chasing contrast in their instantaneity with the Flagey oak's architectonic fixity and timelessness.

Courbet's oak was a particular tree that supposedly marked the site of the defeat of the Gallic chieftain Vercingetorix by the Roman leader Julius Caesar. Through its allusion to resisting central authority, it has a historical significance similar to that of the Château d'Ornans, as well as a personal one for Courbet. According to articles published by the Society of Emulation of the Doubs, which included many of Courbet's close friends, ancient Alesia, the site of the battle, was now Alaise, a hamlet near Salins, where Courbet often visited his friend Max Buchon. Courbet and Buchon were both deeply interested in such local historical matters and, although the Doubs's archaeological claims were ultimately disproved, in 1864 they were a source of great local pride. The Oak of Vercingetorix stood for the ancient historical independence of Courbet's region and focused attention on values other than economic associated with the land. Although Courbet and his entire family were property owners, they also felt their activities maintained traditions that transcended business. Their sense of history was quite literally founded on a relationship to nature which differed considerably from that of their urban contemporaries.

A second new motif Courbet developed during 1864 was the cavern called *The Source of the Loue River*. In one version the figure of a fisherman (152) gives the scale of the enormous opening from which flows the spring that becomes the Loue River. The huge grotto is still a famous site near Ornans, and it fascinated Courbet enough for him to make several paintings on the theme taken from diverse angles. All are painted boldly and freely, as if the palette-knife work could express the physical forces underlying the rock formations that dominate the scene, while the substance of the paint itself somehow makes us experience their irregular hardness and density. Naturally, the cave opening of this composition, and other crevices or gorges

152
The Source of the Loue River, 1864.
Oil on canvas; 98·4×130·4 cm, 38¾×51⅛ in.
National Gallery of Art, Washington, DC

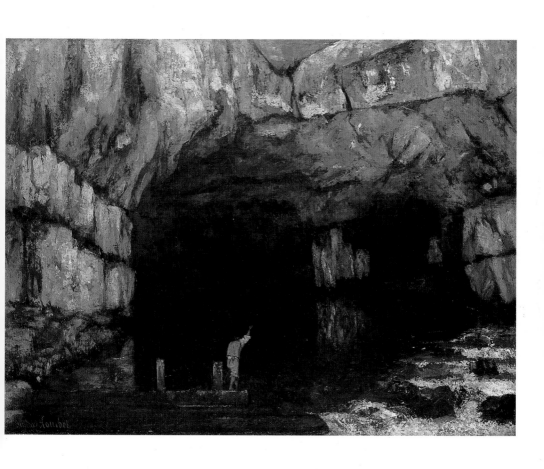

Courbet painted around this time have been compared to *The Origin of the World* (132) for their vaginal connotations. Such limited and solitary spaces create a feeling of intimacy and shelter which in Freudian terms might correspond to the eternal search for the security of the mother's womb. The flow of water, as from the cavern or through the gorge, is commonly given sexual overtones as well. And for Courbet, as we have seen, sexuality often underlay insecurities and needs which he nevertheless translated artistically into terms that apply to us all. The wellbeing Courbet found in these scenes from his home territory is expressed through a sense of warmth and familiarity that arises from his combination of informal technical execution and realism of effect. He makes it possible for us to know these places by enabling us to experience them through physical and emotional directness rather than through the more intellectual – hence less immediate – and more narrative-like process of scrutiny that would have been imposed by a more precisely linear style.

At this period Courbet was increasingly working with private collectors in mind rather than the government. In 1861 he wrote to Francis Wey that the government would not be able to support him, since it was 'a slave to its own institutions' – that is, it would never show independent taste. He no longer believed that official acceptance of Realism was inevitable. He added: 'I must rely on private collectors if I want to go on being as free as I am.' But he also worried about not showing enough paintings within their financial reach at the Salon, even while he continued to believe that the Salon was a place where he had first and foremost to maintain his visibility and reputation. And he was also concerned that those same collectors might not understand paintings that lacked conventional finish: 'If the tiniest detail is missing, the work no longer exists for them. That landscape [a snow scene] was not finished, the leaves were not picked out, they existed only as a mass. It would have been successful only among artists.'

Courbet's style, based on massing of colour rather than on draughtsmanship, was a particular problem for snowscapes, a type of landscape he had developed recently and pursued more systematically

during the winter months of his stays in Ornans. At first, his snow-scapes were associated with hunting themes, as in *The Hind Forced Down in the Snow* or the superb *Fox in the Snow* (155) with its prey. Courbet subsequently produced many other works in which the snow allowed him to construct his compositions almost as abstractions. For example, the motif of *Trees in Snow* (153) has little special interest other than as the pretext for the vigorous spreading of paint over the darker elements of the scenery. In such works the bright, pure, heavily impastoed flecks of white are applied in a complex and intuitive combination of stiff-brush stippling, palette-knife scumbling, and effects of miscellaneous other tools, including rags, sponges and probably Courbet's own fingers. They contrast with

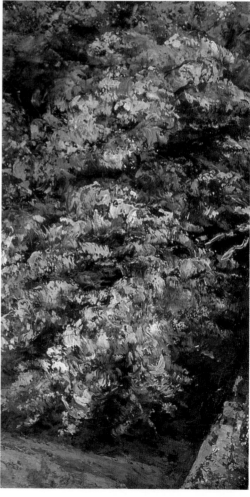

153–154
Trees in Snow,
c.1865.
Oil on canvas;
72·4×91·5 cm,
28½×36 in.
National
Gallery of
Scotland,
Edinburgh
Right
Detail

155 **Overleaf**
The Fox in the Snow, 1860.
Oil on canvas;
85×127 cm,
33¾×50 in.
Dallas Museum
of Art

the warm, dark brown underpainting to produce an almost mono-chrome richness enlivened by scattered, barely visible particles of other colours, often blues and reds. These scenes, in other words, permitted Courbet to concentrate on the virtuoso effects of art technique appreciated by a slowly growing clientele.

As the government was mounting its second Universal Exposition in 1867, Courbet once again planned his own concurrent exhibition in a specially built pavilion which he hoped would become his permanent studio (156). It was located at the Place de l'Alma, along the route between the Exposition itself on the Champ de Mars (where the Eiffel Tower now stands) and the Salon (since 1857 held at the Palace of Industry, near the Rond Point des Champs-Elysées). As for his 1855 exhibition, Courbet assembled a survey of his career. However, this time approximately half of his more than one hundred works were landscapes. Courbet considered snowscapes a special category, giving them a separate designation in the catalogue for his exhibition. Returning to Ornans in the winter of 1866–7 to prepare for the show, Courbet made a couple of large snowscapes on hunting themes. A photograph (157) documents him in his studio painting the largest of them, *The Hallali of the Stag* (158), which he exhibited as his only recent figure painting. In the photograph one can see Courbet filling in the landscape after painting the figure of the stag. The figures

156
Courbet's Exhibition Pavilion at the Place de l'Alma, Paris, 1867

157
Étienne Carjat, Courbet painting *The Hallali of the Stag* in his studio in Ornans, c.1866–7

158
The Hallali of the Stag, 1867. Oil on canvas; 355×505 cm, 139⁷⁄₈×199 in. Musée des Beaux-Arts et d'Archéologie, Besançon

159
Paul de Vos,
*Stag Chased
by Dogs*,
1637.
Oil on canvas;
212×347 cm,
83½×136¾ in.
Museo del
Prado, Madrid

stand out against the winter background like heroes of manly exploits in their personal arena of fulfilment. Courbet has even given the horseman the look of the swashbuckling Turkish rider from Delacroix's *Scenes from the Massacres at Chios* (see 6), a comparison that enhanced his claim to be making contemporary history painting.

The majority of Courbet's landscapes were without figures, but many include animals. *The Covert of the Roe Deer* is an elaborate instance of a type of painting that Courbet produced in many simpler and smaller examples, too. In one of those, *The Hunted Roe Deer*, the animal seems to be listening, intelligently, perhaps for hunters giving chase. Hunting was so ingrained an aspect of interaction between man and his environment in Courbet's milieu that love and sympathy for such animals never extended so far as to criticize the hunt itself, as many people do today. However, in *The Hallali of the Stag* one senses the pain of the animal's suffering, as the dogs revel in attacking it until warded off by the hunter's whip. The dogs' bestiality is emphasized by the grotesque poses of some, including the one held back by the hunter and one just above Courbet's signature rolling on his back exposing his genitals. Yet compare the gravity of Courbet's hunting scene with the furore of the attack in *The Stag Hunt of Diana* by Peter Paul Rubens and Frans Snyders (destroyed) or the *Stag Chased by Dogs* (159) by Paul de Vos (1596–1678).

At this time, perhaps more than before, Courbet felt alienated from and angry at Paris and officialdom. In 1866 he was involved in a long and acrimonious correspondence with Nieuwerkerke over the allegedly broken promise to buy the *Woman with a Parrot*, and he had recently brought a lawsuit over the stockbroker Lepel-Cointet's refusal to pay for the *Venus and Psyche*, which he had purchased at the same time as *The Covert of the Roe Deer*. The proprietors of the Brasserie Andler were suing him for unpaid bills, which Courbet claimed others had charged indiscriminately to his account. Courbet's disillusionment seemed complete. Perhaps this helps explain why he returned to subjects of life around Ornans, such as *The Poachers* and another winter scene, showing a peasant mother begging from door to door with her children and a goat, called

Poverty in the Village, Ornans. In the following year he painted the *Alms of a Beggar at Ornans* (160), which he had planned earlier as part of his 'roadside' series, and a summer scene (161) called *Siesta during Harvest Season (Doubs Mountains)*. It would seem that Courbet sought a catalogue of both the hardships and the beneficence of country life, in which the human relationship to the environment and the climate was primordial. The *Siesta during Harvest Season* is especially unusual for, unlike the popular Barbizon artists, Millet, Jacque and Troyon, whose work Courbet admired,

160
Alms of a Beggar at Ornans, 1868.
Oil on canvas; 211×175·3 cm, 82½×69 in.
Burrell Collection, Glasgow

161
Siesta during Harvest Season (Doubs Mountains), 1868.
Oil on canvas; 212×273 cm, 83½×107½ in.
Musée du Petit Palais, Paris

Courbet rarely painted cattle or other farm animals, with the notable exception of *The Peasants of Flagey Returning from the Fair*. In the *Siesta* the animals are bulls, beasts of burden who draw the ploughs seen in the background. They and the human figures thus share a moment of respite during the hot summer day. *The Alms of a Beggar at Ornans* recalls *The Young Ladies of the Village*, who are engaged in an act of charity. Thus, Courbet's return to figure painting of Ornans themes has a retrospective character and, when compared to the ambitious works of the early 1850s, now seems slightly sentimental and nostalgic. Courbet's own motives appear confused. Did he really want to return to the days when figure painting was his primary concern, with all the political and aesthetic challenges it had brandished? Or was he seeking solace in the ways of his countryside? Courbet's own comparison, in a letter to Castagnary, of the *Siesta* to *The Covert of the Roe Deer* underscores the equivalency in his mind between human and animal subjects as equally capable of conveying feelings of nature as a place of ideal harmony.

In Courbet's solo exhibition of 1867 the single largest category of subject matter consisted of seascapes. Recall that he had spent the late summer of 1865 at Trouville. From September to October 1866 he returned to Normandy, this time to Deauville as the guest of the young Count de Choiseul, who commissioned the artist to portray two of his greyhounds (162). Contrasting in colour and pose, they cut elegant figures against a low horizon. It was during this stay, in addition to the previous summer's, that Courbet produced the large stock of seascapes he exhibited in 1867. He enjoyed such work because he could do the pictures so quickly and freely – he estimated two hours per painting. They were also commercially successful. Here, dramatic point of view mattered little compared to dramatic pictorial effect. Indeed, Courbet told of walking once with Baudelaire, who urged him to paint this particular view or that. Yet Courbet claimed he could set his easel anywhere: 'There is no point of view', he responded. Although we have seen that he often chose places and motifs in Franche-Comté that had emotional and even political connotations for him personally, for seascapes Courbet had no artistic agenda that required a certain

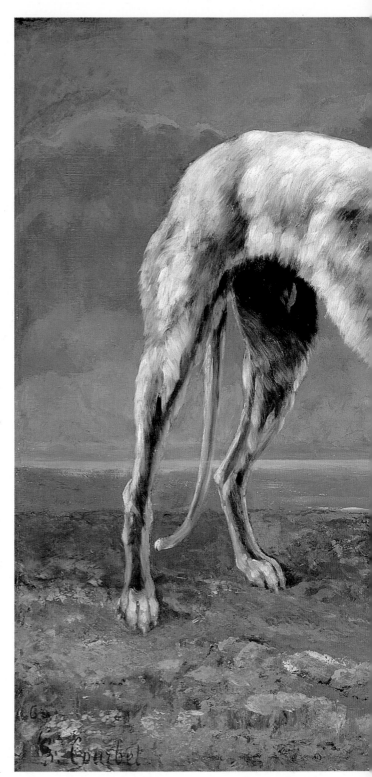

162
*The
Greyhounds of
the Count de
Choiseul,*
1866.
Oil on canvas;
89·9 × 116·2 cm,
35⅜ × 45¾ in.
St Louis Art
Museum

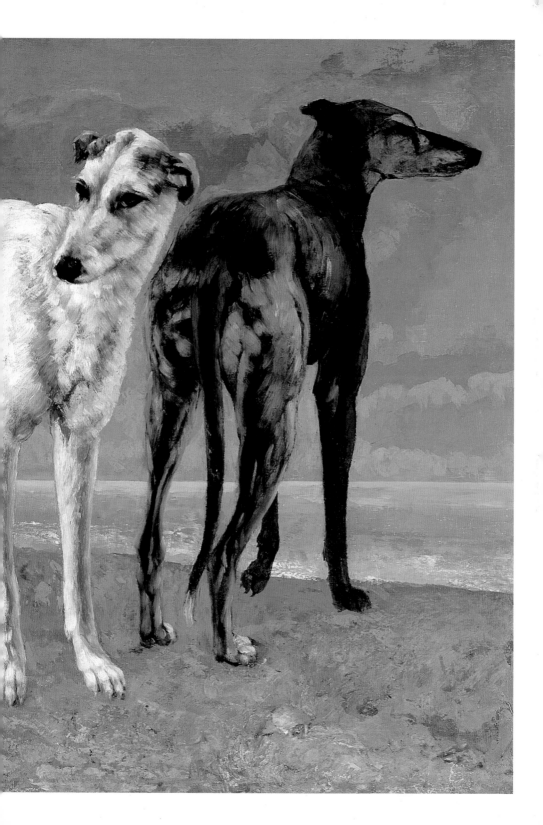

compositional recipe. There his freedom was complete.

What Courbet's paintings may have lost in conventional picturesque-
ness, they gained in authenticity, much like photography. The latter,
because it used a mechanical device, was equated with lack of selec-
tivity. The same criticism had dogged Courbet and was fundamental
to the attack on Realism. A comparison between a photograph of the
sea by the well-known landscape photographer, Gustave Le Gray
(163), and a seascape by Courbet (164) offers striking similarities
and differences. Both reveal of course the emptiness and vastness of
views on to the water. The drama is entirely visual, the result of light
playing through clouds and off the surface of the sea. In the photo-
graph our sense of reality derives from the sharpness of the image,
which testifies to the technological perfection of a device that
records the imprint made by nature upon the light-sensitive surface
of its negative. There is little immediate consciousness of the
photographer's selecting and composing input. In Courbet's paint-
ing, by contrast, resemblances are generalized. Although the prece-
dent of photography in a sense legitimized his direct engagement
with an unparticularized natural scene, the artist's expression of
spontaneity in representing it lent authenticity to the scene's status
as art. That is, the ostensibly unmitigated realism of the 'photo-
graphic' was counterbalanced by evidence of the artist's creative
subjectivity and will. The dualism of Realist art becomes especially
notable here. Thus, Courbet's bold and broad palette-knife work, his
massing of paint to form clouds and the streaking across the fore-
ground are all marks of the artist's physical presence that declare
the immediacy of his process in the making of the picture. One is as
enthralled by the magic through which he creates the illusion of
nature as by the appearance of nature's own grandeur and serenity.
The result is a feeling of energy and imminence that is absent from
the photograph, despite its pristine beauty. There is a sense of
dialogue and participation with nature on material terms that once
again corresponds to the personal experience of nature Courbet was
able to convey in so many of his other landscapes.

It has often been observed that, as in photographs, Courbet's land-

63
Gustave Le
Gray,
The
Mediterranean
Sea, near Sète,
1860

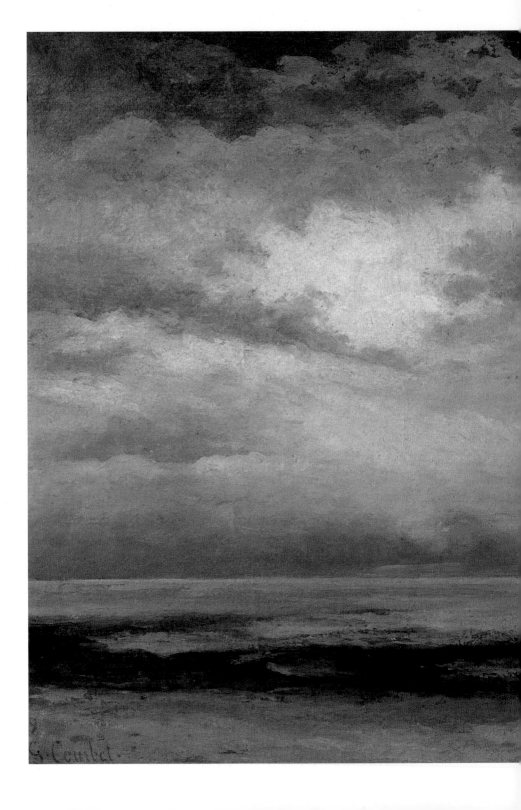

164
Immensity,
1869.
Oil on canvas;
60×82·2cm,
23⅝×32⅜in.
Victoria and
Albert
Museum,
London

scapes became increasingly flat, the result of instances where he treated the canvas as a surface upon which to assemble various landscape effects. The idea lying behind traditional landscape composition was to create a structure within which the eye would move progressively, as if following a visual narrative from spot to spot. That movement would invariably lead the eye into 'space', that is, the fictive space that underlies and produces traditional compositional coherence. This method of composition gave way to far simpler and more instantaneous readings. For example, earlier, in *The Château d'Ornans* (140) the eye moves from the fountain in the foreground, along a valley, to a village and distant cliffs; a bit later, in *The Brook of the Puits-Noir* (141), it goes from boulders in the foreground, back along the stream and through the gorge into the deep woods, but now the lack of an open horizon could be taken to hamper the impression of depth, and the physicality of Courbet's paint constantly reminds us of the picture's material surface. In many other paintings the flattening effect is even clearer. Courbet tended to concentrate attention on a primary motif, and he rendered his pictorial effects of brushwork and palette knife, rather than precise description, simultaneously on the surface rather than sequentially into space.

Writing to Max Buchon, Champfleury once observed that Courbet's directness was so simplistic that 'the sky is pure blue, the rocks are grey, the fields are green. That is enough for him to make a painting.' Champfleury had understood how such simplifications, which produced a 'sudden, green, vital and fresh impression of nature', were well suited to the city dweller, burdened by business affairs and in need of effortless relief. Courbet was producing and packaging nature as an object for consumption. Only those whose attitudes were less urban had trouble understanding his Parisian success. What they did not realize was that Courbet had become more than a man of Ornans. His attitudes towards scenery that did not look like Franche-Comté were the same as those of his urban clientele. At the seashore he was as much a vacationer as his hosts.

Courbet's patrons even ordered paintings by type or by category of

effect, requesting a *Puits-Noir*, a marine, a waterspout, and so on. Seascapes, with their indeterminate spaces and limitless horizons, best exemplify his new system of 'painting by effect', as art historian Anne Wagner has called it. One critic wrote of it tongue-in-cheek: 'Just as God brought forth the heavens from nothingness, Monsieur Courbet has brought forth his seascapes from nothing at all, or next to nothing. Three colours on his palette, three strokes of the brush – in the way only he knows how to do – and *voilà*: an ocean and infinite sky! Prodigious! Prodigious! Prodigious!' Though ironic, this writer had put his finger on the secret of Courbet's success. But that success does not mean that Courbet's vision was somehow insincere. Recall that Courbet's first experiments with seascapes date to his visit to Bruyas in Montpellier, near the Mediterranean. From that time they followed the same reductive formula of basic horizontal coloured zones signifying shore, sea and sky. Judging by those examples now most frequently reproduced in books or shown at exhibitions, the ones that are most popular today are the emptiest and most abstract – the most ostensibly modern. Yet, more than in the Mediterranean views, Courbet reveals himself a subtle colourist in many Normandy scenes. Each band retains colours from the other, creating a gentle, overall, pastel-like unity. Unlike in his other landscapes, Courbet did not work towards lighter hues from a dark ground, but painted entirely in luminous tones in the manner, perhaps, of the many watercolourists – including Delacroix (165) – who frequented the coast. However, the majority of Courbet's seascapes were either framed on one side by cliffs (166) – most notably the cliffs at Etretat made famous later by Claude Monet (1840–1926) – or had boats or fishermen in the foreground to create a sense of scale. Moreover, Courbet sought further variety by using changing states of weather. *The Waterspout*, showing a phenomenon caused by the transformation of vapour over water into rain, was an especially successful effect, which he reproduced in several versions. In subsequent campaigns to make seascapes for his new dealer Paul Durand-Ruel (who would become the chief agent for the Impressionists), Courbet could paint a *Calm Sea* as well as a huge, storm-driven wave (167). The latter was an especially

165
Eugène
Delacroix,
Cliff at Etretat,
c.1859.
Gouache over
black chalk on
bluish paper;
14·5×24 cm,
5⅝×9½ in.
Boymans-van-
Beuningen
Museum,
Rotterdam

166
*The Cliffs at
Etretat after the
Storm*, 1870.
Oil on canvas;
133×162cm,
52³⁄₈×63⁷⁄₈in.
Musée d'Orsay,
Paris

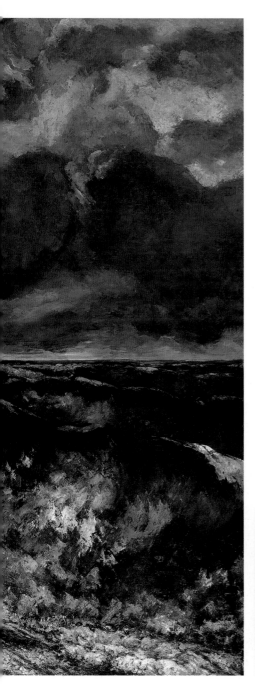

167
The Wave,
1870.
Oil on canvas;
112×144 cm,
44¹⁄₈×56³⁄₄ in.
Nationalgalerie,
Staatliche
Museen, Berlin

168
Victor Hugo,
Ma Destinée,
1857.
Gouache, pen
and wash;
17×26 cm,
6⁵⁄₈×10¹⁄₄ in.
Maison de
Victor Hugo,
Paris

powerful new motif, in which Courbet gave not just the water, but the heavy clouds themselves a feeling of dense physicality. His painting may be compared to the quintessentially Romantic image of the sea entitled *Ma Destinée* (*My Destiny;* 168) made by the great poet Victor Hugo. But Courbet has transformed Hugo's symbolism of the sea as the infinite and the spiritual which tosses a boat into a wall of brute material force devoid of literary associations.

Although the idea of painting in series is often associated with Impressionism, especially Monet's famous images of grain stacks, Rouen Cathedral and waterlilies, the seascapes by Courbet surely constitute the first such series in the Impressionist vein. Earlier, Courbet's concept of 'series' was based on a scientific notion of finding patterns of similarity across different topics. Now, the series became a 'variety pack' within a single topic, motivated, no doubt by the painter's continuing curiosity about natural events and appearances, but certainly facilitated by the commercial success of the seascapes among patrons who nonetheless demanded compositions that were unique, not mere copies or variants of an original. Courbet's works surely left their mark on Monet, whom Courbet befriended along with Charles Daubigny (1817–78) and Eugène Boudin during his many stays in Normandy. The on-the-spot or *plein-air* approach to painting, the bright colours and the broad, direct attack on the canvas were attitudes all four men shared. The flattening found in many of Courbet's works became characteristic of the Impressionists, but their fascination with Japanese prints took the latter even farther towards the compositional schematization and formal simplifications we find in seascapes by both Manet and Monet of the mid-1860s. It is as if the wilful modernity of the Impressionists resided in such effects, while Courbet continued to develop a formula he had discovered many years earlier. Indeed, as a colourist, Courbet certainly remained more traditional and can be distinguished from his Impressionist colleagues of the 1860s in that regard, as well.

One may still wonder how such obviously modern works as the seascapes fit into Courbet's career overall. For, although the subject

169
Stock,
Caricature of
The Wave.
Stock-Album,
1870

matter of nature in its rawest form may have given Courbet the opportunity to create a novel genre, it also afforded him the opportunity to be himself most completely. For one thing, the relationship between solitude in nature and freedom, however complex we have seen it to be, is a master-theme of his landscape painting. It should be observed that figures are rare in Courbet's seascapes, in spite of the fact that the beaches had become places for bathing and socializing, as witnessed in Impressionist paintings (211). When figures are present at all, they are usually distant, like parts of the natural scene itself. As in so many of the Franche-Comté landscapes, Courbet produced a sense of the physicality of the natural realm. Even when looking on to emptiness, Courbet brought the world to his surface, and we experience its existence through webs or lumps of paint. In such solitary environments Courbet alone became the dominant force; his role becomes that of nature's actual producer. He is present through his gaze and its almost erotic appetite for matter. A caricature of one of his paintings of waves (169) shows surf served up on a palette knife with the caption: 'Allow me to offer you a slice of this lightweight painting.' The irony is that the substance on the palette knife indicates not the lightness but the materiality of Courbet's water. Courbet had told his students at the short-lived atelier of the rue Notre-Dame-des-Champs that 'painting is an essentially *concrete* art and can consist only of the representation of *real and existing* things. It is a completely physical language.' Although there he was arguing primarily that artists

671. — LA VAGUE, par Courbet.
Permettez-moi de vous offrir une tranche de cette peinture légère.....

cannot represent what cannot be seen, his choice of words also implies that the reality of the world lies in our physical experience of it and that painting offers the kind of 'language' through which that experience can be conveyed to others.

Thus, Courbet's landscapes partake of the same attitude that we found animating far more programmatic paintings, such as *A Burial at Ornans* and *The Studio of the Painter*. Its key concept is that we are material (as opposed to spiritual) beings whose relationship to the world consists of material events that are contingent on material conditions. In creating the physical sensations of paint and of surface texture in his landscapes, Courbet made available to a wide public an instant and direct form of relationship to what they took to be nature. Though far less complex for them, that relationship was not unlike his own, in which the physical dialogue with nature fulfilled a psychological and emotional need that gnawed at him when he was deprived of it. Ultimately, the engagement with common materiality that Courbet's landscapes embody exemplifies the same Positivist notion of human existence as rooted in time and place that characterized his Realist figure painting. For we also experienced the latter through its physical impact – of scale, of observed detail and of material surfaces. It is tempting to say, then, that in the case of landscapes Courbet enacted a certain form of being through the example of his painterly engagement with the stuff of nature. They can thus be interpreted as consistent with the politico-moralizing claim of *The Studio* that, through the physical production of art, the painter shows society the way to overcoming alienation. In both Courbet's figure painting and landscape, then, the strong duality between the painter as subjective performer and as objective observer persists. Nowhere was this duality between subjectivity and objectivity – one might say between the visionary and the Realist sides to Courbet's artistic profile – given freer expression than in the landscapes, particularly the seascapes. They can be considered both the culmination of his own subjectivity and a perfect embodiment of more general attitudes towards nature as spectacle and effect.

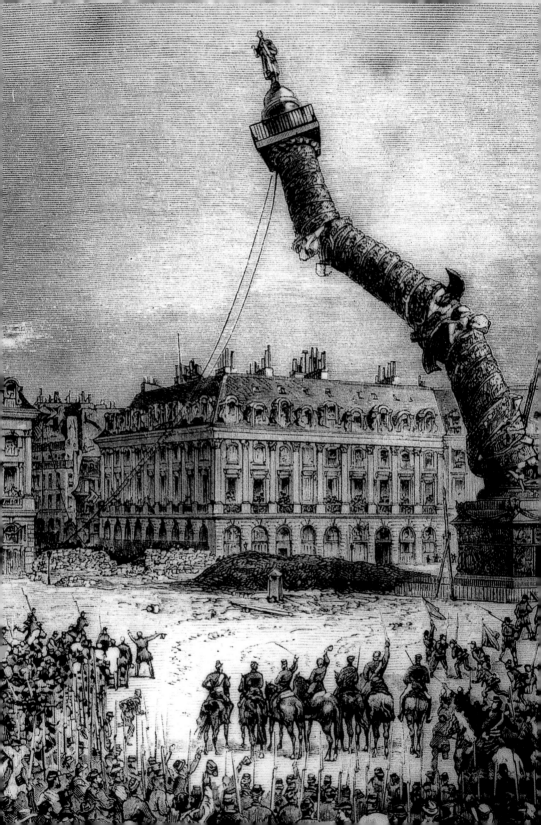

After focusing on Courbet's relationships with women and on his landscapes, it is important to return to his role as a prominent political figure. From the point of view of his presence in Paris, there may seem to have been a lull in Courbet's partisan activities until the Paris Commune. However, Courbet's interests were often simply directed elsewhere than to Paris, and, in any case, his pursuits had never been primarily political, even though his painting so often produced politicized responses. It might additionally be observed that political activities may not always be overt or revolutionary, especially in times of government censorship and repression. We shall recall that when Courbet went to Saintonge, his hosts were the most prominent liberal republicans in the region. His presence there was, for them, a political as well as an artistic one. It was there that he composed the ill-fated satire on priests, *The Return from the Conference*, through which he may have been trying to reassert a political presence and which Proudhon adamantly defended. Even a withdrawal from the limelight to a 'place of freedom', such as during Courbet's extended stays in Franche-Comté, has political overtones when one considers how under attack he felt in his dealings with Nieuwerkerke. Indeed, Courbet's fears of government surveillance were justified. For example, in 1868 the police reported his presence at Proudhon's grave on the anniversary of his death. In 1869 Courbet accepted the title of Knight of the Order of Merit of St Michael offered by the King of Bavaria, because, as he explained, it expressed the will of German artists, who controlled their own exhibitions and awards. The following year he publicly refused the French Legion of Honour, because, he said, he opposed even the appearance of accommodation with the monarchic order which autocratically dominated artistic affairs.

By way of comparison, one might ask whether Proudhon's activities in the decade before his death had been much more political than

170
The Destruction of the Vendôme Column, Paris (detail). Engraving from a drawing by Daniel Vierge, *Le Monde illustré*, 1871

Courbet's? For example, despite his three-year exile in Brussels, Proudhon was too busy writing his books to attend the international conference on art of 1861 in neighbouring Antwerp, where he had been invited to share his views on the effect of modernity on art. Courbet did travel there, where he delivered a tumultuous impromptu speech espousing Proudhonian principles. After listening to many attacks on Realism, in which his name was mentioned by several speakers unaware that he was in the audience, Courbet rose to give a spirited defence. It was then that he coined the famous phrase cited in Chapter 5: 'Realism is none other than the negation of the ideal' and claimed that through Realism he arrived at 'the complete emancipation of the individual and finally at democracy'. Such proclamations caused a stir within Proudhon's circle, members of which seemed to realize that Courbet had stolen the spotlight and done violence to the philosopher's ideas. The fact is that Courbet had simply been trying to position himself as the exiled thinker's disciple. For example, in 1860–1 he had been toying with ideas for paintings directly inspired by Proudhon's attacks on Napoleon III's military adventurism – France had invaded northern Italy in 1859 in order to expel the Austrians. No doubt the political climate in France was too dangerous for him to move from thought to action. After all, if a man as famous as Proudhon had been exiled, there would be no stopping at pursuing a painter.

Yet Courbet could not resist political involvements, and when an incident in Ornans reflected the conflict between Bonapartists and Republicans in a microcosm, he was quick to champion the right to free expression against repressive government. It happens that in 1863 or 1864 Urbain Cuenot's chorale was denied the right to the traditional dinner following its annual performance. The Bonapartist mayor of Ornans had sent the police to threaten the owner of the restaurant where it would normally have been held. The incident would have gone unremembered, had not another friend of Courbet's, Marcel Ordinaire, published in 1867 a satire of local politics in which he goaded the conservative mayor. Ordinaire's opponents struck back with a lawsuit, and in 1868 Courbet jumped in with his own pamphlet, though never published, in which he

attacked the Bonapartist government not only for repression, but for the apathy that its control of artistic patronage created among the citizenry. It was, of course, at this very time that Courbet did a series of scenes of poverty in Ornans. Could there have been some political motivation underlying the timing of their appearance?

Although these episodes are of relatively minor significance, they lead directly to Courbet's political activities beginning in 1870 and continuing under the Paris Commune of 1871. Following the Salon des Refusés of 1863, there had been various attempts at reform in artistic matters, culminating finally, as the empire was weakening, in the elimination of Count Nieuwerkerke's powers by the creation of a separate Ministry of Fine Arts. Under the new structure the Salon juries were finally to be made up of representatives elected exclusively by artists. A landscape painter named Émile-Charles-Julien de la Rochenoire (1825–99), along with Corot, Daubigny and a few others, organized a list of candidates to run on a reform platform, whose guiding concept was that artists alone should form the jury and administer the Salon. In February 1870 Rochenoire invited Courbet to be among the candidates, and he sent Courbet a draft of the proposed constitution. Courbet's response in early March was measured. He felt the new effort was a step in the right direction and that he could not refuse to join it, but he also offered a profound critique of every aspect of Rochenoire's constitution that envisioned continued state paternalism: 'Liberty consists in being able to do without the state (the Revolution seeks to attain this goal). Men must continually be answerable only to themselves. [In relying on state authority,] you are regressive and outside the current trend.' In his belief that centralized governmental authority must be eliminated in favour of self-empowered groups, Courbet continued to espouse the principles of Proudhonian anarchism. In his refusal a few months later to accept the Legion of Honour he sounded the same theme: 'The state is incompetent in artistic matters … The day it lets us be free, it will have fulfilled its duty towards us … Let me end my life as a free man.'

As the empire declined Courbet's political activities increased. In

July 1870, the Franco-Prussian War was declared. Much of Napoleon III's foreign policy in the later 1860s had been spent trying to slow the rise of Prussia, which was hammering together leadership of a unified Germany under Count Otto von Bismarck. The French still had ambitions to restore Napoleonic rule on the left bank of the Rhine, but war was proving increasingly unpopular at home. Military spending was curtailed, and the French vacillated in the face of Prussian victory over Austria. Then Bismarck sprang his trap: he had secretly arranged for a member of the Austrian royal family to accede to the throne of Spain. Feeling surrounded by Germans and insulted by the sudden revelation, the Spanish-born Empress and the French people demanded war; the ailing Napoleon III was incapable of preventing it. Thus Bismarck made France into the aggressor. Two days after its first defeat at Sedan, in eastern France, the regime of the Second Empire fell, replaced on 4 September by the Third Republic, which proclaimed a government of national defence. The Prussians began besieging Paris a few weeks later.

While some artists, such as Monet and Camille Pissarro (1830–1903), went to England during the siege, others stayed to form an Arts Commission and elected Courbet to be its president. Their purpose was to exploit the situation in order to establish their independence from government administration and to assure the safety and integrity of public art collections against both the advancing enemy and outgoing Bonapartist curators who were rumoured to be absconding with works. The Minister of Public Instruction, Jules Simon, appointed Courbet to another commission, to examine the Louvre archives in order to assure the whereabouts of many objects that were not ordinarily exhibited and might easily disappear. (Courbet ultimately resigned from this appointment.) However, other events preoccupied Courbet in the meantime. As early as September, he began proposing the dismantling of the commemorative column in the Place Vendôme. It had been made from melted cannons captured by Napoleon I at the Battle of Austerlitz and obviously had a high symbolic value for the successor regime of Napoleon III, Napoleon's nephew. At the invitation of the socialist journalist Victor Considérant, Courbet read an open letter to the

German army and German artists at a public gathering on 29 October. The gist of his message was that now that they had settled their score with Louis-Napoleon, the Germans should not substitute another repressive regime for his: 'What business do you have with the Republic? Do you want to put the Revolution in chains?' He advocated a European federation and proposed the melting down of weapons from both sides into a monument to liberty. Yet the Prussians were still approaching, and some shells fell near Courbet's studio on the rue Hautefeuille, causing him to move to another location. He donated a painting to be sold in order to purchase a cannon, dubbed 'The Courbet', for the 45th Battalion of the National Guard, and he was made an honorary *lieutenant d'état-major* by its commander. He may have visited the front once or twice as well. When the armistice was signed on 28 January, ceding the provinces of Alsace and Lorraine to Prussia and leaving open the status of the Doubs, Jura and Côte d'Or departments (it seems the Doubs considered becoming a canton of the Swiss Federation), Courbet was among many who believed that France had been sold out by conservative politicians.

It was under those circumstances that the Paris Commune was proclaimed on 18 March, severing the city's ties with the government of Adolphe Thiers, who had negotiated the peace treaty, and setting up an independent municipality that, it was hoped, would eventually confederate with similar communal entities which would spring up spontaneously around the country. Thiers and his followers fled to Versailles. On that same day Courbet published an open letter in several newspapers, using his position of president of the Artists Commission to call upon all artists to participate in reforms like those he had urged before in his critique of the Rochenoire proposal. He proclaimed: 'The preceding regimes that governed France nearly destroyed art by protecting it and taking away its spontaneity. That feudal approach, sustained by a despotic and discretionary government, produced nothing but aristocratic and theocratic art, just the opposite of the modern tendencies, of our needs, our philosophy and the revelation of man manifesting his individuality and his moral and physical independence. Today, when democracy must

direct everything, it would be illogical for art, which leads the world, to lag behind in the revolution that is taking place in France at this moment.' The language of this open letter recalls the programme of *The Studio* and is again indebted to Proudhon, whom Courbet called 'the Christ' of the new movement in a subsequent address. But Courbet's specific proposals were born more of his personal experience than of social theorizing. All artistic matters would be administered by artists, from the running and staffing of museums to the organizing and financing of Salons, the allocation of public commissions and the appointment of teachers of art. Courbet paid for election posters (171) and, after a 'Profession of Faith' published in the

171
Poster announcing Courbet's candidacy for the Commune, April 1871

172
Portrait of Jules Vallès, c.1861. Oil on canvas; 272×221 cm, 107⅛×87 in. Musée Carnavalet, Paris

173
View of the Place Vendôme shortly after the destruction of the column, May 1871

newspaper *Le Rappel* on 15 April, was voted a member of the Municipal Council of the Sixth Arrondissement in elections held on the following day. He wrote to his family on 30 April that he was 'up to my neck in politics … I get up, I eat breakfast, and I sit and I preside twelve hours a day. My head is beginning to feel like a baked apple.'

The most memorable of the political acts with which Courbet is associated is the destruction of the Vendôme Column (170, 173–5). Although he floated the idea in September 1870, his proposal, once clarified, was really for an orderly unbolting of the bronze reliefs which would be preserved in a museum at the Hôtel des Invalides,

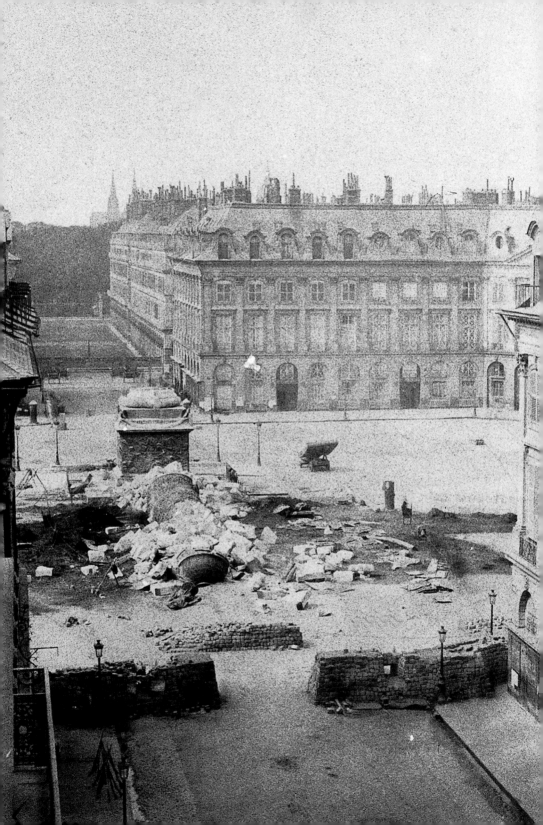

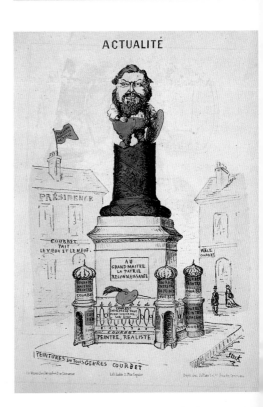

Numéro 7. — 24 Floréal an 79 — 2 SOUS

LE FILS
DU
PÈRE DUCHÊNE
ILLUSTRÉ
Paraissant deux fois par semaine

LE CITOYEN COURBET

Foutant en bas toutes les colonnes.... de Paris.

ACTUALITÉ

174 Above Caricature of Courbet. *Le Fils du Père Duchêne illustré*, 1871

175 Below Stock, Caricature of Courbet. *L'Actualité*, 1871

176 Opposite One of the barricades erected in the rue de Rivoli, Paris, during the Commune, 1871

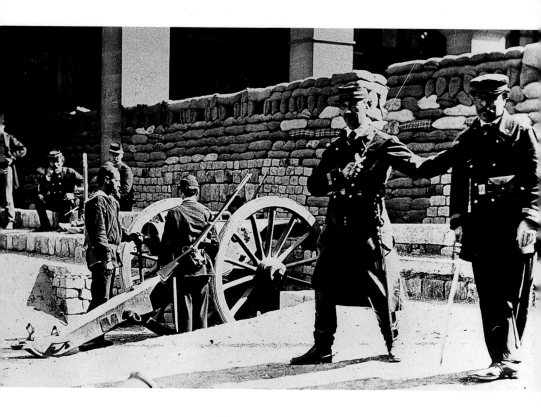

the military veterans' hospice. However, on 4 April 1871 the revolutionary socialist Jules Vallès (172) called for its destruction in his radical paper, *Le Cri du Peuple*, and on 12 April, four days before Courbet's election to the Commune and therefore without his direct participation, a decree to that effect was issued. The humiliating target date was to be 5 May, Napoleon I's birthday, but a delay in making the arrangements meant it was not brought down until 16 May. When the troops of the Versailles government defeated the Commune in a virtual massacre on 6 June, no single act was so central to their pursuit of revenge against the Communards. Although today the destruction of the Tuileries palace seems a far more significant loss, no scapegoat was available (177). But even before then the municipal council members of Ornans showed their displeasure by 'unbolting' the sculpture of a *Boy Fishing Bullheads* that Courbet had made some years earlier for the village fountain. They returned it unceremoniously to the painter's father. To add insult to injury, in Paris the government had demolished the pavilion

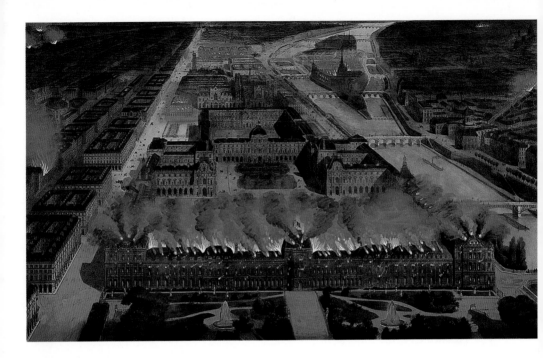

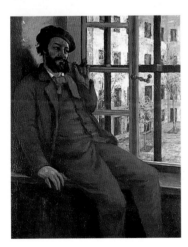

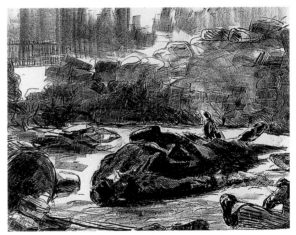

Courbet had built in 1867 and used the rubble for defensive barri-
cades at the city gate of the Porte de la Chapelle. Like many others
who had not fled Paris, Courbet was arrested (on 7 June), jailed
(part of the time in solitary confinement), and tried (in August).
While awaiting trial in prison, he was also saddened by news of his
mother's death at the beginning of the summer. (It was rumoured
that she died when a malicious neighbour falsely announced

Gustave's death.) Yet through it all Courbet maintained that he deserved to be thanked for helping to preserve the art treasures of Paris, even though he also offered to pay for restoring the column. It is true that he disapproved of the destruction of the residence of the Bonapartist minister and first leader of the Third Republic, Adolphe Thiers, and that he saved many works from Thiers's art collection when the house burned down. But Courbet was sentenced to six months in prison and fined 500 francs, half the price of one of his average seascapes. He got off lightly, for many other prominent figures among the nearly 50,000 arrested Communards had been deported or condemned to death. He served much of his sentence at the prison of Sainte-Pélagie in Paris, where common criminals were kept, since Communards were not treated to the special quarters for political prisoners. However, Courbet had enough money to procure a private room and have meals brought in from outside. Even so, stomach troubles and haemorrhoids forced his transfer to a nursing

177
The Tuileries Palace Burning, Paris, 23 May 1871.
Lithograph with gouache;
38·5×55 cm,
15⅛×21⅝ in

178
Self-Portrait in Prison at Sainte-Pélagie, c.1872.
Oil on canvas;
92×72 cm,
36¼×28⅜ in.
Musée Gustave Courbet, Ornans

179
Édouard Manet,
Civil War, 1871.
Lithograph;
39·7×50·8 cm,
15⅝×20 in

180
Self-Portrait, 1871.
Charcoal on brown paper;
81·5×65 cm,
32⅛×25⅝ in.
Musée du Louvre, Paris

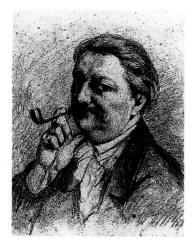

home in the Paris suburb of Neuilly, where he recovered in comfort for the remainder of his prison term and a little beyond. A self-portrait in prison (178), although it probably postdates his actual incarceration, shows the artist in his cell, pensive and slimmed by illness.

Naturally, the intensity as well as brevity of Courbet's political involvements left him no time for painting. Unlike Jacques-Louis

181
Women Prisoners in the Stables at Versailles,
1871.
Charcoal on bluish paper;
16×27 cm,
6¼×10⅝ in.
Musée du Louvre, Paris

182 Above
Still Life with Fruit,
1871.
Oil on wood board;
15·2×71·1 cm,
6×28 in.
Art Gallery of Ontario,
Toronto

183 Left
Still Life with Apples,
1871–2.
Oil on canvas;
59×73 cm,
23¼×28¾ in.
Mesdag Museum, The Hague

David's grand paintings of the French Revolution of 1789–93, or even Manet's famous 1871 lithograph *Civil War* (179), which focuses on a Parisian National Guardsman killed by the Versailles soldiers, there is nothing currently known in Courbet's art that bears direct witness to the momentous events. There is only an uneasy self-portrait drawing in which he has shaved off his beard in an attempt to elude the police (180). When his adventures came to their abrupt end, however, he had nothing but time on his hands. In a sketchbook he used while awaiting his trial, he recorded a number of scenes of prisoners, one of which (181) shows them sleeping in a gloomy

stable, illuminated through a barred window. At Sainte-Pélagie he was allowed to paint only in his cell. His artistic vision nonetheless conceived some marvellous still lifes, one of which he actually did on a door panel (182). It contains a painted escutcheon at the centre with the words 'Ste Pélagie'. Some other still lifes of fruit, a subject he had never before attempted, are arranged in compositions that are almost equally abstract, like coloured symbols of life burgeoning within barren confines. Others, probably painted at the nursing home, show more formal settings, including outdoors, as in a power-ful version that is nevertheless inscribed with the name of the prison (183). By his frequent use of apples for these compositions Courbet may not simply have been choosing the most common and available

fruit, but one that his old friend Buchon had chosen to characterize the spontaneity of the painter's talent – recall his statement that 'Courbet produces paintings as an apple tree produces apples' and also how Courbet described himself as a 'baked apple' in a recent letter to his parents. Yet Courbet represented fruits realistically, as they might appear when found in nature – sometimes bruised, wormy and past their prime, as if they had fallen to the ground. His persistently ungracious – one might say proletarian – technique belies the bourgeois domesticity with which still life was still generally associated. As we saw in *A Burial at Ornans*, an aspect of material existence is mortality; hence the still lifes of blemished fruit may in some sense be viewed as Realist versions of the traditional *vanitas* – the fragility-of-life theme – a new motif made particularly relevant by the vicissitudes of Courbet's personal fortunes and poor health.

184
Faustin
Caricatures of two paintings by Courbet refused at the Salon during his imprisonment. The caption below the first is: *An odalisque with trimmings, or, you've made your bed so you will have to lie on it.* The second caption is: *The fruits of reflection have fallen unripe for having spent six months in the shade – 17,000 francs for the lot!* La Chronique illustrée, 6 May 1872

With the fall of the Commune Courbet seemed like fair game for all. No artist was ever so despised. Alexandre Dumas *fils*'s cruel caricature may well have expressed the right-wing view in 1871: 'From what uncanny cross between a peacock and a slug, from what antithetical genesis, from what sebaceous oozing can this thing called Gustave Courbet have been generated? Under what jar, with what manure, in what mixture of beer, corrosive mucus and flatulent oedema, this loud and hairy gourd, this aesthetic belly, this incarnation of the impotent and imbecile Self?' After prison, Courbet stayed in Paris to try to recover the huge property and financial losses he had incurred during the chaos following the Commune. But the outcry against him had become so vicious that he was reluctant to show himself in public. It was suggested at the National Assembly that he be locked in an iron cage under the pedestal of the column.

So Courbet returned to Ornans in considerable frustration, but he had matters to take care of there, too. The studio he had proudly built for himself on the main road to Besançon had been looted by the Prussians and then vandalized by townspeople who bore him ill will. He stayed with the Ordinaires, who were perhaps the most politically liberal of his remaining friends. Their fishing expeditions may have led Courbet to try a new motif: the enormous brook trout that swam the local streams. Of course, fish are a form of game, and Courbet arranged them as such in a composition (185) where they are hanging limply from a tree. A disparity in scale between foreground and background gives the fish an aura of monumentality that may be ironic in the light of their capture. Indeed, a picture with a single trout (186) shows the creature still alive, but caught on a hook and fishing line. It brings to mind the famous song 'Die Forelle' ('The Trout') by Franz Schubert (1817), a classic by Courbet's time and surely known to an artist who was a lover of song and a Germanophile. Its final verses, repeated twice as a refrain when performed, would have conveyed Courbet's feelings of betrayal: 'Und ich mit regem Blute/Sah die Betrogne an' ('And the blood stirred within me/As I looked at the cheated trout'). An inscription on the painting reads: *in vinculis faciebat* (made in prison), further contributing to a comparison between the trout and the captured

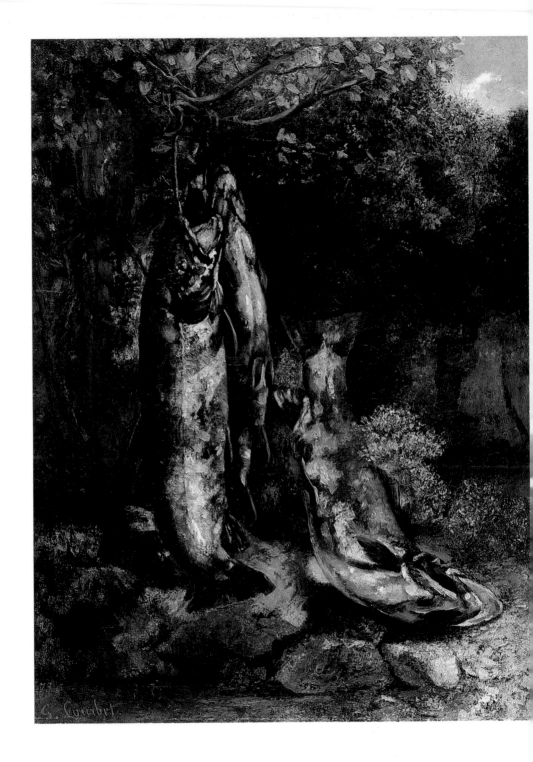

Courbet. Although not actually made in prison – Courbet undoubtedly added the words and predated some works in order to enhance their commercial value – the painting is certainly a poignant recollection of the artist's state of mind.

There is a sense of fatigue in Courbet's letters and his conduct during this period. His health continued to be poor; liver problems, probably from too much drinking, added to his complaints about stomach troubles and haemorrhoids. He was duped by a woman posing as a countess, with whom he carried on a passionate correspondence but who then tried (unsuccessfully) to blackmail him with his explicit letters. But the worst news came in early 1873, when conservatives in the Chamber of Deputies began debating whether to hold him financially responsible for the Vendôme Column in a civil action. (His previous conviction had been before a military court.) His tone became desperate: 'I will have my sisters organize a sale of my possessions. I am in a state of inexpressible anxiety. I have to go to Paris, to Switzerland, etc. I have to paint pictures. I have three lawsuits in Paris, I don't know which one to pay attention to. I would give my life for a penny. I could use a wife.' His paintings were rejected on the grounds of his political past by the Paris committee for the International Exposition to be held in

185
Still Life with Three Trout from the Loue River, 1873.
Oil on canvas;
116×87·5 cm,
45⅝×34½ in.
Kunstmuseum,
Bern

186
The Trout,
1872.
Oil on canvas;
52·5×87 cm,
20⅝×34¼ in.
Kunsthaus,
Zürich

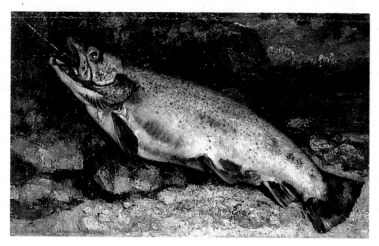

Vienna. He was excluded from the Salons (184), but in any case he hesitated to show his paintings for fear of seizures, which he tried to escape by arranging for dummy purchases. He sold many paintings outright to the dealer Durand-Ruel, who would ship them out of the country. And even though he bragged that his notoriety had caused his prices to triple, he was all the while working at a furious pace, even using assistants to increase production. He claimed his business was earning 20,000 francs per month.

Despite a glimmer of optimism engendered by this apparent financial recovery, Courbet began preparing to leave France. In May the liberal government of Thiers fell, to be replaced by the arch-conservative Marshal MacMahon, whose claims to represent the 'moral order' were heavily backed by the Church. A few days later a law decreeing the reconstruction of the Vendôme Column at Courbet's expense was passed, and on 19 June the Minister of Finance ordered the sequestration of all of Courbet's property in France, pending the outcome of a trial. It was as if the Republic could guarantee its respectability only by persecuting one of its most persistent advocates. Courbet's first reaction was to stand fast. If he had not left France during the Commune, why should he leave now?

LE REBOULONNAGE DE LA COLONNE
— Mais si je la paie... elle sera à moi, la
coloïne, et je ferai mettre ma statue sur la
coloïne.

187
André Gill,
Caricature of
Courbet.
L'Esprit follet,
8 June 1872

188
Hadol,
*The Rebolting
of the Column*
L'Éclipse,
15 June 1873
The caption is
*But if I pay for
it, the column
will belong to
me and I will
place my statt
on the column*

But then again, what if every painting he subsequently made should legally become state property? He expected to be charged the enormous sum of 200,000 francs. (The final amount was more than half as much again.) Caricatures helped undermine Courbet's case by making him appear to have a carefree attitude. In one (187) he is shown smiling complacently, as if unconcerned by his troubles. In another (188) he is insisting that a statue of himself be placed at the column's summit if he is required to pay.

By 23 July 1873, Courbet had crossed the border into Switzerland, breathing a bit easier at the taste of freedom. He soon began setting up shop in La Tour-de-Peilz, a village next to Vevey on the shores of Lake Geneva. The various hearings and appeals, as well as personal lawsuits, preoccupied Courbet throughout his time in Switzerland. In May 1875 his middle sister Zélie died, and Courbet expressed bitterness that political events had prevented him from seeing her, as they had his mother before she died. During his exile Courbet was visited by many friends and relatives, including his 75-year-old father, whose portrait he painted in 1873 (189). Although he produced numerous paintings, often as beautiful as his earlier work,

189
Portrait of
Régis Courbet,
1873.
Oil on canvas;
92×74 cm,
21¼×29⅛ in.
Musée du
Petit Palais,
Paris

190
*The Château de
Chillon*, 1874.
Oil on canvas;
86×100 cm,
33⅞×39⅜ in.
Musée Gustave
Courbet,
Ornans

191
*Sunset on Lac
Léman*, 1874.
Oil on canvas;
54·5×65·5 cm,
21$\frac{1}{2}$×25$\frac{3}{4}$ in.
Musée Jenisch,
Vevey

one is easily tempted to view them in the context of feelings of loss and disillusionment. There is something mournfully still in his views of *The Château de Chillon* (190) on Lake Geneva, or *Sunset on Lac Léman* (the French name for Lake Geneva; 191). Both are calm but with a sense of immobility rather than relief or joy in their solitude. Knowing Courbet's personal saga, it is hard not to psychologize, even while recognizing that both paintings are like picture-postcard views that aimed to sell. Yet even that admission should not exclude the possibility of their greatness or sincerity. Indeed, Courbet's repetition of both motifs in many versions suggests their appropriateness both to his feelings and to those expected of him by the public. The Château de Chillon was legendary for the imprisonment of one Chevalier Bonivard, who had been held there in chains for four years in the 1500s. Lord Byron's poem 'The Prisoner of Chillon' (1819) told

of suffering and political injustice and had already inspired a painting by Delacroix in 1835; that tradition would certainly have given the castle special meaning for Courbet, too. The autobiographical and the moralizing, so obvious elsewhere in his work, are even more unavoidable here.

Courbet's activities in Switzerland were similar to those in France. He painted at many different spots. He sent works to exhibitions, both in Switzerland and in other countries, including England and America, where Whistler had put him in touch with various agents. Geneva was where the largest number of political refugees from France had settled, and Courbet was in touch with that community. It included the left-wing journalist, Henri de Rochefort, whose grim and furtive portrait Courbet made in 1874 (192). Rochefort had been exiled to the French penal colony on New Caledonia in the Pacific, but he escaped by rowing boat and was taken back to Europe by friends. The escape was embarrassing for the conservative French government, a fact that made Courbet's portrayal a kind of act of solidarity with his friends and of defiance towards the government, even though Rochefort did not appreciate the likeness and gave the picture away. Courbet was also welcomed by the Swiss left wing, being made an honorary member of the Democratic Circle of Fribourg in 1875.

As an expression of gratitude to the Swiss and a further act of defiance towards France, Courbet offered a sculpture of the bust of a woman (193) representing *Liberty* or *Helvetia*, the Swiss Republic, to the community of La Tour-de-Peilz in 1875. The bust is perhaps most notable for its obvious ties with the traditions of republican symbolism, especially Delacroix's famous painting of *Liberty on the Barricades* (see 8). He subsequently offered copies of the bust to the city of Martigny and to the Literary and Commercial Circle of Fribourg. His gesture always resulted in ceremonies and banquets, in which he naturally and jovially participated. A photograph of 1875 (194) shows Courbet at a meal with members of the Fribourg Circle, and an account of the celebration includes some excerpts from Courbet's letter accompanying the bust: 'Liberty is the common heritage of all

humanity; it belongs to no nation in particular and can be manifest in any, but on one condition, namely that artistic genius never be hindered by concerns foreign to the idea it wishes to express.'

It may be worth recalling that in the France of the 1870s Impressionism was emerging as the most advanced style. Its cosmopolitan scenes of the Paris boulevards or suburban leisure, painted in bright colours and with an ostensibly casual technique, speak of a very different life from that which Courbet was enduring. Of course, the Impressionists' paintings were not yet accepted by the general public, but for presumably aesthetic rather than political reasons. In 1874, having been excluded from the Salon, the

193
Liberty or
Helvetia,
1875.
Plaster;
a. 100 cm,
39⅜ in.
Communal
Archives, La
Tour-de-Peilz

194
Courbet and
his friends in
Switzerland,
1875

Impressionists organized their first independent exhibition in the studio of the photographer Nadar, an old friend of Courbet. But there is no indication that Courbet was very aware of what was going on; indeed, he complained that the French government was interfering with his ability to practise art by, among other things, making it impossible for him to see what was happening in Paris. Yet Courbet's Swiss work, done in relative isolation, nonetheless paralleled that of the Impressionists when it shared their informality. For example, a late *Sunset on Lac Léman* (195) suggests the broken brushwork and scattering of light and reflection over the

195
*Sunset on Lac
Léman*, *c.*1876.
Oil on canvas;
74×100 cm,
29⅛×39¾ in.
Kunstmuseum,
Saint-Gallen

196
Alfred Sisley,
*View of the
Canal St
Martin*,
1870.
Oil on canvas;
50×65 cm,
19¾×25⅝ in.
Musée d'Orsay,
Paris

water that is so often found in the work of Monet or Alfred Sisley (196). Yet, on a lark, Courbet could go in a diametrically opposite direction. His signboard for the Café du Soleil at Nyon (197) is a brilliantly archaic still life, worthy in its wooden immobility and simple classicism of the best seventeenth-century provincial master. His sense of humour had not left him entirely, nor had his lack of prejudice towards different genres of art.

During this exile a new kind of rumour hounded Courbet, one traceable not simply to his estranged sister, Zoé, whose denunciations (to Bruyas for example) were one source of the complaints, but to his own practices. He was accused of signing paintings made by his

197
'Bon Logis à Pied', signboard for the Café du Soleil, c.1877. Oil on wood; 44·5×103 cm, 17½×40⅝ in. Musée Historique, Nyon

assistants in order to obtain the higher prices his own name would bring. He protested that certain dealers, such as Alexandre Bernheim, were knowingly selling fakes, and a newspaper reported that a factory near Geneva was producing them. Ultimately, however, Courbet seems to have been more concerned with receiving the money for paintings attributed to him than with scrupulously maintaining the highest level of quality. Certainly, he felt desperately in need of money, for which he was ready to sacrifice his respect for a few less fortunate collectors. Examples of such collaboration are difficult to find, however, for Courbet was not really using his assistants to make finished pictures, but rather to prepare his canvases in

order to save time. One snow scene from 1873 (198) actually bears the signature of Cherubino Pata (1827–99) along with Courbet's initials. There also exist works both by Pata and by Marcel Ordinaire (1848–96) using similar motifs to Courbet's, such as Ordinaire's *Ravine of the Brême* (199) near the famous Black Well. Unsigned imitation Courbets of varying degrees of mediocrity are much more common. Paintings by Pata with Courbet signatures exist as well, but it is very hard to know who actually put in Courbet's name.

In March 1876 the Republicans gained control of the Chamber of Deputies in the general elections. Later that year Jules Simon became prime minister of a liberal government. On 4 May 1877 the final verdict on Courbet was decided. He would have to pay 323,091·68 francs for the re-erection of the Vendôme Column, but he could pay in semi-annual instalments of the reasonable sum of 5,000 francs. Although Courbet hesitated to accept a deal that would indenture him for over thirty years, he badly wanted to return to France, for he dearly missed his father and his sister Juliette. By agreeing, he assumed that he would be able to return, and he began preparing for the Salon of 1877 a large painting of a *Grand Panorama of the Alps, the Dent du Midi* (200). On 16 May, however, MacMahon dissolved Jules Simon's government and temporarily imposed the monarchist Duke de Broglie as prime minister. In the face of such instability, Courbet is said to have given up his painting in despair, leaving it unfinished. Whether Courbet would actually have returned to France, however, is doubtful. He might have visited his family, but according to his friends in Switzerland he would not have left until all other Communards were allowed to return as well. By this time another factor had intevened: Courbet's health had begun seriously to deteriorate. He admitted that he had been drinking a great deal and that depression had led him to take absinthe, a wormwood distillate known to cause brain damage and delirium. His body began to retain so much liquid that by his own estimation his waist measured 140 cm (55 in). He was weak with exhaustion. Gustave Courbet died on 31 December, his father at his side. He was fifty-eight years old. He was buried in La Tour-de-Peilz on 3 January 1878.

198
Cherubino
Pata,
*Entrance to the
Forest in
Winter*,
1873.
Oil on canvas;
50×78 cm,
19³⁄₄×30³⁄₄ in.
Musée Gustave
Courbet,
Ornans

199
Marcel
Ordinaire,
*Ravine of the
Brême*,
1879.
Oil on canvas;
73×92 cm,
28³⁄₄×36¹⁄₄ in.
Musée des
Beaux-Arts et
d'Archéologie,
Besançon

200
*Grand
Panorama of
the Alps, the
Dent du Midi*
(unfinished),
1877.
Oil on canvas;
151×209 cm,
59½×82⅜ in.
Cleveland
Museum of
Art

On 26 November 1877 an auction of paintings and other belongings seized from Courbet's studio in the rue Hautefeuille was held in Paris. The proceeds were to go towards his debt. At his death, Courbet left everything to his sister, Juliette, who refused to pay any claims. In 1880, a general amnesty allowing exiled Communards to return to France was declared, and those on whom the government had levied fines were released from obligation. However, Courbet's body was not returned to France until 1919, on the centenary of his birth.

Toute la vérité.

La vérité

Rien que la vérité.

No theories of art historical development or of an artist's personality
will ever fully explain a work of art. For a picture is itself a piece of
evidence in history and biography as much as it is the object of
investigation. In Courbet's case nothing really explains the boldness
of *A Burial at Ornans* or *The Studio of the Painter*, or, for that matter,
The Origin of the World. Their explosive presences and sweeping
reconceptions of the art of painting are not adequately anticipated
by what can be learnt through Courbet's stylistic evolution, his
personality or even his politics.

Following an artist's death, historians and critics often try to make
sense of his or her career. Consciously or not, they generally find
terms for it that fit the needs and perceptions of their time. But in so
doing, interpreters are often obliged to play down the uncanny, the
unpredictable and the mercurial in the artist in order to render that
career as a part of normative and orderly historical development.
Only thus can they produce a coherent and historically continuous
object for public consumption. That is not to say that the result is
always false, but rather that its side of truth may serve purposes and
may have an emphasis that shift over time. Courbet is a perfect
example of that phenomenon. For nothing could be so obvious in
retrospect as the relationship between Courbet's rehabilitation and
the political developments of the Third Republic; yet, ironically, the
means to that rehabilitation was to depoliticize Courbet. In 1881–2
the left wing of the Republican party took power and established a
Ministry of Fine Arts with the long-time friend of Manet, Antonin
Proust, as its director. Proust oversaw the purchase of five important
works by Courbet for 150,000 francs and received the donation of *A
Burial at Ornans* from Juliette Courbet. In 1882 the École des Beaux-
Arts organized a major Courbet exhibition, the opening of which
was attended by the president of the Republic. Even the monarchist
newspaper *Le Figaro* applauded the 'new recognition of Courbet's

201
Randon,
*The Master. Le
Journal
amusant,*
15 June 1867

talent'. At the Universal Exposition of 1889 no fewer than eleven works by Courbet were shown at the official exhibition celebrating a century of French art since the 1789 Revolution.

Yet, as art historian Linda Nochlin has clearly demonstrated, at the same time as political liberalization was making possible Courbet's entry into the canon of French art, critical writings on him either avoided or denigrated the relationship of his art to politics by omitting his political aims and connections while stressing the so-called trans-historical values embodied by his style. Shortly after his death several writers published assessments of his career. According to one of them, despite his greatness as a painter, Courbet was 'a simple idiot' when it came to being 'a philosopher, a moralist and a politician'. For this writer politics had nothing to do with art, and its influence can only have been 'pernicious'. A second writer more or less concurred, claiming that 'Courbet was an instinct more than a brain', and a third claimed his greatest achievement lay in landscapes (an ostensibly neutral subject matter). The picture of Courbet offered by his most intimate friend and supporter through the later years, Jules Castagnary, was related. For Castagnary the French tradition was grounded in the democratic character of naturalism, of which landscape was the most perfect expression. Courbet's landscapes thus exemplified what was best and lasting in French art. Although few knew better than Castagnary how committed to politics Courbet had been, Castagnary regarded Courbet's specific political actions as secondary to his general embodiment of the spirit of French art he was now trying to define.

Still following Nochlin's analysis, the one dissenter to the depoliticizing chorus that followed Courbet's death was none other than one of his left-wing journalist friends, Jules Vallès. Writing pseudonymously from exile in London, Vallès held that Courbet could not have done otherwise than become involved in politics, and he took that as a positive quality rather than something that happened to the painter in spite of himself. Vallès saw Courbet's Realist urge to 'penetrate nature' as including the nature of humanity: 'He plunged into the ocean of the crowds; he heard the heart of a people beat

like the thuds of a cannon.' Rather than integrating Courbet into a tradition of French painting, he saw him as its independent exception: 'The pistol shots that are fired against tradition, even when the barrel of the pistol is a paint brush, disturb the tranquillity of those who lick their fingers over paintings, who lick their fingers over ministers.' But Vallès's point of view had little impact. And on the centenary of Courbet's birth, Théodore Duret, chronicler of the Impressionists who had been part of Courbet's Republican circle in Saintonge, could assert: 'Time has made its action felt. Courbet the political man has vanished from our attention.' It was not until the poet (and Stalinist polemicist) Louis Aragon's book, *L'Exemple de Courbet* of 1952, that a politicized view of Courbet's career returned, but it was both a nostalgic glorification of the rising proletariat as well as a contemptuous attack on bourgeois hatred for political art. The political interpretation of Courbet received little credibility until T J Clark's *Image of the People* of 1973 gave it a solid footing in thorough research. With Clark, indeed, there flared a battle within art history, not simply over Courbet, but over a new form of art history – the social history of art – that would re-ground art in the context of its social, political and economic conditions. Indeed, since the 1970s, Courbet has been a focus for various new approaches to art – including Marxism, gender studies and psychoanalysis. They collectively constitute the so-called 'New Art History'. This book has attempted to follow the narrative of Courbet's career and to provide a basic understanding of his aesthetic while informing both with the insights provided by these interpretative viewpoints. It has tried to suggest complexities and possibilities within Courbet rather than impose on him a singular version of truth.

Even during his own lifetime, there was no single Courbet. The tension between politics and art that required his rehabilitation after death lay behind the legend that surrounded him in life. In Max Buchon's remarks on *A Burial at Ornans*, one may recall how Courbet's *naïveté* and his politics were considered two sides of the same coin. 'Absolute realism', Buchon maintained, was 'indispensable in painting as well as in politics'. In Champfleury's early accounts, too, politics and realism were inseparable. By 1860,

however, he was more focused on Courbet the 'master-painter', that is, on the extraordinary pictorial talents Courbet used to 'colour nature with [his] own temperament'. In 1870 he quoted Courbet as saying, simply 'I make stones think.' He chided Courbet for believing that his painting resulted from doctrines of free, independent and democratic art: Proudhon knew nothing about art, and Courbet had been a fool to be taken in by him.

The final blow to the link between Courbet and Proudhon may have been delivered by Alexandre Schanne's memoir of 1887. It is a caricatural account of an alleged conversation between Courbet and Proudhon from the 1850s:

'Tell me now, Citizen Master Painter, what brought you to do your *Stonebreakers*?'

'But,' answered the Citizen Master Painter, 'I found the motif picturesque and suitable for me.'

'What? Nothing more? ... I cannot accept that such a subject be treated without a preconceived idea. Perhaps you thought of the sufferings of the people in representing two members of the great family of manual labourers exercising a profession so difficult and so poorly remunerated?'

'You are right, Citizen Philosopher, I must have thought of that.'

From that time on it was not unusual to hear Courbet say: 'One would think I paint for the pleasure of it, and without ever having meditated my subject ... Wrong, my friends! There is always in my painting a humanistic philosophical idea more or less hidden ... It is up to you to find it.'

As early as 1856 Théophile Silvestre had mocked 'Courbetism', deriding Courbet's intellectual abilities and contributing to the image of Courbet as loud and low-class, uncouth and uncultured. That his spelling was atrocious and that his grammar was shaky were widely known in his circle, for he had often asked friends to write down or copy over statements he wanted to make public. By 1884 Joseph Peladan could state that 'Courbet is not someone to be refuted, but whom one quotes in order to pity, he is so ridiculous, or to laugh.'

202
Gill,
Courbet Avant la Lettre.
L'Éclipse,
2 July 1870

Avant la lettre.

Randon's cartoon of 1867, entitled *The Master* (201), presents Courbet's disembodied head like the sun with radiating paintbrushes, and makes facetious puns on his doctrines: 'The truth, the whole truth, nothing but the truth', and in the caption: 'Nothing is beautiful but the true, only the truth is good.' A caricature of 1870 by André Gill (202) shows him as a roly-poly country bumpkin, carefree in a cloud of pipe smoke. Who could take seriously the ideas of such a buffoon? Yet it was precisely the method to Courbet's 'madness' that triggered such responses. He used the press more directly than artists before him had ever done. He wrote letters in response to articles and demanded that they be printed. He published his open letter to art students. He spoke before the Congress at Antwerp, which was reported in the press. He leapt at the opportunity to work with Proudhon on a book on art. He published pamphlets with his political opinions, and he ran for public office. And, however extreme his statements may have been in many cases, they were far from incoherent ravings; they all have a common thread.

The legacy of an artist is only truly knowable through its effects on later generations. Courbet's example certainly encouraged further development of the imagery of provincial life and of working classes from which his own painting had first grown. The melodramatically heart-rending *The Forced Halt* (203) by Alexandre Antigna (1817–78), for example, reveals the distress of a homeless family whose search for a better life is cruelly interrupted by the death of their horse. But although such representations of the common people and social themes deserve to be included under the general heading of Realism, their elaborate strategies for winning sympathy also suggest they belong to a long tradition of paternalistic homilies that Courbet's painting defied. As we saw, it was Courbet's link to popular culture and his material matter-of-factness that sparked political uneasiness and accusations of vulgarity.

The group portrait of 1864 by Henri Fantin-Latour (1836–1904), called *Homage to Delacroix* (204), brings together artists who represent a second generation of Realism. They include Édouard Manet,

203
Alexandre Antigna,
The Forced Halt, 1855.
Oil on canvas;
140×204 cm,
55⅛×80⅜ in.
Musée des Augustins, Toulouse

204
Henri Fantin-Latour,
Homage to Delacroix, 1864.
Oil on canvas;
160×250 cm,
63×98½ in.
Musée d'Orsay, Paris

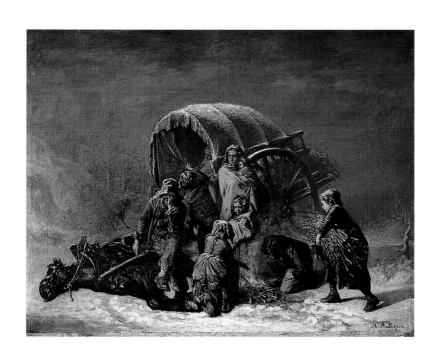

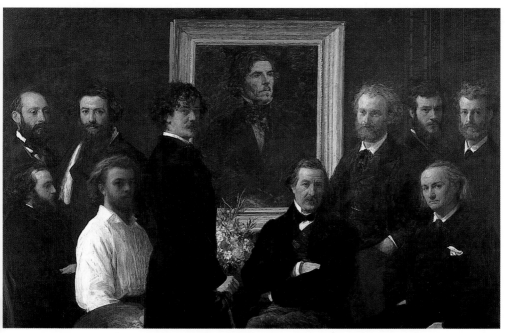

James McNeill Whistler, Alphonse Legros and Félix Braquemond, joined by the writers Edmond Duranty and Baudelaire, in addition to Champfleury, placed before the *Self-Portrait* of Delacroix, who had died the previous year. By the mid-1850s the standard critique of Realism had attacked its lack of creativity, and in his essay on the *Salon of 1859* Baudelaire vehemently reformulated the same theme. During a discussion of Delacroix's concept of imagination, Baudelaire defined Delacroix's differences from Realism, which he now labelled Positivism. He wrote: 'The *positivist* says: "I want to represent things as they are, or as they would be, supposing that I did not exist." The universe without man. The man of imagination says: "I want to illuminate things with my mind and project their reflection to the minds of others."' Perhaps it is not so odd, then, that painters such as Manet would honour the great Romantic, Delacroix. And Courbet's absence from Fantin-Latour's group is conspicuous. Indeed, these artists seem to look back beyond Courbet as a way to reaffirm their sympathy with the poetic and personal rather than the empirical and political enterprise of the arts.

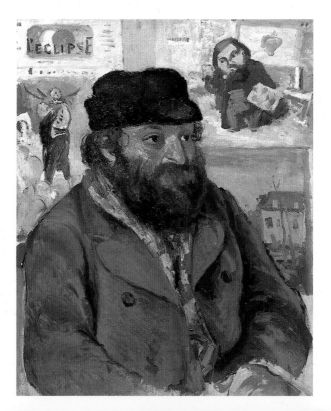

205
Camille Pissarro, *Portrait of Paul Cézanne* (with caricature of Courbet in the background), 1874. Oil on canvas; 73×59 cm, 28¾×23¼ in. Private collection

In 1874, ten years after Fantin-Latour's portrait, the Impressionist Pissarro made a portrait of his friend Paul Cézanne (205), a painter whose attachment to the physicality of forms may be directly linked to Courbet's Realist vision. On the wall in the background of Pissarro's image is a caricature of Courbet from the journal *L'Éclipse*. At one very excitable point in his career Pissarro, a sometime follower of Proudhon, had advocated the destruction of museums as the only way for artists to be able to start anew. Courbet, we know, never went so far – he worked hard under the Commune to preserve the national collections. In 1874, the same year as Pissarro made his portrait, the young painters of his group, several of whom were Courbet's friends, had organized the first Impressionist exhibition. They thus followed Courbet's precedent of showing outside official channels. Indeed, at the same time as they received the name 'Impressionists', his group was also known as the 'Intransigents', a term derived from 'Los Intransigentes', the name of Spanish anarchists whose refusal to compromise caused a collapse of the Spanish government in 1873. Hence, the Impressionists' gesture of independence was for a time interpreted as having political connotations. Even Renoir was wary of exhibiting too exclusively with the group because of their excessively radical tinge.

However, the Impressionists for the most part were not politically engaged. The conservative and aristocratic Edgar Degas (1834–1917) had no political qualms about his relationship to them. And while Édouard Manet's political beliefs were undoubtedly republican, his disdain for any politics at all was even stronger. In his *Déjeuner sur l'herbe*, which was originally called *The Bath*, the model's nudity is ostensibly explained by its relationship to bathing. A second woman, in the background, is actually in the water. Courbet's *The Bathers* of 1853 and *The Young Ladies of the Banks of the Seine* of 1856–7 had been the first to introduce such themes of contemporary bathing and leisure in outdoor settings so boldly into the realm of large-scale painting. Manet's painting caused a comparable scandal but without the political edge, for Manet's figures were obviously Parisian and his gesture of provocation was aimed at classical art. Although his painting threatened conventional morality, too, it made no claim for

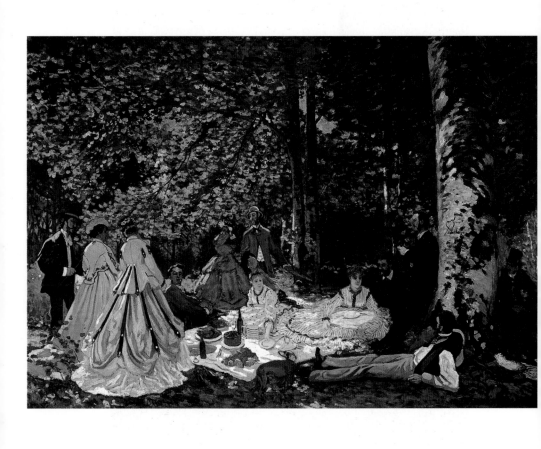

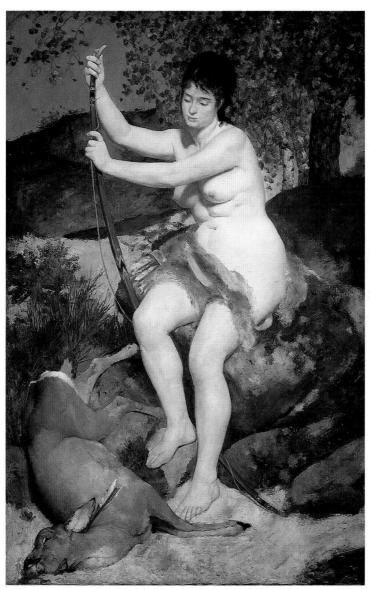

206
Claude Monet,
Sketch for *The Picnic*, 1865.
Oil on canvas;
130×181 cm,
51¼×71¼ in.
Pushkin
Museum of Fine
Arts, Moscow

207
Pierre-Auguste Renoir,
Diana Huntress,
1867.
Oil on canvas;
199·5×129·5 cm,
78½×51 in.
National Gallery
of Art,
Washington, DC

the outsider's role in high culture. Claude Monet also concocted an outdoor scene, in which he is said to have included Courbet as the figure stretched out to the right. In his sketch (206) Monet seems to offer a corrective to Manet's obviously studio-conceived and executed composition, for Monet based his on direct observation and used brushwork inspired by Courbet's example, particularly for the tree trunks and foliage. The pattern of challenging past art initiated by Courbet continued through Manet and Monet, but was now confined to aesthetics.

In a number of paintings of the later 1860s the politically timid Auguste Renoir also drew from Courbet's style. Both the slain deer and the robust nude of his *Diana Huntress* (207) bear obvious resemblances to Courbet's women and his hunting scenes, and Renoir's somewhat awkward palette-knife work, which he eventually gave up, reveals the seriousness of his interest in this particularity of Courbet's technique. In addition, throughout his career Renoir's feeling for the mass and volume of the figure stayed closer to Courbet than to the flattening of the other Impressionists, so much

208
Paul Cézanne,
Uncle Dominique,
c.1866.
Oil on canvas;
79·7×64·1cm,
31³⁄₈×25¼ in.
Metropolitan
Museum of Art,
New York

209
Claude Monet,
Still-Life with Salmon, c.1870.
Oil on canvas;
31·1×46cm,
12¼×18⅛ in.
Fogg Art
Museum,
Harvard
University Art
Museums,
Cambridge,
Massachusetts

so that many of Renoir's figure paintings might be viewed as brightly coloured suburban versions of Courbet. At the same time, Paul Cézanne had come to Paris briefly during the 1860s from Aix-en-Provence, a town less remote than Ornans but nonetheless provincial. In a number of portraits, such as one of his *Uncle Dominique* (208), Cézanne used the palette knife to create boldly physical surfaces that seem to embed his representations in the materiality of their pigments. For him Courbet's workmanlike manner and earth-toned palette offered a means for the outsider he believed himself to be to respond to Manet's leisure-oriented Parisian modernism featuring stylish and informal surface effects. Claude Monet's development of a style based on fragmented brushwork laid the basis for the classic Impressionism we associate with the 1870s and is worth comparing to Courbet's, too. In paintings of fruit from the same period, Courbet built up his forms from short brushstrokes technically close to the Impressionists (see 183). However, unlike the Impressionists, Courbet used closely related colours to produce modelling. In comparison, Monet's brushstrokes produce a thin,

210
Paul Cézanne,
*Apples and
Biscuits*,
c.1879–82.
Oil on canvas;
46×55 cm,
18⅛×21⅝ in.
Musée de
l'Orangerie,
Paris

211
Claude Monet,
The Beach at
Sainte-Adresse,
1867.
Oil on canvas;
75·8×102·5 cm,
29⅞×40⅜ in.
The Art
Institute of
Chicago

screen-like surface pattern, as in his *Still-Life with Salmon* (209), for example. Monet's contrasting colours corresponded to 'retinal' experience rather than to the desire to recreate the sense of rounded and laden forms we found in Courbet. Paul Cézanne, in choosing apples as the theme for many of his still lifes (210), seems to effect a reconciliation between Monet's Impressionism and Courbet's Realism.

A further comparison between Courbet and Impressionism might use Monet and Courbet's representations of the seaside. Monet's brushwork, as in *The Beach at Sainte-Adresse* (211), ultimately suggests closer observation than the broad generalizations of the spatula-like palette knife Courbet used for his many scenes (see 166). The greater role Monet allows to human figures and their boating activities suggests a familiar and domestic side of the landscape. Oddly, then, in Courbet's late work (see 195), the painter who supposedly could not look beyond the surface and materiality of nature, seems less rooted in observation and daily experience than his successor. Indeed, he uses colour in a manner that implies a liberation from material form or, perhaps, a celebration of materiality as something other than descriptive.

The traditions of naturalism and landscape were stronger in central Europe and the Low Countries than in France. In Germany Courbet's impact was immediate. His first visit was to Frankfurt, where he stayed from August 1858 to February 1859. Here Jacob Becker, a professor at the Frankfurt Academy, lent Courbet a studio, where he worked on landscapes, portraits, including the well-known *Lady of Frankfurt*, and his large stag scenes. Courbet developed a considerable following among the younger painters, the most remarkable of whom were Victor Müller (1830–71) and Otto Scholderer (1834–1902). One of Scholderer's most beautiful paintings, *A Girl Cutting Flowers* (212), directly recalls Courbet's versions of similar subjects from Saintonge. Courbet's second major trip to Germany took him to Munich for six weeks in October and November 1869 to receive in person the Order of Saint Michael from the King of Bavaria. Following his participation in the World Art Exhibition in the Glass Palace of Munich with a number of important works –

212
Otto
Scholderer,
*A Girl Cutting
Flowers*,
c.1869.
Oil on canvas;
93×78cm,
36⅝×30¾in.
Kunsthalle,
Bremen

including *The Stonebreakers, The Woman with a Parrot, The Somnambulist* and *The Hallali of the Stag* – German artists had voted Courbet the award. Courbet's influence on younger German artists is evident in such works as *Descent from the Cross* (213) by Wilhelm Trübner (1851–1917), which combines Courbet's earthy figure type and earth-toned palette with a more fragmented technique that in this case resembles Manet and the Impressionists.

Compared to Impressionism, of course, Courbet's Realism is dark and earth-bound. Manet declared that his predecessor's greatest mistake was to have used too much black. As the critic Edmond Duranty once wrote, Manet and the Impressionists seemed to throw open the windows wide to let in light. It is as if the darkness of Courbet's painting prevents the viewer's escape to the brighter aesthetic pleasures of Impressionism by keeping us grounded in the material conditions Courbet sought to represent. So the desire for escape was perhaps in part provoked by Courbet's insistence on the earthly and the physical; and one could see in France how quickly Realism was transformed into the preoccupation with form that became the driving force of Modernism. From Cézanne, a version of Realism led to Analytic Cubism as practised by Pablo Picasso (1881–1973), who then moved rapidly to cut representation off from its roots in observation, so that Cubism's next, so-called Synthetic phase made the final break with Realism.

Yet despite developments in France, a certain version of Realism persisted in central and eastern Europe, where it may have given rise as much to the acerbic caricatures of George Grosz (1893–1959) and Otto Dix (1891–1969) as to the heavy-handed propaganda of Soviet Stalinism. It also had adherents in North America, where it continued to be associated with regionalism and leftist politics. In recent years, in Pop Art or in the fatalistic painting (214) of Lucian Freud (b.1922), total reconceptions of Realism – owing little directly to Courbet – have emerged with some respectability. However, if one regards not Courbet's visual style but his actions as an artist – his published statements, his appearances, his posture of protest and his attraction to theory – Courbet is anything but marginal. The

213
Wilhelm
Trübner,
*Descent from
the Cross*,
1874.
Oil on canvas;
95 × 109·5 cm,
37½ × 43⅛ in.
Kunsthalle,
Hamburg

notion of the artist as social reformer or spiritual guide in one way or another lay behind the careers of avant-gardists from William Morris (1834–96) and Paul Gauguin (1848–1903) to Picasso and Jackson Pollock (1912–56). And the persona of the artist as publicity hound informs our responses to those from Salvador Dalí (1904–89) and Andy Warhol (1928–87) to Joseph Beuys's (1921–86) performances and the Guerilla Girls' public demonstrations.

It may be said that when a style is recognized as such it is already dead or at least fixed as a stable concept. In the case of Realism, Courbet's claim for its existence made his use of it a deliberate choice, rather than the result of *naïveté*, and perhaps that is what disturbed his critics and even his followers most of all. For they were banking on the notion of an artist who painted spontaneously, without calculation, as a way to justify the claims to 'truth' that Realism made. However, Courbet's emphasis on artistic freedom made other choices just as likely when they might serve other purposes. And for his followers and successors up until this day, it is that kind of integrity, not the loyalty to a particular style, that counts.

214
Lucian Freud,
And the Bridegroom,
1993.
Oil on canvas;
231·8×196·2c
91¼×77¼ in.
Private
collection

So Courbet served as a model for two quite opposed forms of art that redefined the artistic discourse of his time and are still with us today. On the one hand, he is obviously the father of various brands of Realism that have succeeded his own example. The notion of the artist's freedom and the duty to represent the world as he or she sees it visually, as if it were a form of free speech whose politics would always be progressive, is obviously indebted to his insistence on independence and authenticity. But, on the other hand, the avant-garde holds the freedom of the artist to be absolute, such that he or she need not be a Realist at all. The artist may paint from internal experience or confine artistic exploration to theoretical problems of form. Artists may serve humanity simply by expressing their freedom of vision. Indeed, for some, subordination of artistic vision to any ulterior purpose – political or otherwise – would subvert the ideal of liberty which the avant-garde artist has come to symbolize. In this sense the aesthetic avant-garde may often be politically and socially conservative.

Just as Courbet ended his explanation of *The Studio of the Painter* with Baudelaire, I shall conclude with him as well. One knows Baudelaire was troubled by the political aims Courbet ascribed to his painting, perhaps all the more as he shared some responsibility for that aspect of Courbet's beliefs. Yet he admitted that in spite of it all one must still give Courbet credit. For Courbet, Baudelaire said, had 'in no small way contributed to restoring a taste for simplicity and frankness, as well as for the absolute and disinterested love of painting'. Even though the avant-garde was formed in the crucible of politics, its achievement did not mean it must forever be political; on the contrary, it assured the freedom to be the opposite – to be absolute and disinterested. In this sense, then, all artists can consider themselves heirs to the legacy of Courbet.

Glossary

Academic, Academy Although the Royal Academy of Painting and Sculpture was destroyed during the 1789 Revolution, a school, called the École des Beaux-Arts (Fine Arts School) inherited its instructional functions and its de facto control over art for much of the nineteenth century. Conservative by its institutional structure, it perpetuated attitudes and styles associated with **Classicism**, even though its actual practices included landscape sketching and certain other forms that we now view as more progressive. Because of its continuing domination of government-sponsored exhibitions and awards, the products of its members also came to be regarded as 'official' art. It thus became a symbol of a corrupt establishment, and by the 1860s had lost much of its credibility among young artists.

Avant-Garde From a term equivalent in English to 'vanguard', meaning the leading force in a military advance. As applied to art, the term refers either to a form of art or to an artist or group of artists who are in the forefront of artistic development. Originally, this notion of artistic leadership was forged in the political context of romantic or **Utopian Socialism** in which artists were among those whose visionary gifts would lead society towards progress.

Barbizon School A group of painters of landscapes and rural themes centred around the village of Barbizon, next to the Forest of Fontainebleau, about 100 km (60 miles) south of Paris. The best-known members of this group are Jean-Baptiste-Camille Corot (1796–1875), Charles-François Daubigny (1817–78), Jules Dupré (1812–89), **Jean-François Millet** and **Théodore Rousseau**. Considered precursors of Realism because of their truth to observation, nature for them represented a refuge from urban life and an embodiment of virtue, ideals which parallel those present in early Realist literature. Their practise of painting, broadly inspired by Dutch landscapes and by the English painter, John Constable (1776–1837), helped close the technical gap between sketch and finished painting – a direction that would culminate in Impressionism.

Bohemianism A term derived from Bohemia, a region of central Europe, which was considered to be the home of gypsies. By extension, those with unconventional lifestyles, often on the margins of poverty, such as artists, writers and musicians, began, in the 1840s, to be called Bohemians. In 1845, Henri Murger (1822–61), a member of Courbet's circle of artists and writers, published a romanticized account of the poor artists' life entitled *Scènes de la vie de Bohème* which contributed to the popularization of the concept. This work provided the basis for Puccini's opera *La Bohème* of 1896.

Classicism A conservative style of painting whose chief practitioner in the years preceding Courbet's career was Jean-Auguste-Dominique Ingres (1780–1867). It was based on an attitude or reverence for the past, allowing for no modern subjects, and on academic teachings that stressed careful drawing and a high level of finish. It is seen to be directly opposed to the looser, more colouristic approach associated with **Romanticism** as practised by **Eugène Delacroix** (Ingres's arch rival) and his followers.

Hierarchy of Genres, History Painting, Genre Painting A system of status or ranking of categories (genres) of subject matter for art. History painting was considered to be the most noble, since it dealt with enduring themes of human heroism. Genre painting represented everyday individuals, and even though their actions might sometimes be taken as examples of morality, their proximity to the present made idealization improbable and therefore lowered their status. Portraiture, landscape and still life were considered still lower in rank. Contemporary historical themes blurred the lines between history painting and genre painting by claiming historical validity for actions in the present. The defence of such themes was thought to reveal an underlying political liberalism, through its assertion of equality between ordinary citizens and ancient heroes and its inclusion of the common among the concerns of high art.

July Monarchy, Bourgeois Monarchy When the population of Paris erected barricades in the streets in July 1830, King Charles X of the Bourbon line quickly abdicated in favour of Louis-Philippe d'Orléans, a member of a parallel branch of the royal family. Louis-Philippe was accepted by French liberals because his father, nicknamed Philippe Egalité, had supported the French Revolution and because Louis-Philippe himself had been educated in England, with its tradition of constitutional monarchy. Louis-Philippe affected

an English style by wearing a bowler hat and carrying an umbrella, items which were considered signs of bourgeois loyalty. His regime, which lasted until the Revolution of 1848, was known as the Bourgeois Monarchy because it had extended the right to vote to include many of the more prosperous property owners and because it promoted business interests. However, it was also noted for its censorship and its repression of workers' movements.

Master-Painter, Worker-Painter Both terms were applied to Courbet, thereby linking him to popular traditions. The former derived from craft practices that predated the foundation of the Academy and thus refers to a sphere outside its influence. Under the craft guild system, the Master was an artisan who had attained the right to exercise his craft through years of apprenticeship. The term Worker-Painter parallels the term Worker-Poet, which referred to a phenomenon of the 1830s and 1840s. In accordance with left-wing utopian beliefs, artistic inspiration was sought among the lower classes, and workers were encouraged to experience the liberating effects of artistic creation.

Paris Commune The socialist government of the city of Paris from 18 March to the end of May 1871. The Commune seceded from the Third Republic following the latter's capitulation to the Prussians after their siege of Paris. It refused to surrender and hoped to join a federation of communes that would be a link to similar movements in other cities. The Commune ended in a bloodbath when troops loyal to the national government, which had fled to Versailles, overran Paris.

Popular Imagery Anonymous images, usually woodcuts, often crudely executed, that were associated with rural culture and the peasantry. Such images were cheaply printed and widely distributed. Distinct from political prints and caricatures, which also enjoyed wide distribution but were pertinent to specific moments or events, they generally represented themes of more general concern with a conservative, homiletic morality.

Positivism A general belief in the primacy of positive facts and material phenomena in knowledge, and opposed to speculation about ultimate causes or origins. More specifically, the mid-nineteenth-century philosophical doctrine of Auguste Comte (1798–1857), who propounded such beliefs coupled with a schematic description of social evolution in phases and a doctrine for social reform that would ground politics in science in order to attain a final 'positive' and democratic phase. Like Henri de Saint-Simon (1760–1825; see **Utopian Socialism**), Comte's dogma acquired religious overtones towards the end of his life.

Regionalism A trend in painting and literature of the 1840s representing scenes of daily life from the French provinces in an idealized or nostalgic way. Writers such as **George Sand** and **Jules Champfleury** might be included among its practitioners, although their work also had national significance. In visual art, Regionalism was a more peripheral phenomenon, practised by artists such as the Leleux brothers (Adolphe-Pierre 1812–91 and Armand Hubert Simon c.1818–85), Gustave Brion of Alsace (1824–77), Phillippe-Auguste Jeanron (1809–77) and, later, Jules Breton (1827–1906). Courbet's representations of Franche-Comté differ from Regionalism in their unvarnished representation of the countryside as a complex and contradictory place and their consequent engagement with contemporary political and social issues.

Romanticism Less a single style of art than an attitude of individualism expressed through various styles and choices of subject matter that reflected a desire to explore new fields and to rely more on imagination and personal experience than on academic rules. In the 1820s, Romanticism came to be defined in opposition to **Classicism**, that is, its themes were modern and its forms were more freely painted and derived more from observation of nature. **Eugène Delacroix** became its leader in the visual arts. According to the great poet and critic **Charles Baudelaire**, Romanticism was modern art that expressed the ethos of its own times. With its emphasis on independent vision and modernity, Romanticism clearly laid a foundation for Courbet's Realism, although Romanticism's more literary and escapist leanings led Courbet to dismiss it as 'art for art's sake'.

Second Empire A year after the *coup d'état* of 1851, **Louis-Napoleon Bonaparte** established the Second Empire, giving himself the title of Emperor Napoleon III and assuming almost dictatorial powers. The Second Empire saw the expansion of French industry and trade, and major renovations of Paris, with the Emperor taking the lead in lavish displays of wealth and profligacy. Its militarized foreign policy, with campaigns in the Crimea and northern Italy, was meant to restore the respect for France that had been lost at Waterloo. These policies failed when the Prussians, under Bismark, attacked France in 1870 and quickly besieged Paris. The empire collapsed with the declaration of the Third Republic as a government of defence.

Second Republic, Republican Following the Revolution of February 1848 (the February Days), a new republic was established in France, the second since that of the 1789 Revolution, which had

established its republic in 1792. Socialist in inspiration, the Second Republic decreed universal male suffrage and created national workshops for employment. Following conservative results in the elections of April 1848, much of this work was dismantled. After a left-wing uprising in June (the June Days), General Cavaignac became President of the Council. By November, a constitution was adopted which called for a single chamber of representatives and a president. In December, **Louis-Napoleon Bonaparte** was elected to that office. The Second Republic was overthrown by his *coup d'état* of 2 December 1851. As supporters of the principle of government by the people, and whether loyal to the traditions of the First or to the new Second Republic, republicans were always opposed to any government in which a single individual, king or emperor, held exclusive power.

Series In its simplest meaning, a group of representations on related themes, such as images of the provinces or seascapes. The term had special significance in the 1830s and 1840s, however, when it indicated a way of thinking that relied on observation in order to discover underlying patterns. 'Seriation' was a key concept for certain **Utopian Socialists**, especially Charles Fourier (1772–1837) and **Pierre-Joseph Proudhon**, for whom it seemed to offer a serious scientific method of analysis. Its form of rationalism, as interpreted by Courbet, was especially appropriate to visual representation, which helped aid progress by creating links or oppositions between social phenomena. Illustrated series such as *Les Français peints par eux-mêmes* (The French Painted by Themselves, 1839–42) had already become a popular form of visual culture before Courbet took up the idea for painting.

Utopian Socialism, Romantic Socialism A set of political theories or beliefs shared by many thinkers during the first half of the nineteenth century, but now generally regarded as visionary and impractical. Its basic tenets were that socialism based on democracy and equality would lead to a harmonious society in which all individuals would be able to realize their full potential. These concepts were often joined by a view of historical evolution that made social progress the result of virtually irresistible forces. Among the best-known strains of thought within utopian theory are those identified with two very different leaders, Henri de Saint-Simon and Charles Fourier. Saint-Simon believed that a trinity of scientists, industrialists and artists would form a governing élite that would lead society to a stage where the interests of all classes would converge. He gave his theory a doctrinaire, quasi-religious dimension towards the end of his life. His followers include the Positivist Auguste Comte and the editor of the Romantic literary journal *Le Globe*, Pierre Leroux (of whom **George Sand** was a close associate). Fourier, on the other hand, believed that society should organize into phalanxes, small internally diverse and cooperative communities, which would form the elements in a decentralized federation. In his system, with its proto-anarchist refusal of central authority, artists' freedom from serving ulterior needs would exemplify the goal of universal happiness. **Pierre-Joseph Proudhon** was among those who would develop Fourier's ideas.

Brief Biographies

Charles Baudelaire (1821–67) Probably the most famous poet and critic of nineteenth-century France, author of the collection of poems *Les Fleurs du mal* (1857), which created a scandal in its time. He also wrote many essays on literature and visual art, including those on the Salons of 1845 and 1846, on his favourite painter **Eugène Delacroix**, and *The Painter of Modern Life* (1863). He met Courbet, **Proudhon** and other members of the Realist circle around 1848, sharing their political radicalism for a time. Courbet collaborated with him and others on a short-lived journal, *Le Salut public*. After the failure of left-wing politics in the 1850s, Baudelaire became sceptical of Courbet and the political aspirations associated with Realism. His artistic interests then turned more towards **Édouard Manet** and his circle.

Louis-Napoleon Bonaparte, Napoleon III (1808–73) Nephew of Napoleon I. As leader of the Bonapartist cause, he conspired to regain the throne of France. Finally, with promises of liberal reform, he won the election for the presidency of the **Second Republic** which was established thanks to the Revolution of 1848. Prevented by the constitution from re-election, he led a *coup d'état* on 2 December 1851, and a year later he declared the **Second Empire**, with himself as Emperor Napoleon III. Under his regime, France expanded both its economic and its military power, yet at the same time it wallowed in corruption, with the Emperor himself and his family often taking the lead. At the collapse of his empire in 1871, and in poor health, he fled to England, where he died two years later.

Alfred Bruyas (1821–77) Son of a wealthy banker from Montpellier in the South of France, Bruyas was interested in combining his utopian political beliefs with patronage of the arts in order to 'solve' the problems of society. To this end he began collecting the works of contemporary artists. When he saw Courbet's work, he became Realism's foremost patron, purchasing *The Bathers* (1853) and commissioning other works such as *The Meeting* (1854). Courbet hoped Bruyas's financial resources would contribute to his artistic independence, in particular to his effort to exhibit outside official channels, especially at the Universal Exposition of 1855. In an extended correspondence with Bruyas, Courbet explained many of his ideas about the function of art and the role of the artist. Bruyas himself wrote about his own collections and his utopian aspirations for them.

Max Buchon (1818–69) Schoolmate of Courbet's who became a Realist poet, a translator of German and Swiss literature, and a political writer, as well as a supporter of Courbet. Buchon wrote the first article on Courbet's work, giving it a political interpretation while claiming that Courbet's *naïveté* made him an artist of the people. Buchon fled to Switzerland in 1851, returning in 1856 to settle in Salins, near Ornans, and later in Besançon.

Jules-Antoine Castagnary (1830–88) Liberal politician, lawyer and art critic from the Saintonge region of western France. He met Courbet in 1860 and was instrumental in the artist's visit to the region a few years later. Castagnary wrote reviews of art exhibitions, in which he praised Courbet and advocated 'naturalism' for its ability to express democratic attitudes. He became Courbet's closest supporter towards the end of the painter's career, particularly when Courbet was under political attack and had been driven into exile; he wrote a biography of Courbet and defended his role in the Vendôme Column affair. As a Fine Arts administrator after Courbet's death, he helped to rehabilitate the artist's public reputation.

Jules Champfleury (1821–89) Pen-name of Jules-Antoine-Félix Husson, early Realist author and critic, and a member of the 'bohemian' literary circle of the Brasserie Andler, frequented by Courbet and others such as **Proudhon** and **Baudelaire**. His stories and novels of the 1840s, such as *Chien-Caillou* (1845) and *Feu-Miette* (1847), share **George Sand**'s admiration for rural virtues in their representations of ordinary folk. His interest in visual art led him to the rediscovery of the Le Nain brothers (Antoine, *c*.1588–1648, Louis, *c*.1593–1648, and Mathieu, *c*.1607–77), painters from Laon, his hometown, whom he praised for their *naïveté* and expression of popular values. For similar reasons, he collected and studied popular imagery, publishing a book on the topic in 1869. He was an early supporter of Courbet and perhaps even collaborated with him. Courbet represented Champfleury in *The Studio of the Painter*, and addressed one of his detailed explanations of the painting to

him. Their views gradually diverged, however, to the point where, in 1863, their friendship ended acrimoniously.

Urbain Cuenot (1820–67) Schoolmate of Courbet's who shared his liberal political views and found himself imprisoned in Marseille in 1851 and briefly exiled to Algeria. Cuenot lived in Ornans, where his relative wealth allowed him to pursue his interest in music and letters and to accompany Courbet on various travels. His choral society in Ornans was the source of an incident that inspired Courbet to write a political pamphlet. Besides an early portrait commissioned by his friend, Courbet included Cuenot in *The Studio of the Painter*.

Honoré Daumier (1808–79) Lithographer and painter. His biting satires of contemporary political figures, as in *Le Ventre législatif*, earned him a six-month prison term in 1832, yet he continued to fight for freedom of speech and of the press. After the imposition of press censorship in 1835, he concentrated more on social satire. His representations of common folk formed the most powerful example of a Realist impetus in the graphic media, which contributed to making the subject matter of everyday life a familiar aspect of visual culture. The Revolution of 1848 led Daumier briefly to take up painting, with, among others, a project for an *Allegory of the Republic*. Under the **Second Empire**, his characters Ratapoil (literally, Rat-Whisker, or Naked Rat) and Robert Macaire satirized the greed and corruption of that regime. His cartoons commenting on foreign policy just before the Prussian declaration of war brought a bitter end to his career.

Eugène Delacroix (1798–1863) Painter of historical and literary subjects generally considered to be the leader of French Romanticism. His large paintings of the 1820s, especially the *Scenes from the Massacres at Chios* (1824), established **Romanticism** as an art of modern subjects and relatively naturalistic style, as opposed to the more traditional, so-called **Classicism** of his great rival, Jean-Auguste-Dominique Ingres (1780–1867). In this limited sense, he paved the way for Realism. In addition, for many artists and writers, especially **Baudelaire**, Delacroix stood as a beacon of independence and artistic imagination in the face of convention. In that sense, too, Courbet's efforts built on his predecessor's. Delacroix in turn recognized Courbet's great pictorial talents, but he could not fathom Courbet's choice of subjects, which he considered vulgar.

Édouard Manet (1832–83) Painter of Parisian subjects whose early style, inspired by Dutch and Spanish art, and relationship with **Baudelaire** have linked him to Realism. However, his leisure-oriented themes and his pictorial artifice, such as spatial flattening inspired by Japanese prints, and broad, dry handling of brushstrokes, has also led to his classification as an Impressionist. Two early paintings, *Déjeuner sur l'herbe*, exhibited at the Salon des Refusés (1863), and *Olympia* (Salon of 1865), established Manet's reputation amid scandal (*Olympia* shows a naked prostitute) and as a rebel against artistic convention. Although his activities were more aesthetic than political, Manet is considered Courbet's successor in the tradition of the **avant-garde**.

Jean-François Millet (1814–75) Painter of the **Barbizon School**, whose works depicted monumental figures engaged in timeless activities of rural life, earning him the epithet 'rustic Michelangelo'. Born in Normandy, educated in the history of art, he first tried to make a living painting decorative compositions and nudes. He left Paris in 1849 and began devoting himself to themes of rural labour. In often suggesting a religious reverence for everyday activities, as in *The Sower* (1850), Millet's work perpetuated the ideal of the virtuous countryside. He thus helped lay the ground for Courbet's interest in rural themes, although Courbet was to represent them in a far less nostalgic and idealistic light. Nonetheless, Millet was sympathetic to republican politics and his work, as in *Man with Hoe* (1863), was often associated with advocacy of social reform.

Claude Monet (1840–1926) Painter of the Impressionist school, specializing primarily in landscapes, whom Courbet befriended during his stays on the Normandy beaches, near Monet's home. His predilection for painting out of doors directly from the motif corresponded to aspects of Courbet's own practice, and his later conception of paintings in series focusing on a single or closely related objects also took up a theme of Courbet's art. His *Women in the Garden* of 1867 can be viewed as a response to Courbet's picture of fashionable women, *The Young Ladies of the Banks of the Seine* (1856–7). Monet represented Courbet among the picnickers of his *Déjeuner sur l'herbe* (1865–6).

Alfred-Emilien, Comte de Nieuwerkerke (1811–92) Superintendant of the Fine Arts Administration until the fall of the **Second Empire**, he was the individual most responsible for government patronage during almost the entire span of Courbet's career. It was he who tried to get Courbet to agree to terms for an exhibit at the Universal Exposition of 1855, only to be met by the artist's defiance. In 1865, Nieuwerkerke purchased a version of the *Brook of the Puits-Noir*; a year later, however, Courbet publicly accused him of reneging on a promise to purchase the *Woman with a Parrot*. By the mid-1860s, artists' dissatis-

faction with Nieuwerkerke's administration had grown to such a degree that in 1870 **Napoleon III** asked Maurice Richard to head a new and separate Ministry of Fine Arts, thus seriously curtailing Nieuwerkerke's powers.

Pierre-Joseph Proudhon (1809–65) Political philosopher and economist, one of the fathers of anarchism, whose working-class and Franche-Comté origins led him to use its traditions of independence and cooperation among social classes as a model for social theory. Drawing on both **Utopian Socialism** and Hegelian materialism, Proudhon claimed to offer more practical proposals for reform rooted in economics and science. An early treatise, *What is Property?* (1840) attracted attention for its claim that property is theft – referring to the kind of property that was not earned through manual labour. In *System of Economic Contradictions, or Philosophy of Poverty* (1846) and later works he argued for a system of cooperatives, bartering and trade unionism that he called mutualism. Karl Marx (1818–83) attacked these theories as nostalgic failures to recognize the uniqueness of the proletariat. Proudhon also held that art was the highest manifestation of human labour, which attained freedom and spirituality as it became art. He met **Baudelaire** and Courbet in 1848. He was jailed from 1849 to 1852 for his opposition to **Louis-Napoleon** and while in prison wrote *The Philosophy of Progress*. Courbet visited Proudhon there and gleaned some ideas for his *Studio of the Painter* from the book, which also discussed Courbet's *The Bathers* (1853). At the time of his death, Proudhon had been preparing a treatise on art, published posthumously as *On the Principle of Art and its Social Destination* (1865). Using Courbet's painting as his primary example, Proudhon argued the social purpose of art in reflecting its own times. This theory was quickly attacked in a review by the young Émile Zola (1840–1902), who wrote that art was 'a corner of nature seen through a temperament'.

Théodore Rousseau (1812–67) Landscape painter whose paintings of the French countryside helped, by the 1830s, to establish the credibility of representations of local sites, as inspired by the Dutch and British example, rather than the previous generation's predilection for scenes of Italy. With other landscapists and painters of rural life, such as Jules Dupré (1812–89), Constant Troyon (1810–65), Charles-François Daubigny (1817–78), Jean-Baptiste-Camille Corot (1796–1875), and **Jean-François Millet**, he formed a school centred around the village of Barbizon, southeast of Paris, where many of them resided. Although his choice of homely motifs, as in *A Marsh in Berry* (1842) certainly anticipates Realism, the emotionalism and sentimentality permeating his sunsets and stormy skies, as in *Route Through the Forest of Fontainebleau* (*c.*1860–5), differs greatly from Realism's ostensible neutrality. However, Rousseau's loose handling of paint to create sensations of immediacy and physical richness, was certainly a powerful example for later generations.

George Sand (1804–76) Pen-name of Aurore Dupin, Romantic/Realist novelist. After a relatively unfettered childhood in the Berry region of France, she married Baron Dudevant, from whom she quickly separated. Her independent life included love affairs with several leading cultural figures of her time, including the composer Frédéric Chopin (1810–49) and the poet Alfred de Musset (1810–57). The principal theme of her writings was the opposition between nature and society, as exemplified by tensions between love and convention. In the pursuit of happiness based on sincere personal feeling, she saw the possibility of moral regeneration, as described in her novels *Lélia* (1833) and *Consuelo* (1842–3). Her pastoral settings, such as those in *La Mare au Diable* (1846), suggested the virtues of the countryside and found parallels in the writings of **Champfleury** and in the paintings of **Millet** and the early work of Courbet.

Key Dates

Numbers in square brackets refer to illustrations

The Life and Art of Gustave Courbet

A Context of Events
(primarily French, unless otherwise noted)

1819 Gustave Courbet born in Ornans, 10 June	
1831 Courbet studies at the Little Seminary in Ornans	**1830s** Revolution of July 1830: After three days of barricades, abdication of Charles X (Bourbon) in favour of more 'liberal' Louis-Philippe d'Orléans. Beginning of the so-called Bourgeois Monarchy or July Monarchy, under which minister Guizot declares to parliamentarians: 'Make yourselves rich!' Several worker uprisings. Restoration of press censorship. Delacroix paints *Liberty on the Barricades* [8], 1831. Balzac begins series of novels called *La Comédie humaine*. Théodore Rousseau's works rejected from the Salon. Daumier serves jail term 1830s
1837 Attends boarding school in Besançon	
1839 Leaves for Paris supposedly to study law but intending to become an artist	**1839** Photography becoming established. Britain: Hunt, *The Art of Photography*
1840 Studies on his own at the Louvre and at the studio of the model, Suisse	**1840** Proudhon, *What is Property?*
1841 Submits portraits of his friends Marlet and Cuenot to the Salon. Both refused	
1842 Submits a hunting scene and an interior scene to the Salon. Both refused	**1842** Comte, *Course on Positive Philosophy*
1843 Submits a portrait and a small *Self-Portrait with Black Dog* to the Salon. Both refused	
1844 Submits large painting, *Lot and his Daughters* and a larger *Self-Portrait with Black Dog* [10] to the Salon. The latter accepted	**1844** Karl Marx in Paris. Dumas, *The Three Musketeers*
1845 Submits five paintings to the Salon. Only the *Guitarrero* [17] accepted	**1845** Ireland: Failure of potato crop. Germany: Wagner composes *Tannhäuser*
1846 Meets Champfleury and other 'bohemians' at the Brasserie Andler. Submits eight paintings to the Salon. One, a self-portrait, accepted	**1846** Balzac, *Cousine Bette*. Baudelaire, *Salon of 1846*. Berlioz, *Damnation of Faust*. Proudhon, *System of Economic Contradictions, or Philosophy of Poverty*. Sand, *La Mare au Diable*
1847 Son born to his mistress, Virginie Binet. Submits three paintings to the Salon, including *Portrait of Urbain Cuenot*. All refused	**1847** Champfleury, *Chien-Caillou*. Michelet, *Le Peuple*

The Life and Art of Gustave Courbet	A Context of Events
1848 Friendships with Baudelaire and Proudhon. Does not participate in combat during the Revolution. Designs frontispiece for *Le Salut public* [25], on which he collaborates with Baudelaire and Champfleury	**1848** February Revolution of workers. Louis-Philippe abdicates. Second Republic declared, but moderates gain in April elections. June insurrection of leftists crushed. December presidential election of Louis-Napoleon Bonaparte. Murger, *Scènes de la vie de Bohème*. Britain: Pre-Raphaelite Brotherhood is founded. Germany: Uprisings in Berlin and Frankfurt. Marx and Engels, *The Communist Manifesto*. Italy: Uprisings in Milan and Venice
1849 Six paintings and a drawing accepted by the Salon. *After Dinner at Ornans* [26] awarded a second-prize medal, purchased by the state and deposited at the Lille Museum. Returns to Ornans, paints *The Stonebreakers* [32] and begins *A Burial at Ornans* [49]	**1849** Millet paints *The Winnower* [35]. Millet settles in Barbizon. Italy: Intervention of French armies, which take Rome and Venice
1850 Continues to work on paintings for the Salon in Ornans. Arranges exhibitions of the *Burial* in Ornans and Besançon	**1850** Opening of Salon delayed until New Year's Eve. Death of Balzac
1851 Other works included at the Salon of 1850–1 are: *The Peasants of Flagey* [57], *Portrait of Jean Journet*, *Portrait of Berlioz*, and a self-portrait, *Man with Pipe* [30]	**1851** December *coup d'état* of Louis-Napoleon. Britain: Great Exhibition at the Crystal Palace
1852 *The Young Ladies of the Village* [66], *Portrait of Cuenot*, and a landscape of the Doubs exhibited at the Salon. *Young Ladies* purchased by the Count de Morny. Visits Proudhon in prison. Shows paintings in Frankfurt	**1852** Napoleon III proclaims Second Empire. Beginning of modernization of Paris by Baron Haussmann
1853 *The Bathers* [74], *The Wrestlers* [70] and *The Sleeping Spinner* [77] exhibited at the Salon. Meets Bruyas and paints his portrait [78]. Meeting with Count Nieuwerkerke	**1853** Proudhon, *The Philosophy of Progress*. Planning for Universal Exposition, to be held in 1855
1854 Visits Bruyas in Montpellier. Paints *The Meeting* [83] and his first seascapes. Returns to Ornans to begin *The Studio of the Painter* [87]	**1854** France joins England against Russia in the Crimean War
1855 Works on *The Studio*, which he submits along with thirteen other paintings to the Universal Exposition being organized by the government. *The Studio* and *A Burial* are rejected. Courbet organizes his own private showing, called 'Realism', which lasts until the end of the year and has *The Realist Manifesto* as its introduction	**1855** Rapprochement between England and Napoleon III, who visits London. Franco-British defeat at Sebastopol
1856 Paints *Young Ladies of the Banks of the Seine* [110]. Travels to Lyon and Ornans in autumn	**1856** Treaty of Paris, ending Crimean War. Flaubert, *Madame Bovary*
1857 Paints *The Quarry* [143]. Second visit to Bruyas in Montpellier. Begins year-long stay in Brussels and Frankfurt	**1857** Baudelaire, *Les Fleurs du mal*
1858 Leaves for Frankfurt, where he goes hunting with great success. Paints *The Hunting Picnic* [145]	

The Life and Art of Gustave Courbet	A Context of Events
	1858 Assassination attempt against Napoleon III by an Italian nationalist, Orsini. Italy: Victor-Emmanuel and his minister Cavour form alliance of Piedmont with Napoleon III. Creation of Romania
1859 Return to Ornans and Paris. Continues to paint hunting scenes and landscapes. A 'Fête du Réalisme' held in his studio	**1859** Darwin, *On the Origin of Species*
1860 Begins construction of new studio in Ornans. Exhibits work in Montpellier, Besançon and Brussels	**1860** Continuation of Italian campaign. Nice and Savoy ceded to France
1861 Paints *Battle of the Stags* [146] and *The End of the Run* [148]. Makes speech at Congress of the Arts in Antwerp. Opens teaching studio in rue Notre-Dame des Champs	**1861** Italy: Garibaldi takes Sicily and Naples. Unified Kingdom of Italy proclaimed. Death of Cavour. USA: Beginning of Civil War (to 1865)
1862 Closes studio in rue Notre-Dame des Champs. Exhibits in Bordeaux, Besançon and London. Begins stay in Saintes and Port-Berteau, where he paints flower still lifes, portraits, and *The Return from the Conference* [117]	**1862** Hugo, *Les Misérables*. French intervention in Mexico. Prussia: Bismarck becomes prime minister
1863 *Return from the Conference* rejected from Salon, which leads Proudhon to begin *On the Principle of Art and its Social Destination*	**1863** Elections in France show increase of Republican opposition to the Second Empire. Salon des Refusés where Manet exhibits *Déjeuner sur l'herbe* [121]. Renan, *The Life of Jesus*
1864 Paints *Venus and Psyche* [120], which is rejected from Salon. Paints *Oak of Vercingetorix* [151] and begins *Hallali of the Stag* [158]	**1864** Tolstoy, *War and Peace*
1865 Courbet begins posthumous portrait of Proudhon. At end of summer begins stay of several months in Trouville. Paints seascapes and meets Whistler. Begins *Woman in a Podoscaphe* [123]	**1865** Death of Proudhon. Posthumous publication of his *On the Principle of Art and its Social Destination*
1866 Shows *Woman with a Parrot* [126] at Salon and begins dispute with Count Nieuwerkerke over its purchase. Paints *Sleep* [129] and *Origin of the World* [132] for Khalil Bey. Stays with Count Choiseul in Deauville. Paints more seascapes	**1866** Dostoevsky, *Crime and Punishment*
1867 Returns to Ornans. Death of Cuenot. Paints *Death of the Stag* and *Siesta* [161]. Opens second one-person show in Paris near Universal Exposition of 1867	**1867** Zola, *Thérèse Raquin*. Marx, *Das Kapital*. Death of Baudelaire
1868 In Ornans, paints *Alms of a Beggar at Ornans* [160] and *Siesta* and writes political pamphlet attacking local politicians. Exhibits in Ghent and Le Havre	**1868** Monet paints *On the Bank of the Seine, Bennecourt* [111]
1869 Exhibits in Brussels and Munich. Stays in Etretat. Goes to Munich to receive artists' award. Returns to Ornans, where Buchon dies	**1869** Flaubert, *Sentimental Education*. Suez Canal inaugurated

The Life and Art of Gustave Courbet	A Context of Events
1870 Courbet preoccupied with reforms for art juries. Refuses Legion of Honour. After proclamation of Third Republic, Courbet elected to commission to safeguard artworks during Franco-Prussian War. Courbet also appointed to committee on the Louvre. Courbet reads an open letter to the Prussian army	**1870** Hostilities declared between France and Prussia. French defeat at Sedan. Fall of the Second Empire and proclamation of the Third Republic. Siege of Paris by the Prussian army
1871 Courbet flees his studio in rue Hautefeuille because of shelling. Is elected to the Commune. Demolition of the Vendôme Column on 16 May. Courbet's mother dies on 4 June. Courbet arrested on 6 June and imprisoned, eventually convicted. Prison paintings limited primarily to still lifes [182]	**1871** Paris capitulates to the Prussians. Founding of the Paris Commune on 18 March and retreat of the government of Thiers to Versailles. Commune defeated by Versailles troops on 28 May
1872 End of Courbet's prison sentence. Returns to Ornans. Paints fish pictures [185–6]	
1873 National committee refuses Courbet's participation in Vienna International Art Exhibition. Fearing liability for cost of Vendôme Column, transfers many works to art dealer, Durand-Ruel. Order of sequestration placed on Courbet's property. Courbet goes into exile in Switzerland	**1873** Hard-liner Marshal MacMahon becomes president of the Third Republic
1874 Courbet condemned to pay full cost of Vendôme Column. Paints many Swiss landscapes [190–1] and several portraits [192]	**1874** First Impressionist Exhibition
1875 Makes sculpture of *Liberty* [193]. Death of his sister Zélie	**1875** Constitution adopted for Third Republic
1876 Hopes new government will afford him some relief from penalties and prints a letter requesting appeal of his sentence	**1876** More liberal Republicans elected to government. New cabinet is formed by Jules Simon
1877 Begins *Grand Panorama of the Alps* [200]. His plans for return to France are dashed by reaffirmation of the verdict, but he is allowed to pay in installments. Falls ill in November and dies on 31 December	**1877** Cabinet of Jules Simon dissolved, replaced by Monarchist, Duc de Broglie. Zola, *L' Assommoir*
1880s Purchases of Courbet's paintings by the French state. Inclusion of his works in official exhibitions. Rehabilitation by critics	**1880s** Ministry of Arts founded with Antonin Proust, supporter of Manet, at its head
1919 Courbet's body returned for burial in France	

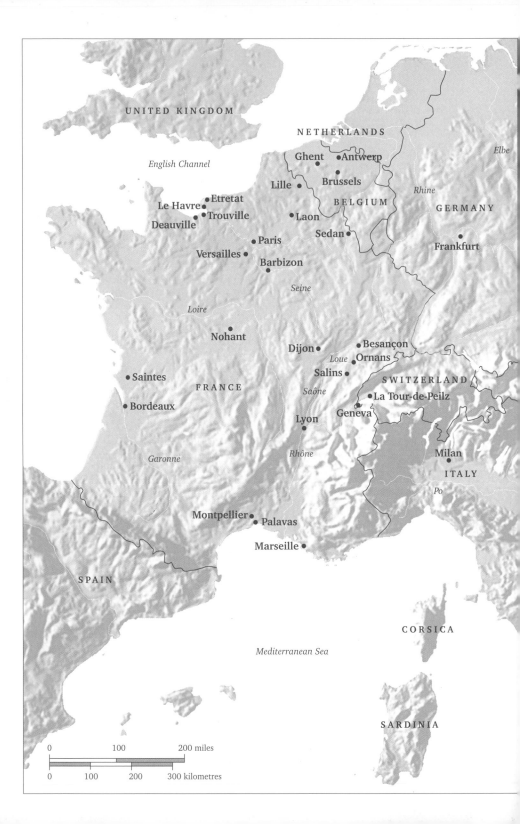

Further Reading

Some works covering Courbet's entire career are listed only in the general bibliography. Specialized sources for particular topics are shown under the pertinent chapters. Entries for individual paintings in the exhibition catalogues listed in the general bibliography should also be consulted by anyone seeking more information.

General

Georges Boudaille, *Courbet: Painter in Protest* (Greenwich, Connecticut, 1969)

Jules Champfleury, *Le Réalisme, textes choisis et présentés par Geneviève et Jean Lacambre* (Paris, 1973)

Petra ten-Doesschate Chu, *The Most Arrogant Man in France: Gustave Courbet and the Nineteenth-Century Media Culture* (Princeton, forthcoming)

— (ed.), *Letters of Gustave Courbet* (Chicago, 1992)

— (ed.), *Courbet in Perspective* (Englewood Cliffs, NJ, 1977)

Timothy J Clark, *Image of the People: Gustave Courbet and the Second French Republic, 1848–1851* (London and New York, 1973)

—, *The Absolute Bourgeois: Artists and Politics in France, 1848–1851* (London and New York, 1973)

Courbet und Deutschland (exh. cat., Hamburger Kunsthalle, 1978)

Pierre Courthion (ed.), *Courbet Raconté par lui-même et par ses amis,* 2 vols (Geneva, 1948 and 1950)

Georges Dupeux, *French Society, 1789–1970* (London and New York, 1976)

Sarah Faunce, *Gustave Courbet* (New York, 1993)

Sarah Faunce and Linda Nochlin *et al.*, *Courbet Reconsidered* (exh. cat., The Brooklyn Museum, 1988)

Robert Fernier, *La Vie et l'oeuvre de Gustave Courbet: Catalogue raisonné,* 2 vols (Lausanne and Paris, 1977–8)

Michael Fried, *Courbet's Realism* (Chicago, 1980)

Klaus Gallwitz and Klaus Herding (eds), *Malerei und Theorie: Das Courbet Colloquium,* 1979 (Frankfurt, 1980)

Gustave Courbet, 1819–1877 (exh. cat., Museum of Fine Arts, Boston, 1960)

Klaus Herding (ed.), *Realismus als Widerspruch: Die Wirklichkeit in Courbets Malerei* (Frankfurt, 1978)

Klaus Herding, *Courbet: To Venture Independence* (New Haven, 1991)

Charles Léger, *Courbet* (Paris, 1925)

—, *Courbet selon les caricatures et les images* (Paris, 1920)

Jack Lindsay, *Gustave Courbet: His Life and Art* (New York, 1973)

Gerstle Macke, *Gustave Courbet* (New York, 1951)

Neil McWilliam, *Dreams of Happiness: Social Art and the French Left, 1830–1850* (Princeton, 1993)

Linda Nochlin, *The Development and Nature of Realism in the Work of Gustave Courbet: A Study of the Style and its Social and Artistic Background* (New York, 1976)

—, *Realism and Tradition in Art 1848–1900: Sources and Documents* (Englewood Cliffs, NJ, 1966)

Pierre-Joseph Proudhon, *Du Principe de l'art et de sa destination sociale* (Paris, 1865)

Georges Riat, *Gustave Courbet, peintre* (Paris, 1906)

James H Rubin, *Realism and Social Vision in Courbet and Proudhon* (Princeton, 1980)

J M Thompson, *Louis-Napoleon and the Second Empire* (Oxford, 1954, repr. New York, 1967)

Hélène Toussaint, *Gustave Courbet, 1819–1877* (exh. cat., Grand Palais, Paris, 1977)

Theodore Zeldin, *The Political System of Napoleon III* (London, 1958, repr. New York, 1971)

Chapter 1

Petra ten-Doesschate Chu, *Dutch Painting and French Realism* (Utrecht, 1975)

Timothy J Clark, *Image of the People,* op. cit., pp.21–76

Peter Demetz, 'Defenses of Dutch Realism and the Theory of Realism', *Comparative Literature*, 15 (Spring 1963), pp.97–115

Jean-Jacques Fernier et al., Courbet et Ornans (Paris, 1989)

Marie-Thérèse de Forgues et al., Autoportraits de Courbet (exh. cat., Musée du Louvre, Les Dossiers du Département des peintures 6, Paris, 1973)

Michael Fried, Courbet's Realism, op. cit., pp.53–84

Nicholas Green, The Spectacle of Nature: Landscape and Bourgeois Culture in Nineteenth-Century France (Manchester and New York, 1990), pp.10–66

Ilse Hempel Lipschutz, Spanish Painting and the French Romantics (Cambridge, MA, 1972)

Léon Rosenthal, Du Romantisme au réalisme (Paris, 1914)

Elizabeth Roark, 'Courbet's Jouers de Dames and "La Vie de Bohème"', Gazette des Beaux-Arts, 112 (December 1988), pp.277–80

Jerrold E Seigel, Bohemian Paris: Culture, Politics, and the Boundaries of Bourgeois Life (New York, 1986)

Gabriel P Weisberg (ed.), The Realist Tradition: French Paintings and Drawing, 1830–1900 (exh. cat., The Cleveland Museum of Art, 1981)

Chapter 2

Robert Bezucha, 'Art and the History of Nineteenth-Century France', in Gabriel P Weisberg (ed.), The European Realist Tradition, Bloomington, IN, pp. 4–5

Timothy J Clark, The Absolute Bourgeois, op. cit.

—, Image of the People, op. cit., pp.77–120, 146

Georges Duveau, 1848: The Making of a Revolution (Paris, 1965, New York, 1967)

Robert L Herbert, Jean-François Millet (exh. cat., Grand Palais, Paris, 1975–6)

Neil McWilliam, '"Un enterrement à Paris": Courbet's political contacts in 1845', Burlington Magazine, 125 (1983), pp. 155–7

Edgar Leon Newman, 'Sounds in the Desert: The Socialist Worker-Poets of the Bourgeois Monarchy, 1830–1848', Proceedings of the Western Society for French History Studies, 3 (1976), pp. 269–99

Michael Nungesser, '"Und selbst die sociale Frage zieht ein in die geöffneten Pforten der Kunst." Die Steinklopfer im Spiegel der Kritik', in Herding (ed.), Realismus als Widerspruch, op.cit., pp.177–93

Gabriel P Weisberg, Bonvin (Paris, 1979)

Chapter 3

Yoshio Abe, 'Un Enterrement à Ornans et l'habit noir baudelairien: Sur les rapports de Baudelaire et de Courbet', Etudes de langue et de littérature francaises (Bulletin de la Société japonaise de langue et de littérature françaises) I (1962), pp.29–41

Jean Borreil 'Représentations du peuple et allégorie de l'artiste: A propos de Courbet et de l'histoire sociale de l'art', in Jacques Rancière et al., Esthétiques du Peuple (Paris, 1985), pp.77–109

Timothy J Clark, Image of the People, op. cit., pp.77–161

Jean-Louis Ferrier, Courbet: 'Un Enterrement à Ornans' (Paris, 1980)

Francoise Gaillard, 'Gustave Courbet et le realisme: Anatomie de la reçeption critique d'une oeuvre: "un enterrement"', Revue d'histoire littéraire de la France, VI (1980), pp.978–98

Claudette R Mainzer, 'Who is Buried at Ornans?' in Courbet Reconsidered, op. cit., pp.77–81

Jean-Luc Mayaud, 'Courbet, peintre de notables a l'Enterrement … de la République', in Ornans à l'enterrement (exh. cat., Musée Gustave Courbet, Ornans, 1981), pp.40–76

Linda Nochlin, 'Innovation and Tradition in Courbet's Burial at Ornans', in Essays in Honor of Walter Friedlaender, Marsyas Studies in the History of Art, 2 (New York, 1965), pp.119–26

Meyer Schapiro, 'Courbet and Popular Imagery: An Essay on Realism and Naïveté', in Modern Art, Nineteenth and Twentieth Centuries: Selected Papers (essay first published 1941, New York, 1978), pp.46–85

Chapter 4

Philippe Bordes, Courbet à Montpellier (exh. cat., Musée Fabre, Montpellier, 1985)

Michael Fried, Courbet's Realism, op. cit., pp.148–55

Klaus Herding, '"Les Lutteurs Détestables": Critique of Style and Society in Courbet's Wrestlers', in Courbet, op. cit., pp.11–43

Werner Hofmann, 'Uber die Schlafende Spinnerin' in Herding (ed.), Realismus als Widerspruch, op. cit., pp.212–22

Diane Lesko, 'From Genre to Allegory in Gustave Courbet's Les Demoiselles de Village', Art Journal, 38 (1979), pp.171–7

Patricia Mainardi, 'Gustave Courbet's Second Scandal: Les Demoiselles de Village', Arts Magazine, 53 (January 1979), pp.95–102

Linda Nochlin, 'The Cribleuses de blé: Courbet, Millet, Breton, Köllwitz, and the Image of the Working Woman', in Gallwitz and Herding (eds), *Malerei und Theorie,* op. cit., pp.49–73

—, 'Gustave Courbet's Toilette de la mariée', *Art Quarterly,* 34 (1971), pp.30–54

—, 'Gustave Courbet's Meeting: A Portrait of the Artist as a Wandering Jew', *Art Bulletin,* 49 (1967), pp.209–22

James H Rubin, *Realism and Social Vision in Courbet and Proudhon,* op. cit., pp.3–63

Chapter 5

Klaus Herding, 'The Painter's Studio: Focus of World Events, Site of Reconciliation', in *Courbet,* op. cit., pp.45–61

Patricia Mainardi, *Art and Politics of the Second Empire: The Universal Expositions of 1855 and 1867* (London and New Haven, 1987)

James H Rubin, *Realism and Social Vision,* op. cit., passim.

Hélène Toussaint, 'Le Dossier de L'Atelier de Courbet', in *Gustave Courbet 1819–1877* (exh. cat., Grand Palais, Paris, 1977), pp.241–72

Chapter 6

Erich Auerbach, *Mimesis: The Representation of Reality in Western Literature* (Princeton, 1953)

Roland Barthes, 'The Reality Effect' (1968) in *The Rustle of Language,* trans. by Richard Howard (Berkeley and Los Angeles, 1989), pp.141–8

Roman Jakobson, 'Du réalisme en art', in Questions de poétique (Paris, 1973), pp.31–9

Linda Nochlin, *Realism* (Harmondsworth, 1971)

Bernard Weinberg, *French Realism: The Critical Reaction, 1830–1870* (New York, 1937)

Chapter 7

Roger Bonniot, *Gustave Courbet en Saintonge* (Paris, 1973)

Petra ten-Doesschate Chu, 'Courbet's Unpainted Pictures', *Arts Magazine,* 55 (September 1980), pp.134–41

—, 'Gustave Courbet's Venus and Psyche: Uneasy Nudity in Second-Empire France', *Art Journal* (Spring 1992), pp.38–44

Francis Haskell, 'A Turk and his Pictures in Nineteenth-Century Paris', *Oxford Art Review,* V, 1 (1982), pp.40–7

Robert L Herbert, 'Courbet's "Mère Grégoire and Béranger"', in Gallwitz and Herding, *Malerie und Theorie,* op. cit., pp.75–89

Marie-Françoise Lévy, 'La Conception proudhonienne de la femme et du mariage', in Pierre Ansart and Gaston Bordet (eds), *P J Proudhon, Pouvoirs et Libertés, Actes du Colloque de Paris et Besançon, 1987* (Paris, 1989), pp.111–17

Christiane Mauve, 'De "l'imagimère" proudhonien', in ibid., pp.119–27

Linda Nochlin, 'Courbet's "L'Origine du Monde": The Origin without an Original', *October,* 36 (Summer 1986), pp.76–86

Pierre-Joseph Proudhon, *La Pornocratie, ou les femmes dans les temps modernes* (Paris, 1875)

Aaron Scheon, 'Courbet, French Realism, and the Discovery of the Unconscious', *Arts Magazine,* 55 (February 1981), pp.114–28

Chapter 8

Petra ten-Doesschate Chu, 'It Took Millions of Years to Compose That Picture', in Faunce, Nochlin et al., *Courbet Reconsidered,* op. cit., pp.55–65

—, 'Courbet's Unpainted Pictures', op. cit., pp.136–41

Nicholas Green, *The Spectacle of Nature,* op. cit., pp.67–185

Robert L Herbert, *Barbizon Revisited* (exh. cat., The Museum of Fine Arts, Boston, 1962)

Klaus Herding, 'Equality and Authority in Courbet's Landscape Painting', in *Courbet,* op. cit., pp.62–98

—, 'Color and Worldview', in ibid., pp.111–34

Steven Z Levine, 'Gustave Courbet in his Landscape', *Arts Magazine* (1980), pp.67–9

Neil McWilliam, *Dreams of Happiness,* op. cit., pp.188–210

Margaret Robinson, *Courbet's Hunt Scenes: The End of a Tradition* (Providence, RI, 1990)

Ann Wagner, 'Courbet's Landscapes and their Market', *Art History,* 4 (1981), pp.410–31

Chapter 9

Jules Castagnary, *Gustave Courbet et la Colonne Vendôme: Plaidoyer pour un ami mort* (Paris, 1883)

Pierre Chessex, *Courbet et la Suisse* (exh. cat., Château de La Tour-de-Peilz, Switzerland, 1982)

Paul B Crapo, 'Courbet's Artistic and Political Activities in the Fall of 1870',

Proceedings of the Annual Meeting of the Western Society for French History, XVII (1990), pp.319–29

—, 'Courbet, La Rochenoire et les réformes du Salon en 1870', *Bulletin des Amis de Gustave Courbet,* Musée Gustave Courbet, Ornans, 84 (1990), n.p.

—, 'Disjuncture on the Left: Proudhon, Courbet, and the Antwerp Congress of 1861', *Art History,* 14 (1991), pp.67–91

—, 'Gustave Courbet and Reform of the Fine Arts under the Government of National Defense: Five Letters of the Artist to Jules Simon', *Gazette des Beaux-Arts* (October 1991), pp.147–60

Klaus Herding, 'A Note on the Late Work', in *Courbet,* op. cit., pp.135–55

Linda Nochlin, 'Courbet, die Commune und die bildenden Künste', in Herding (ed.), *Realismus als Widerspruch,* op. cit., pp.248–62

Jeannene M Przyblyski, 'Courbet, the Commune and the Meanings of Still Life in 1871', *Art Journal,* Summer 1996, pp.28–37

Chapter 10

Louis Aragon, *L'Exemple de Courbet* (Paris, 1952)

Courbet und Deutschland, op. cit., pp. 359–474

Stephen F Eisenman, 'The Intransigent Artist or How the Impressionists Got Their Name', in Charles S Moffet *et al.*, *The New Painting: Impressionism 1874–1886* (exh. cat., The Fine Arts Museums of San Francisco, 1986), pp.51–9

Linda Nochlin, 'The De-Politicization of Gustave Courbet: Transformation and Rehabilitation under the Third Republic', *October*, 22 (1986), pp.65–77

Jean-Pierre Sanchez, 'La Critique de Courbet et la Critique du Réalisme entre 1880 et 1890', *Histoire et critique des arts,* 4–5 (May 1978), pp.76–82

Index

Numbers in **bold** refer to illustrations

Acknowledgements

When it comes to writing a succinct, factual, analytical, and interpretive account of the whole of Gustave Courbet's career, one quickly discovers how much is owed to five important scholars: Linda Nochlin, Klaus Herding, Timothy Clark, Petra Chu and the late Meyer Schapiro. I am glad to count them among my friends and inspiration, and I hope this book will do justice to their contributions to Courbet studies. Of course, I have also made use of many other scholarly and biographical writings, especially the centenary exhibition catalogue by Hélène Toussaint and the exemplary *Courbet Reconsidered* catalogue from the Brooklyn Museum, the biographical monographs by Georges Riat and Gerstle Macke, and the catalogue raisonné by Robert Fernier. I have tried to produce a fresh account, based on my own insights and synthesis, while using the discoveries of the most current scholarship. It may be possible at this time to put recent study into perspective in a way that enriches and illuminates what is still the fascinating story of a powerful and determined artist and his exemplary achievement.

I would like to thank Conway Lloyd Morgan and Marc Jordan for giving me the impetus to conceive this book, as well as the State University of New York at Stony Brook, which provided the sabbatical leave in 1993–4 during which I did additional research and much writing. For their help in obtaining various documents and information, I wish to thank Jean-Jacques Fernier, Marie-Amelie Anquetile, Jean-Marie Cusinberche, Linda Nochlin, Klaus Herding, Petra Chu and Anne McCauley. I am grateful to Nina Athanassoglou-Kallmyer and Henry Alex Rubin for their comments and suggestions on the manuscript. Last but far from least, the staff at Phaidon Press, especially Pat Barylski, Julia MacKenzie, Adrienne Corner, Elizabeth Bacon and Michael Bird, have been exemplary collaborators who have helped to make the book much better than it would have been without them.

JHR

For Annette and Conway

Photographic Credits

Acquavella Contemporary Art Inc, New York: 214; Art Gallery of Ontario, Toronto: gift of Sam and Ayala Zack 182; The Art Institute of Chicago: Mr and Mrs Lewis Larned Coburn Memorial Collection 211, Mr and Mrs Potter Palmer Collection 111, Wilson L Mead Fund 109; Artothek, Peissenberg/Bayerische Staatsgemälde-sammlungen: 34; Barnes Foundation, Merion: 113; Jean Bernard, Aix-en-Provence: 148; Bibliothèque d'Art et d'Archéologie, Fondation Jacques Doucet, Paris: 81; Bibliothèque Nationale, Paris: 54, 59, 60, 62, 69, 72, 76, 82, 84, 89, 97, 103, 163, 170, 188; Bildarchiv Preussischer Kulturbesitz, Berlin: 118, 167; Bridgeman Art Library, London: 32, 164; Bridgeman Art Library/Giraudon: 26, 110, 168; Jean-Loup Charmet, Paris: 41, 93, 173, 176, 177; Charles Choffet, Besançon: 57, 158, 199; Cincinnati Art Museum: bequest of Mary M Emery 36, gift of Emilie L Heine in memory of Mr and Mrs John Hauck 137; The Cleveland Museum of Art: John L Severance Fund 198, 200, Leonard C Hanna Jr Fund 139; Dallas Museum of Art: Foundation for the Arts, Collection Mrs John B O'Hara Fund 155; Edimedia, Paris/Bibliothèque Nationale, Paris: 40, 101; Richard L·Feigen & Co: 17; Harvard University Art Museums: gift of Friends of the Fogg Art Museum 209; Giraudon, Paris: 12, 13, 14, 20, 178, 198, 203; Glasgow Museums, The Burrell Collection: 160; André Jammes Collection: 115, 156, 157, 194; Christian Kempf, Colmar: 33; Kharbine-Tapabor, Paris: 16, 94, 100, 174, 175, 202; Kimbell Art Museum, Fort Worth, Texas: 21; Magali Koenig, Lausanne: 193; Kunsthalle Bremen: 212; Kunsthaus, Zürich: 186; Kunstmuseum, Bern: 120, 185; Kunstmuseum, St Gallen: 195; The Lefevre Gallery, London: 108; Ann McCauley/Préfecture de Police, Paris: 114; G Mangin, Ornans: 2; Mesdag Museum, The Hague: 183; The Metropolitan Museum of Art: The H O Havemeyer Collection 126, 133, gift of Harry Payne Bingham 66, Lillie P Bliss Collection 208; Minneapolis Institute of the Arts: The John R Van Derlip Fund and The William Hood Dunwoody Fund 140; Mountain High Maps, copyright © 1995 Digital Wisdom Inc: p.340; Murauchi Art Museum, Tokyo: 123, 151; Les Musées de la Ville de Strasbourg: 138; Musée des Beaux-Arts, Lille: 27; Collection du Musée des Beaux-Arts, Lons-le-Saunier: 144; Musée des Beaux-Arts, Nantes: 39, 79; Musée Fabre, Montpellier: 30, 47, 74, 77, 78, 83, 85, 88; Musée Gustave Courbet, Ornans: 1, 9, 117,

190; Musée Historique de Nyon: 197; Musée Jenisch, Musée des Beaux-Arts, Vevey: 191; Musées Royaux des Beaux-Arts de Belgique, Brussels: 56; Museo del Prado, Madrid: 28, 159; Museum Boymans van Beuningen, Rotterdam: 165; Museum of Fine Arts, Boston: Henry Lillie Pierce Fund 143; Nasjonalgalleriet, Oslo: 15; The National Gallery, London: 35; National Gallery of Art, Washington, DC : Chester Dale Collection 11, 207, gift of Charles L Lindemann 152, gift of Mr and Mrs P H B Frelinghuysen 136, 141; National Gallery of Scotland: 153, 154; Nationalmuseum, Stockholm: 23, 125; New York Public Library: Astor, Lenox and Tilden Foundations 42, 45, 71, 112, 130; Ny Carlsberg Glyptotek, Copenhagen: 124; Oskar Reinhart Collection, Winterthur: 19; Philadelphia Museum of Art: The John G Johnson Collection 105; The Phillips Collection, Washington, DC: 46; Photothèque des Musées de la Ville de Paris: 4, 10, 18, 68, 122, 129, 134, 161, 172, 189; RMN, Paris: 6, 7, 8, 22, 29, 37, 43, 48, 49, 51, 52, 58, 61, 65, 86, 87, 90, 91, 92, 121, 127, 128, 131, 132, 135, 142, 146, 149, 150, 166, 180, 192, 196, 204, 210; Rheinisches Bildarchiv, Cologne: 145; Rijksmuseum, Amsterdam: 53, 67; The St Louis Art Museum: gift of Mrs Mark C Steinberg 162; SCALA, Florence: 55, 206; Smith College Museum of Art, Northampton, Massachusetts: 80; Szépmüvészeti Museum, Budapest: 70; Tate Gallery, London: 147; Toledo Museum of Art, Toledo, Ohio: gift of Edward Drummond Libbey 116; Jean Vigne, Paris: 102, 106, 107, 184; Wadsworth Atheneum, Hartford: gift of James Junius Goodwin 31; Elke Walford, Hamburg: 213

351 Acknowledgements

Phaidon Press Limited
Regent's Wharf
All Saints Street
London N1 9PA

First published 1997
© 1997 Phaidon Press Limited

ISBN 0 7148 3180 8

A CIP catalogue record for this book is
available from the British Library.

Typeset in Bitstream Charter

Printed in Hong Kong

Cover illustration Detail from *The
Meeting,* 1854 (see pp.128–9)